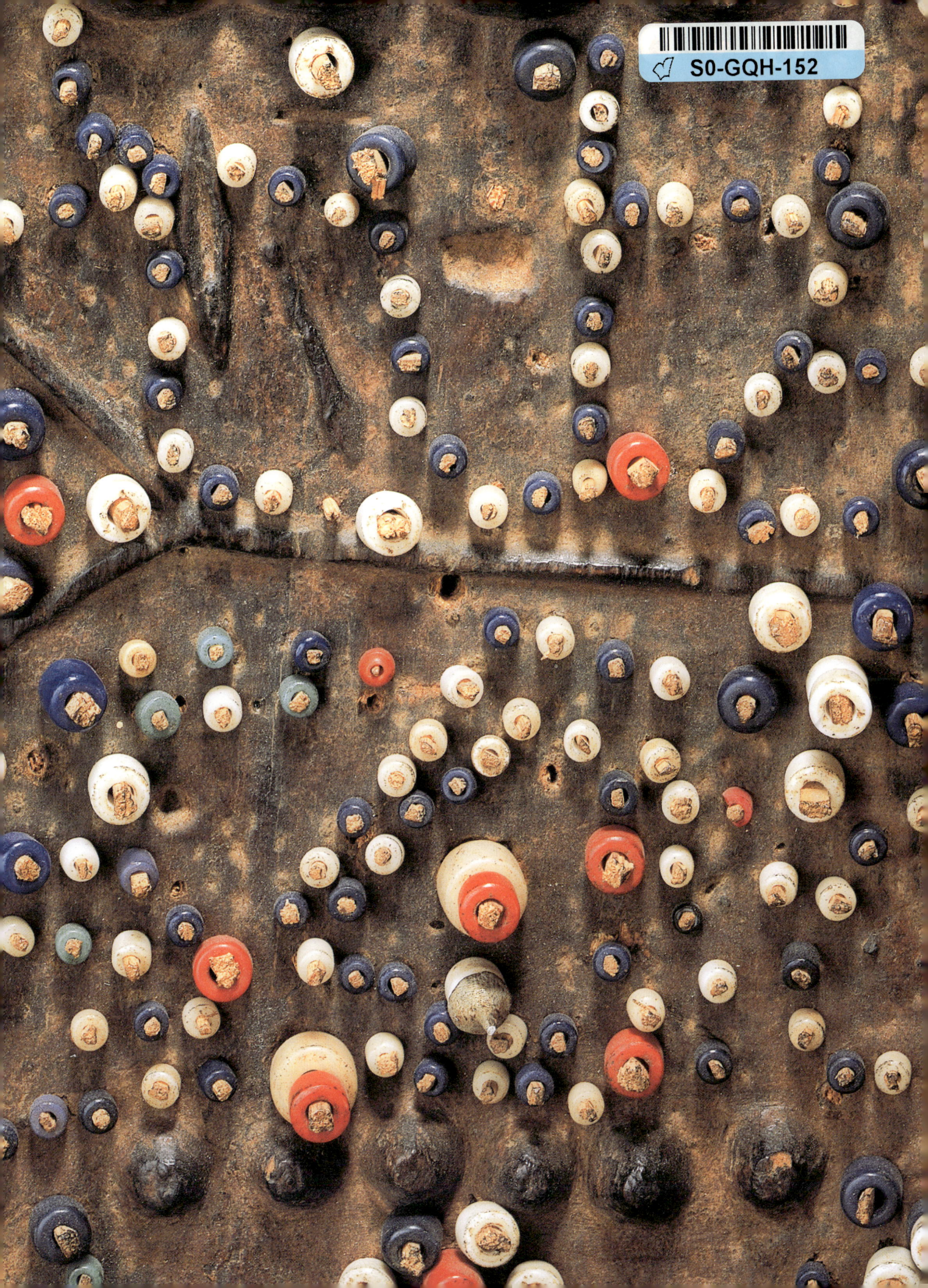

BodyPOLITICS

BodyPOLITICS

*The Female Image in Luba Art
and the Sculpture of Alison Saar*

Mary Nooter Roberts *and* Alison Saar

UCLA FOWLER MUSEUM OF CULTURAL HISTORY

LOS ANGELES

MONOGRAPH SERIES NUMBER 29

Funding for this publication has been provided by

The Jerome L. Joss Foundation
Dr. Richard and Jan Baum
Dr. and Mrs. Ernest Fantel
Mr. and Mrs. Edwin Silver
Anonymous Funders

The Fowler Museum is part of
UCLA's School of the Arts and Architecture

Lynne Kostman, Managing Editor
Daniel R. Brauer, Designer and Production Coordinator
Don Cole, Principal Photographer

©2000 Regents of the University of California.
All rights reserved.

UCLA Fowler Museum of Cultural History
Box 951549
Los Angeles, California 90095-1549

Requests for permission to reproduce material from this volume should be sent to the UCLA Fowler Museum Publications Department at the above address.

Printed and bound in Hong Kong
by South Sea International Press, Ltd.

Cover: *Chaos in the Kitchen* (see fig. 27), Luba cup in the form of a head (see fig. 26).

Library of Congress Cataloging-in-Publication Data

Roberts, Mary Nooter.
 Body politics : the female image in Luba art and the sculpture of Alison Saar/Mary Nooter Roberts and Alison Saar.
 p. cm.
 Catalog of an exhibition held at the UCLA Fowler Museum of Cultural History, Nov. 12, 2000–May 13, 2001.
 Includes bibliographical references.
 ISBN 0-930741-81-1 (soft)
 1. Saar, Alison—Interviews. 2. Sculptors—United States—California—Interviews. 3. Female nude in art. 4. Feminism and art—United States. 5. Sculpture, Luba. 6. Wood-carving—Africa—Congo (Democratic Republic) 7. Luba (African people)—Social life and customs. I. Saar, Alison. II. University of California, Los Angeles. Fowler Museum of Cultural History. III. Title. IV. Series.

NB 237.S165 A35 2000
730'.89'96393—dc21 00-056765

Lenders to the Exhibition

Dr. Richard and Jan Baum
Terry and Lionel Bell
Susanne K. Bennet
Iona Benson
Ronald and JoAnn Busuttil
Carole Cole and John Ernsdorf
Robert and Faye Davidson
Walt Disney—Tishman African Art Collection
Dr. and Mrs. Ernest Fantel
Felix Collection
Gai Gherardi and Rhonda Saboff
Joseph and Barbara Goldenberg
Elaine and Bram Goldsmith
The Hodosh Family
John Hughes, Rhythm and Hues
Phyllis Kind Gallery
Barry and Jill Kitnick
Jay and Deborah Last
Justine I. Linforth
Los Angeles County Museum of Art
Jack E. Lowrance
Robert F. MacLeod
Philip Messinger
Eileen and Peter Norton
Linda and Reese Polesky
John B. Ross
Robert A. Roth
The Schorr Family
Paul J. Sheehan and Associates
Mr. and Mrs. Edwin Silver
Shelley Silverstein and Robert Quintana
Charles and Nancy Sims
Jerry Solomon
Saul and Marsha Stanoff
Dr. and Mrs. Leon Wallace
Diane Steinmetz Wolfe and Ernie Wolfe III

CONTENTS

- **6** Foreword
- **8** Acknowledgments
- **9** Notes to the Reader
- **10** Introduction
- **12** **CONVERSING FORMS**
 A Dialogue between Artist Alison Saar and Curator Mary Nooter Roberts, March 2000
- **62** **IMAGING WOMEN IN AFRICAN ART**
 Selected Sculptures from Los Angeles Collections
- **78** Bibliography
- **80** Contributors

FOREWORD

This book presents a dialogue between Dr. Mary (Polly) Nooter Roberts, one of my favorite scholars, and Alison Saar, one of my favorite artists. It also incorporates a more abstract dialogue between the art of the Luba peoples of the Democratic Republic of the Congo (formerly Zaire) and Alison's remarkable sculpture.

That several fascinating "dialogues," "conversations," and "interviews" with Alison have been published is a measure of her articulateness. At a time when many artists seem to hide behind the phrase "the art speaks for itself," Alison has chosen to amplify the already eloquent voice of her work, revealing the depth and complexity of her thinking about issues of gender, race, and the history of art.

The present dialogue touches upon some of the more salient concerns of contemporary art historical discourse. Issues of identity, power, narrative, and meaning surface throughout the conversation. Themes relating to memory and secrecy are critical to the intellectual interests of both Polly and Alison, and the presentation, manipulation, and alteration of the human body—especially the female body—are central to the discussion.

I first became aware of Alison's work through some of her many important exhibitions at the Jan Baum Gallery. *Secrets, Dialogues, Revelations: The Art of Betye and Alison Saar,* an exhibition held in 1990 at UCLA's Wight Art Gallery, was also an epiphany for me. I was captivated by the scale and power of Alison's art. The image of the female, especially the African American female, was an important focus. Her solo exhibition *Directions,* held at the Hirshhorn Museum in 1993, explored African American popular culture and stereotypes. *Fertile Ground*, an exhibition of the same year held at the High Museum in Atlanta, looked at ties to the South, sharecropping, and a sense of place.

For nearly five years Alison's sequined *Sapphire* (1986) has hung in my home, recalling for me some of the Haitian riffs in *Secrets, Dialogues, Revelations,* as well as our own Museum's *Sacred Arts of Haitian Vodou*. Certainly formative in my appreciation of Alison's work was bell hooks's substantial and affectionate "Talking with Alison Saar," published in *Art on My Mind: Visual Politics* (1995). After thoughtfully considering such themes as "sexual longing and desire," and "soulfulness and soullessness," in Alison's work, hooks concludes the chapter with a statement that in some ways prefigures *Body Politics:*

> The politics of passion and desire that is articulated throughout your work needs to be discussed more by critics. We need to do more to describe the naked black figure. We need to talk about the vulnerability in these images—the passion of remembrance. These longings that we know to be universal in people, the longing to connect, to experience community, to embrace the mysterious. Your work calls us again and again to that realm of mystery.

Polly Roberts's investigation of issues discussed in *Body Politics* is rooted in her research on one of the most celebrated cultures and sculptural traditions in all of Africa, that of the Luba peoples of the Democratic Republic of the Congo. With an array of art forms featuring the female image in a variety of poses and contexts, the Luba produced a "body of art" that provides illuminating comparisons with the work of Alison Saar. After a year spent studying Luba art in Belgian museums and archives, Polly lived with the Luba in Zaire from 1987 to 1989 while conducting her doctoral research. Her husband, Dr. Allen F. Roberts, has done extensive research among groups neighboring the Luba, and together they published the highly acclaimed *Memory: Luba Art and the Making of History* (1996), recipient of the College Art Association's Alfred Barr Book Award for Museum Scholarship in 1998. I would also like to single out *Secrecy: African Art that Conceals and Reveals* (1993)—

among Polly's many other publications—as particularly relevant to the present volume. In July of 1999, we were extremely fortunate to have Polly join the Fowler Museum staff as chief curator; shortly thereafter she embarked on this project. Her consummate research skills, critical thinking, and amazing productivity are much admired by myself and the rest of our staff.

 I would like to thank Polly and Alison for their vital and stimulating collaboration on this project. Their friendship and rapport has created a provocative exhibition and a thought-provoking discussion. I also join them in extending gratitude to the entire Fowler Museum staff whose efforts on both the publication and exhibition can only be described as extraordinary.

Doran H. Ross
DIRECTOR

ACKNOWLEDGMENTS

This book reflects the creativity and efforts of many, and we would like to express our gratitude to a few of those who have participated. First, we wish to thank Jan Baum for her graciousness and unflagging support from the very inception of this project. Jan assisted Mary Nooter Roberts at every stage of planning—from identifying lenders to securing photographs. The project would not have been possible without her. Jan and her husband, Richard, have also lent several pieces from their own collection to *Body Politics*. It is always difficult to part with cherished works of art, and knowing this, we are especially grateful to each and every lender (see p. 4 for a list of "Lenders to the Exhibition").

The present volume would not have come to fruition without the generous financial support of the Jerome L. Joss Foundation, facilitated by Morris Kaplan; additional support has come from Cherie and Edwin Silver, Jan and Richard Baum, Mary Louise and Ernest Fantel, and other anonymous friends of the Museum. It is dedicated friends such as these who make the UCLA Fowler Museum of Cultural History such an extraordinary place to work and to visit.

The Fowler staff also deserves our special thanks. Lynne Kostman was a superb editor, Danny Brauer brought his provocative design sense to this volume, and Don Cole captured the beauty and essence of the works he photographed. Sarah Kennington, Fran Krystock, Jo Hill, Farida Sunada, Anna Sanchez, and Teva Kukan efficiently expedited the processing of loans, arrangements for photography, and preparation of condition reports. Our thanks also go to Lynne Brodhead and Leslie Denk for their work in securing financial support for the exhibition; to Christine Sellin and Amy Hood for their public relations efforts; to Patti Goldberg for research assistance; to Alicia Katano and Ilana Gatti for program planning; and to Clarissa Coyoca for her administrative support. David Mayo and his exhibition team have created a "performance piece" through the ingenious juxtaposition of objects and words. Martha Crawford found creative solutions to exhibition graphics. Betsy Quick, who brings her astute interpretive capability to every Fowler project, has shaped the exhibition text to speak to the broadest possible audience. And finally, Director Doran H. Ross has offered his stalwart support from the beginning and his curatorial insights throughout the development of every aspect of *Body Politics*.

A number of African art scholars contributed firsthand information to our understanding of the works presented in "Imaging Women." These colleagues include Henry Drewal, Kate Ezra, Manuel Jordán, Alisa LaGamma, Frederick Lamp, Keith Nicklin, and Jill Salmons.

Kyrin Hobson and Marc Léo Felix each offered valuable counsel to Mary Nooter Roberts during exhibition development. We wish to extend especially warm appreciation and gratitude to Professor Samella Lewis with whom we both studied African art during our undergraduate years at Scripps College in Claremont, California.

Finally, Mary Nooter Roberts dedicates this book to her husband, Dr. Allen F. Roberts, who is a constant source of intellectual inspiration and editorial guidance; to her children, Sidney, Seth, and Avery; and to her parents, Nancy I. Nooter and Robert H. Nooter. Alison Saar dedicates the book to her husband and collaborator, Thomas Leeser; her children, Kyle and Maddy; and her parents, Betye Saar and Richard Saar.

Mary Nooter Roberts and Alison Saar

Notes to the Reader

Throughout the dialogue "Conversing Forms," short descriptive texts appear in the captions to the photographs of the Luba objects, while none appear in the captions for Alison Saar's sculptures. This is based on the fact that virtually all the Saar works are discussed in the dialogue by the artist herself, whereas most of the Luba works are explained by curator Mary Nooter Roberts only in a more generalized way.

The quotations by Luba individuals that appear in the dialogue and captions were collected during predoctoral field research in the Democratic Republic of the Congo (formerly Zaire) between 1987 and 1989 by Mary Nooter Roberts. The many individuals upon whose immense knowledge an understanding of Luba art and political history is based resided at that time in the Kinkondja and Kabongo collectives of Katanga Region, formerly Shaba. These quotations represent fragments of extended conversations and interviews conducted by Mary Nooter Roberts with a wide range of individuals on topics of royal culture, divination and healing, women's status and responsibilities, and artistic heritage.

Whereas all of the works by Alison Saar included in the volume date from the 1980s to the present, virtually all of the Luba works of art date from the eighteenth to the early twentieth centuries, with the majority probably from the nineteenth century. It is virtually impossible to date African wood sculpture with precision, although surface patination, quality of the wood, and stylistic attributes all provide some indication of age and place of origin. A striking contrast between Luba artworks and the sculptures of Alison Saar lies in their scale. Saar's works often attain a larger-than-life scale, whereas Luba art is much smaller. This contrast is one of the aspects of the Luba–Saar sculptural dialogue that emerges prominently in the exhibition but is much less apparent in the book.

MNR

INTRODUCTION

One is not born, but rather becomes a woman.

Simone de Beauvoir

One is not born beautiful, but rather becomes beautiful over the course of a lifetime.

Luba Proverb

Body Politics emerged when I first saw several of Alison Saar's powerful sculptures juxtaposed with African art in the Los Angeles home of Richard and Jan Baum. Having studied the female image in Luba sculpture from the southeastern regions of the Democratic Republic of the Congo (formerly Zaire) for twenty years, I found Alison's works to sometimes whisper, sometimes shout similar messages about the politics reflected by and embedded within the female form. This revelation led to a first meeting during which Alison and I discovered a mutual preoccupation with women's issues and images. Our subsequent conversations led to this publication and the accompanying exhibition.

Saar and Luba materials share startlingly similar themes. Both demonstrate intimate links between women's bodies and sacred places; indeed, in both cases, a woman's body is the primary place of memory and reflection. Both reveal women's physical and moral presence in the labors of domestic and community contexts. For Alison Saar and for Luba artists, women's hair, skin, and other parts of the body communicate fundamental messages about everyday life and spiritual purpose. And women possess corporeal connections to dreams and divination, for in both the sculpture of Alison Saar and the Luba people, the female body is a spirit vessel. The evocative ways in which Luba artists have visualized the powers and prerogatives of women through sculpture thus provide particularly fruitful opportunities for comparative study with Saar's oeuvre.

Body Politics bridges two continents and two centuries through a global perspective. Even though Alison's sculpture is influenced by African objects and ideas, neither she nor I was interested in seeking direct linkages between African art and her work. Nor were we concerned with modernist approaches to "affinities" between the two. Instead, we felt that compelling thematic crossovers existed between Luba objects and Alison's works, in spite of the extraordinary differences that led to their creation. *Body Politics* has been an opportunity to open a dialogue and allow the works to share a space of discussion and a conversation of forms. In both cases, female figures express complex ideas about gender, power, societal ideals, and spiritual uplift.

In *Body Politics* we hope to underscore the notion that categories of self and other are always negotiated within and reflected by the body. The book and the exhibition posit a conjunction between the complex power and gender politics encoded within Luba sculptures from precolonial central Africa and within the gripping figural commentaries of a turn-of-the-twenty-first-century Los Angeles-based woman artist. In so doing, the publication and the exhibition refuse to present African art as insular, remote, or irrelevant to our concerns. The interconnected themes and messages of the two bodies of material transcend arbitrary categories of Africa and the West, traditional and contemporary, original and derivative.

The Luba art in *Body Politics* reflects the magnificence of the Luba kingdom—one of central Africa's most influential precolonial states from approximately the seventeenth to the late nineteenth century. The works were commissioned by male rulers and diviners and made by male artists, as is the case with most wood sculpture in Africa; yet the iconography emphasizes women in highly symbolic poses. Each Luba object in this book helped uphold political authority by conveying complex notions about the nature of power itself and the critical role of Luba women in secular, spiritual, and moral governance.

In contrast, Saar's works are the product of her contemporary American circumstances and represent

one woman's artistic vision of the female body as a site of negotiation and intense political discourse. The Saar figures in *Body Politics* portray the social expectations, idealized images, and harsh realities of women's lives, while at the same time celebrating the strength of women who have harnessed spiritual resources to override their conditions. Saar addresses the complexities of race, gender, and identity in the United States and brings her own experiences to bear upon the vivid stories that she recounts. Saar has said of her work, "I hope to make art which will relate to [my] children, to the fact that they are of mixed heritage. More and more families are of mixed heritage, and part of educating my children is to show them that you may look white, but part of your heritage is black" (*San Gabriel Valley Tribune*, May 7, 2000, section D, p. 1). Yet while hers is a personalized vision, profound social and philosophical messages emerge from her work.

As important as the visual connections between the two bodies of art are, other associations emerge from the dialogue. Just as Luba works in their own contexts stimulate oral recitations about history, politics, and sacred royalty, so Saar's sculptures act as mnemonics for the artist's life stories. Yet, like all mnemonics, her female images do not produce the same tales with every telling. The conversation presented in these pages may raise more questions than it answers and produce more beginnings than endings, but its essence lies in the call and response of the works of art.

The place of female imagery in Luba art has been studied in great depth and is the subject of ongoing research and writing (see Suggested Reading, p. 78). Yet, African art is rich in female representation. The section of this volume and of the exhibition entitled "Imaging Women in African Art: Selected Sculptures from Los Angeles Collections" has thus been conceived as a complement to *Body Politics*. After a journey through the conversing forms of Saar's sculpture and Luba art, *Imaging Women* offers a glimpse of the conceptual breadth and sheer visual splendor of works that celebrate femininity across Africa. Behind every depiction of an African mother, queen, or deity, there surely lie stories as profound as those of the Luba. Some such stories are already known, but many remain to be learned. It is hoped that the conversations begun in *Body Politics* may be extended to these diverse legacies by the next generation of scholars.

Mary Nooter Roberts

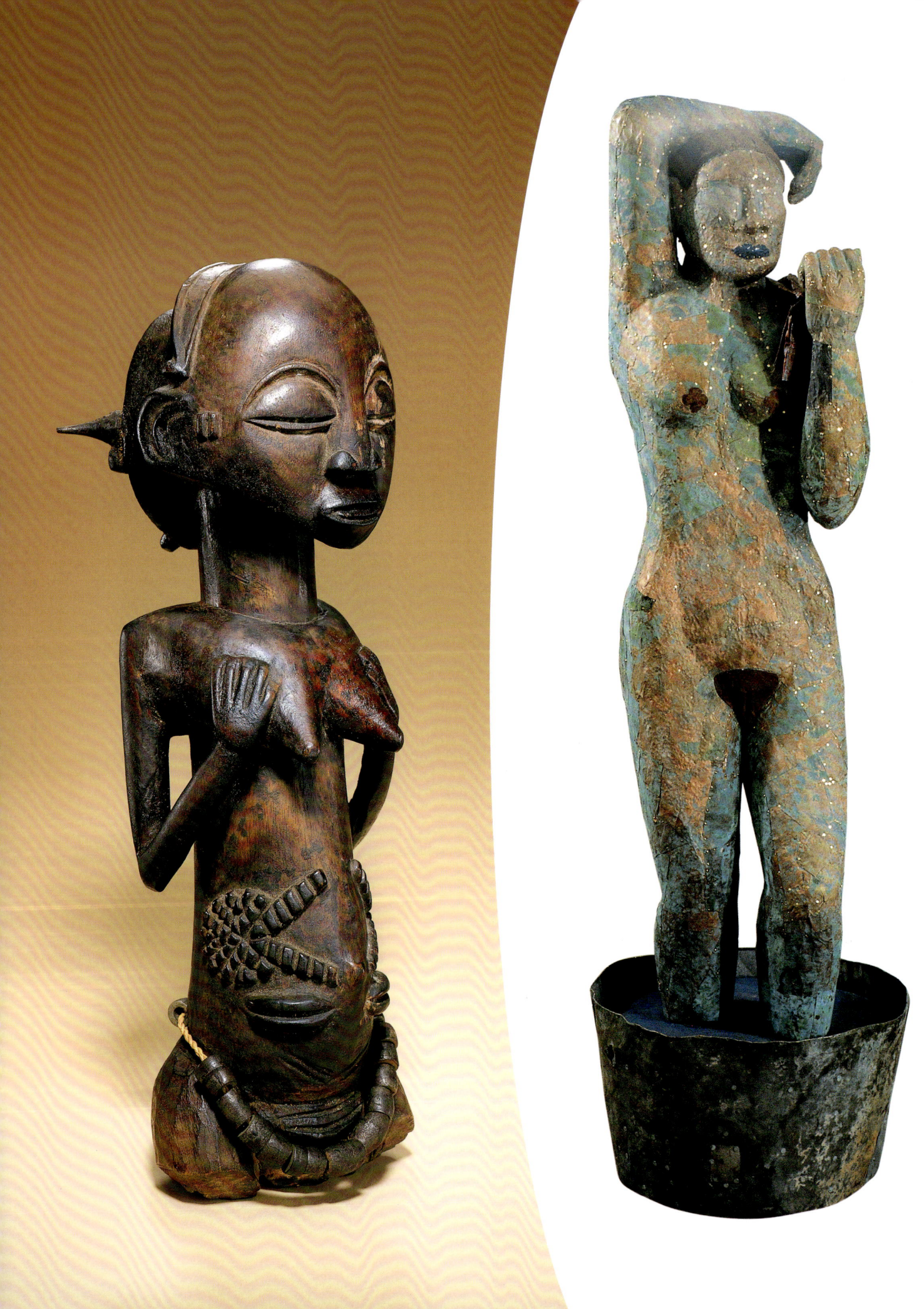

Conversing FORMS

A Dialogue between Artist **Alison Saar** *and Curator* **Mary Nooter Roberts**

March 2000

Men are chiefs in the daytime, but women become chiefs at night.

Luba Proverb

It's about how all these women are always being perceived and viewed by the audience.… You're seeing her experience, but you're not really understanding her experience of being observed.

Alison Saar

MNR: I was thinking that the exhibition and the publication would open with just two works side by side, a wonderful nineteenth-century Luba female figure from the Fowler's collection and your life-size female bather *Bain Froid* (figs. 1, 2A). I'm not necessarily interested in a one-on-one sort of juxtaposition, but for the introduction it seems important to tell people that this is a dialogue, that this is about these two different sculptural situations talking to each other and what can be learned about each through the other. We don't want to suggest that this is about "affinities."

AS: I think a lot of times it's dovetailing, and there's a lot of real departure from each other as well.

MNR: I have said to people that I don't think that your work is directly influenced by Luba art, but indirectly it is—certainly by African art in general and perhaps somewhat by Luba. But that's not the point. The point is more that both your work and Luba art are resonant and that they're coincident in theme and spirit. How about you? Why is this interesting to you?

AS: It's really interesting to me because I think these things are created simultaneously, and there are

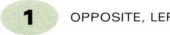 OPPOSITE, LEFT

FEMALE FIGURE
Luba, Democratic Republic of the Congo
Wood, fabric, iron, mixed media
H: 31 cm
FMCH X65.7488; Gift of the Wellcome Trust

Luba royal emblems depicting female figures were commissioned by male rulers from the seventeenth to the nineteenth century to express fundamental precepts about Luba kingship. The figures portray women with marks of beauty in the form of scarification patterns on their skin, elegant hairdos, and a serene, composed attitude. This exceptional figure has medicinal substances packed inside the tresses of her hair, which is adorned with a miniature iron pin representing a blacksmith's anvil, symbol of the kingdom's success.

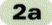 OPPOSITE, RIGHT

ALISON SAAR, *BAIN FROID*, 1991
Wood, copper, tin, nails
H: 200.7 cm
Charles and Nancy Sims

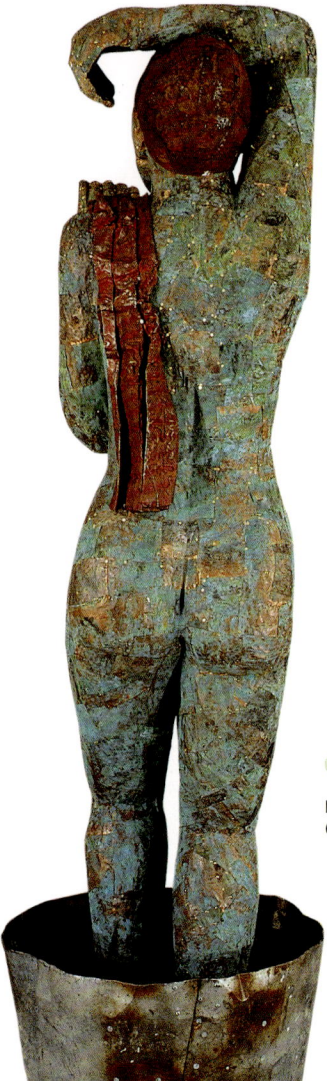

2b
BACK OF *BAIN FROID* (fig. 2a).

3 OPPOSITE, TOP

HEADREST
Luba, Democratic Republic of the Congo
Wood, copper
H: 15.5 cm
FMCH X91.60; The Jerome L. Joss Collection

Luba female figures are often shown in postures of support—as caryatids on stools and headrests—or surmounting scepters, spears, and ceremonial weapons and tools. Here, a female figure displays her marks of beauty while gracefully upholding a headrest once owned by a Luba elder.

4 OPPOSITE, BOTTOM

HEADREST
Luba, Democratic Republic of the Congo
Wood
H: 14 cm
FMCH X91.307; The Jerome L. Joss Collection

Some Luba female figures are reduced to the head and torso in order to express the importance of these parts of the body as loci of memory, wisdom, and spirituality.

crossovers that are not necessarily conscious crossovers, and so that's why the whole exhibition is really fascinating to me. There are some things that really hook up and then there are other things that just take completely—I wouldn't say opposite—but very disparate points of view. It's not one-for-one all the way down the line.

MNR: Apart from at the Jan Baum Gallery, where you worked after college, and at the Baltimore Museum of Art, where they have placed a Kongo *nkisi* [a power figure] next to your piece *Strange Fruit,* have there been other instances where your work has been exhibited with African art?

AS: I don't think so; they've always been very separate. Except when I had my piece *Terra Rosa* (the one that's sitting and coming out of the dirt) at the High Museum. Across the hall was the Zaire show, and they had this beautiful photomural of women in the river with their hair done up the same way, and that was just such a nice sort of curious happening, but otherwise it hasn't really intentionally been done.

MNR: You told me that at one point you studied African art and thought that you might become an Africanist art historian.

AS: It never really got that far. I think I had a grand total of two semesters of African art, although it was with Dr. Samella Lewis, and she was so great. But I'm always embarrassed that I only skimmed the surface. To assume that I know anything about African art would be the same thing as trying to study all of European art in one or two semesters—it would be equally ludicrous. So, I was really interested, and I did independent studies of African elements in Haitian art and in the Americas. Then I got very interested in self-taught artists, specifically African American self-taught artists and seeking out traditions that carried over. That's really been my exposure, which is another reason why I really love this project because it's bringing me back into it, and you guys are giving me all this information.

MNR: Let's walk through the exhibition. You know, I like the idea of exhibiting *Bain Froid* so that you first see her from the back (fig. 2B).

AS: Having her back to you?

MNR: Personally I like it. What do you think?

AS: That's interesting. Whether she's mooning you, I don't know.

MNR: Well, tell me a little about…

AS: What she looks like from the front?

MNR: Yes, and what she means to you.

AS: Well, it actually was a political response to Gauguin and all these Postimpressionists who were doing "native" women, and it being very voyeuristic and them bathing and how wonderful it was that they were bathing in the river, and it was so "au naturel," and the purity of this natural beauty. And so I wanted to do one that was a southern American version of that and really talk about how it was very voyeuristic, and this sort of a European imperialistic view of the "natives," and "native" women, and also to really talk about poor southerners drawing water out of the river and taking a cold bath—which is what *Bain Froid* means—in this kind of rusty tin tub. It was the reality of this romantic version of impoverished cultures and impoverished people. And at the same time, it's a curious little fence that it's straddling because it still appeals on that very Postimpressionist and very voluptuous level, but then it's supposed to—hopefully—also relate to the political and economic realities of that lifestyle. From the front she has one hand holding the towel. She doesn't have eyes, but she has a different color blue lips, a different color metal (copper), so that's the other thing, the classic bronze patina. And then also this blue just because it's cold water and she's cold, so it's a play on that material as well.

MNR: I think that's a perfect piece to start with, because it conjures up so many of those images and icons of womanhood that have been part of our understanding of the female image through Western art. In a lot of ways, the Luba female figure serves the same purpose right at the outset when presented without a lot of information because westerners who don't really know what it means perceive it in terms of the stereotype of sexuality and fertility without understanding that it might have this kind of depth, dual meanings, political meanings, and this ambiguity even of its own gendering, which we'll talk about as we go along. So I think it poses a really nice dialectic with your work.

AS: Also, the hand gesture is very similar. In *Bain Froid* it's up by the shoulder, but it's like this flat hand up against the breast. And the shut eyes are really nice, because hers are shut as well, so it's sort of this blindness to being seen and not seeing.

MNR: Is that what the shut eyes mean to you?

AS: You know people have asked me, and it's a couple of things. In part, it's about how all these women are always being perceived and viewed by the audience, and some of them take on freak-show sort of things,

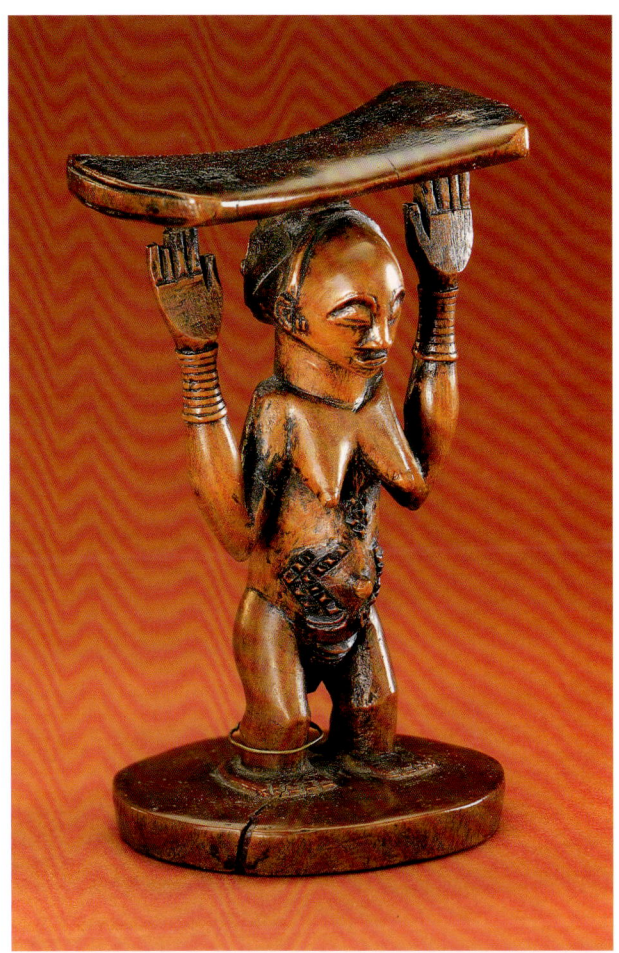

15

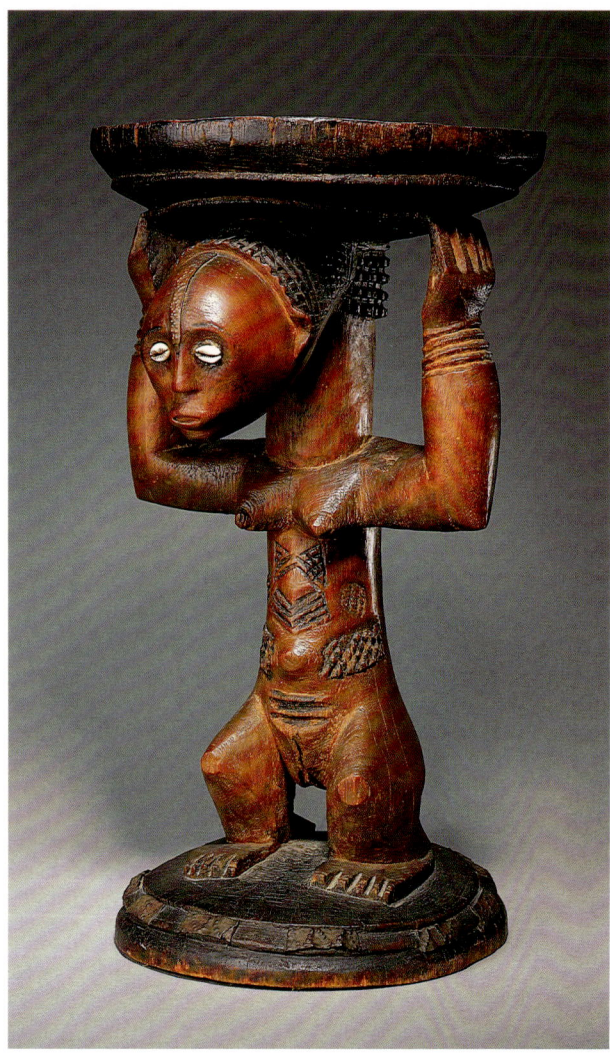

5

STOOL
Luba, Democratic Republic of the Congo
Wood, cowrie shells, metal
H: 44 cm
Ex-Jay C. Leff Collection, once in the collection of the well-known British collector and writer on African art, Leon Underwood
Private Collection

Luba female figures generally assume a downcast gaze. Their eyes often appear averted or their gaze directed inward. Here, a regal throne supported by a strong woman reveals eyes inlaid with cowrie shells, symbols of the luminous moon and the figure's implicit connection to the spirit world.

and again it's voyeuristic. You're seeing her experience, but you're not really understanding her experience of being observed. So it's about the disconnection between the viewer and the subject.

MNR: There's a lot of interesting discussion about downcast eyes in art history right now and a lot of literature about the different ways that people think about perception and seeing. Luba artists always show the eyes downcast (figs. 3, 4). You never see a Luba female figure looking at you. Sometimes they'll have cowrie shells for eyes, so it looks more penetrating, but that's actually a reference to the otherworld and to divination (fig. 5).

AS: Whether they're downcast or shut is kind of questionable too, and it also seems referential to dreams and this separate reality.

MNR: Absolutely, because we don't actually know if they are closed or not. And I think that's part of the deliberate ambiguity. Would you rather see *Bain Froid* from the front?

AS: In light of what we were talking about in terms of it being voyeuristic, maybe it does work nicely to approach her from the back.

MNR: If we put it from the rear you'd still be able to walk around it, and that would play on the whole voyeurism idea because you'd have to come around it if you *really* want to take a look…

AS: Right, exactly. You're not even facing her. It's not even face-to-face.… Maybe you could walk through a keyhole…

Whose Body *Is* This?

Only the body of a woman is strong enough to hold a spirit as powerful as that of a king.

Ngeleka (a Luba male titleholder)

A lot of the work is about women's resistance to pain and the ability to go beyond the pain…you can always push beyond those boundaries that are presented because you realize that the job still needs to be done.

Alison Saar

MNR: The idea of this section is to convey the problem of the stereotype, as you were just recounting through *Bain Froid,* and as I was talking about through the Luba figure, but here it's explored in

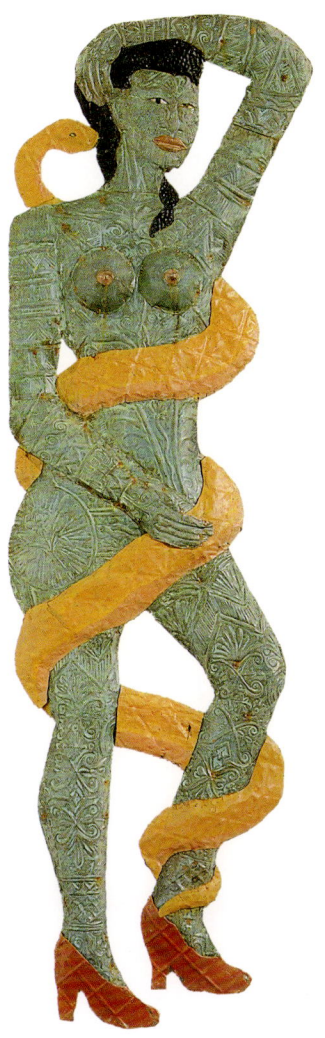 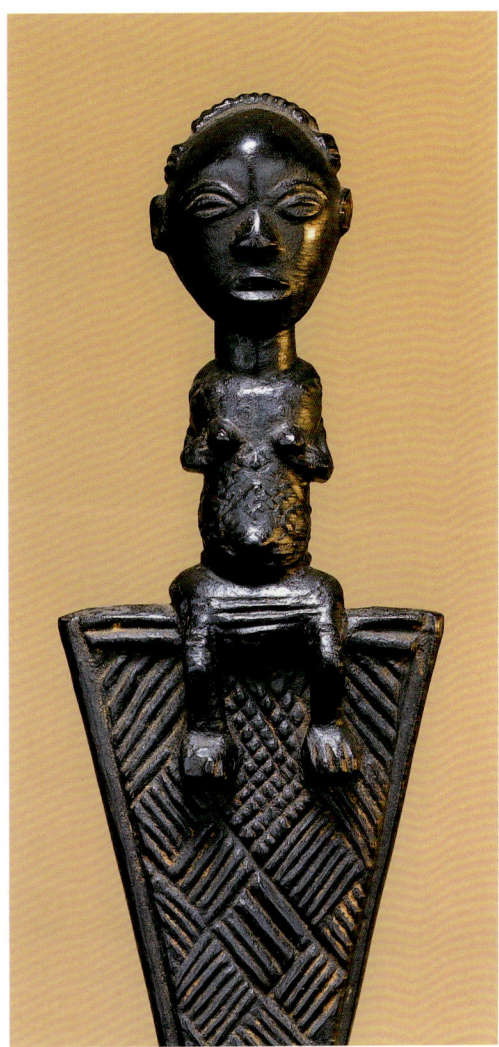 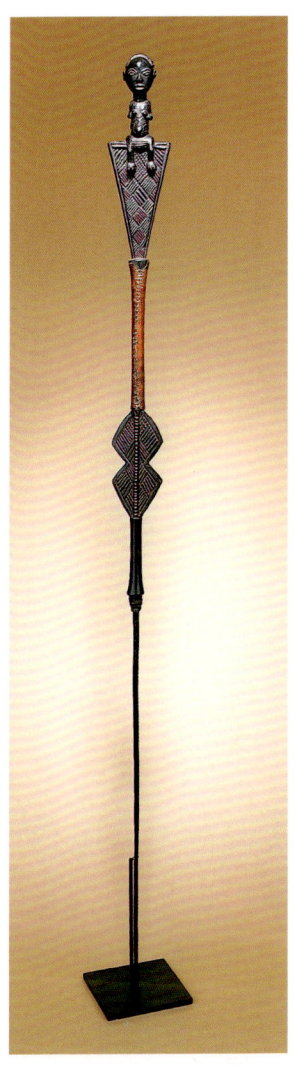

more depth (figs. 6, 7). On the Luba side, it has to do with the fact that a lot of assumptions were made by outsiders about what these figures represented before anyone actually went to Zaire and tried to find out from Luba people themselves. There were assumptions that it must be a matrilineal society, and in fact it's not, it's a patrilineal society. So, even though all the imagery represents women, it has nothing to do with descent through the mother's line. But it was assumed that it did. And it has *always* been assumed in African art that images of women have to do with fertility. Over and over again, you see these superficial references to "fertility" and "ancestor" figures, yet Luba female imagery is so much more complex than that. With your works, I took the liberty of selecting some figures that I thought addressed the problem of the stereotype, but where there is also more going on. I personally really like this figure. Who is she?

AS: This is *Sweet Thang* (fig. 8). It's a really early piece for me. I did this probably in '83, and I did it at the

6 ABOVE, LEFT

**ALISON SAAR,
LA PITONISA, 1987**
Wood, copper, tin
H: 167.6 cm
Justine I. Linforth

7 ABOVE, CENTER AND RIGHT

STAFF
Luba, Democratic Republic of the Congo
Wood, iron, copper
L: 153 cm
Collection of Dr. Richard and Jan Baum

The female figure surmounting this elegant staff of office may have been a reference to the king himself. Luba rulers use staffs as three-dimensional maps to narrate family histories and to trace lineage, ancestry, and connections to the royal Luba center. The king is depicted as a woman because, according to some Luba officials, "the king is a woman" conceptually and spiritually.

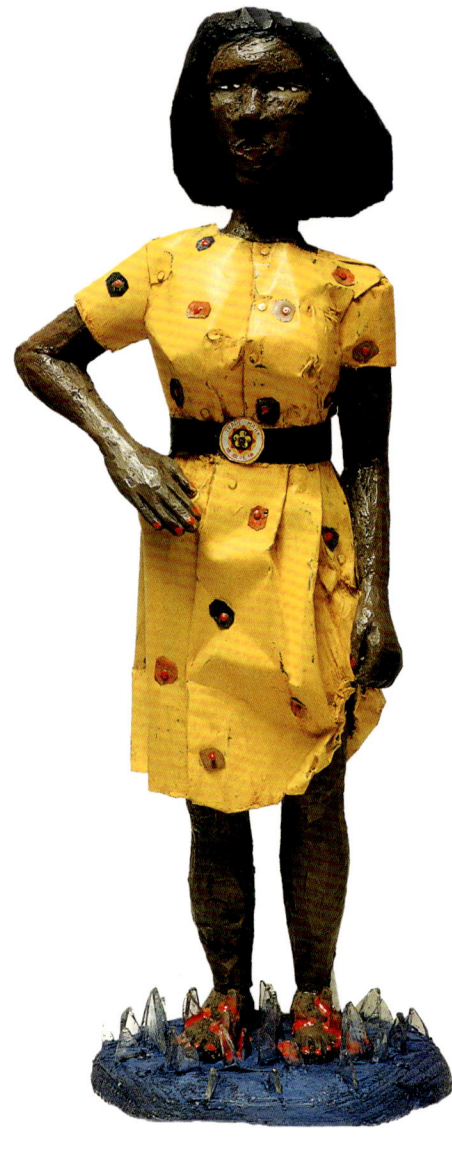

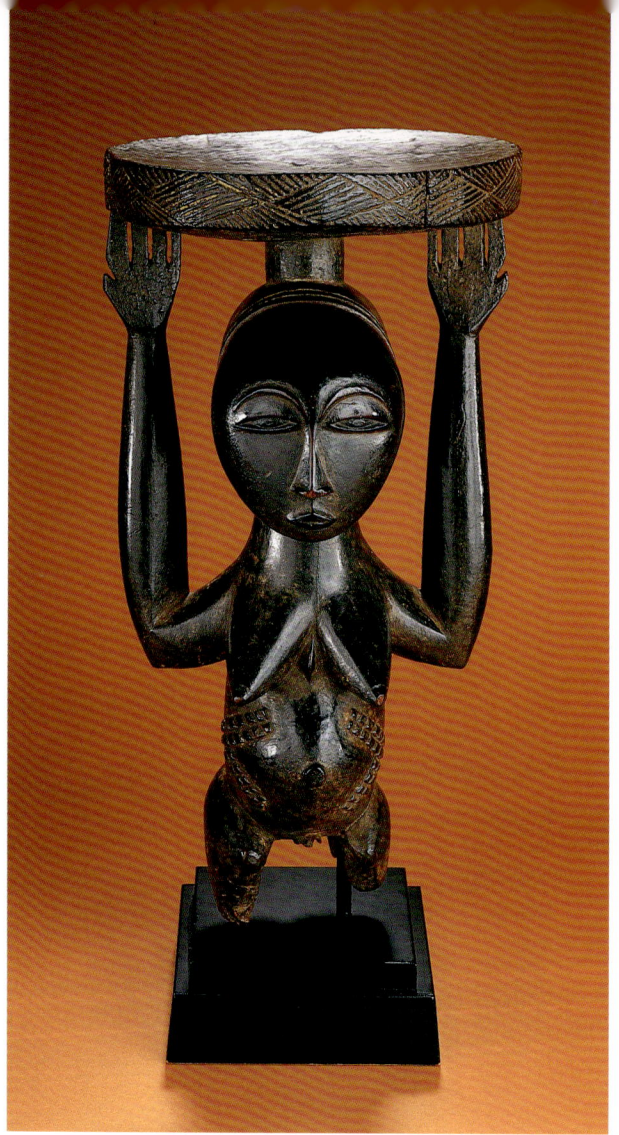

8 ABOVE, LEFT

ALISON SAAR,
SWEET THANG, 1983
Wood, tin, glass, mixed media
H: 48.3 cm
Jack E. Lowrance

9 ABOVE, RIGHT

STOOL
Luba, Democratic Republic of the Congo
Wood, metal
H: 47.5 cm
Saul and Marsha Stanoff

A Luba stool serves not only as the throne of a king or chief but also as a symbolic microcosm of sacred spirit capitals called *bitenta*, where the spirits of previous kings are guarded by female spirit mediums. This elaborately carved stool with its smooth and gleaming patina depicts a woman, but it embodies the spirit of a king.

Studio Museum when I was in residence there. You can see how the figures have really changed a lot—these early ones have eyes and they have clothes. Now they're really pared down. In the earlier work, they're doll-like, some are even jointed. I guess this piece is really about survival; *Sweet Thang* is about stereotypes and surviving and utilizing stereotypes for survival as well. It's also about martyrdom, sacrifices to survive and sacrifices to help your family survive. She's standing on these shards of glass that are coming up through her feet, and blood is oozing out, so it's kind of gruesome.

MNR: It's a very powerful piece; you don't notice the feet at first. I only noticed the yellow spring dress and her hand-on-the-hip attitude, and then your eye hits the feet and it's jolting.

AS: A lot of the work is about women's resistance to pain and the ability to go beyond the pain, which is such a great wonderful stereotype: you can always push beyond those boundaries that are presented because you realize that the job still needs to be

10 BELOW, LEFT

ALISON SAAR, *CLEO*, 1987
Wood, tin, linoleum
W: 38.1 cm
Collection of Dr. Richard and Jan Baum

11 BELOW, RIGHT

ALISON SAAR, *HEATHEN TEA AT TRUMPS*, 1982
Tin, palm fronds, paint, glass
H: 45.7 cm
Collection of Dr. Richard and Jan Baum

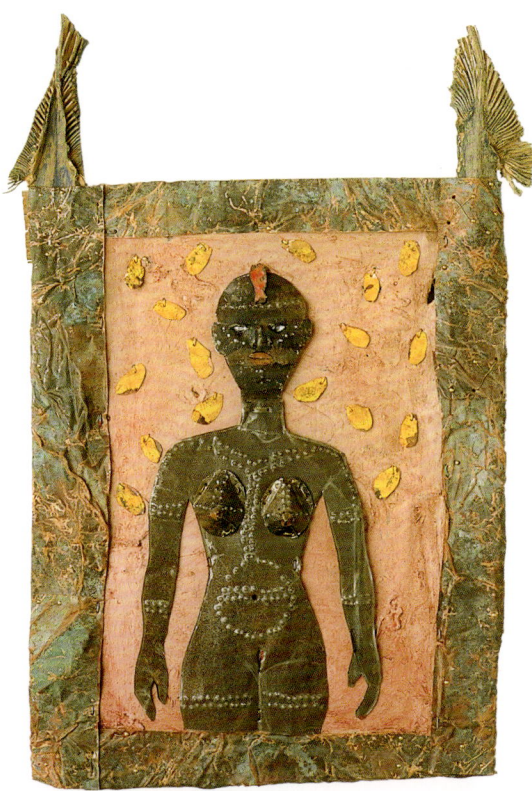

done. It's a stereotype or a romanticizing of our situations and predicaments. So she's all dolled up; she's got her nails done and her toenails done, but you know she's still struggling. That's pretty much what she's about.

MNR: This makes me think of some of the perceptions of Luba women as martyrs that have formed in the West around the iconic Luba stools that show women in a seemingly subservient pose and covered with scarifications that are misunderstood by westerners as forms of self-mutilation and pain (fig. 9). And yet, Luba female images turn out to be the exact opposite. They're all about women's power and the idea that only a woman's body is strong enough to hold a spirit as powerful as that of a king, and the necessity of having a woman's counterpart to every male form of authority, because power is perceived as both male and female.

Continuing are two more of your works. It is true that the things I've picked for this section tend to be your older pieces, and they get more and more current as the show goes on. Oddly enough, that was just a coincidence, but the pieces of yours that seem to be most about stereotypical images tend to fall into your earlier period of work.

AS: I think that *Cleo* fits in thematically with this section (fig. 10) and *Heathen Tea at Trumps*, which is just a bust and specifically African (fig. 11). It's a play on odalisques and voyeurism. *Heathen Tea* really talks about the stereotype of savagery and savage women and "nubile Nubians," and all those other things. They're all Western stereotypes or Western points of view, either through art or other cultural encounters, their view of Black women and African women as being these objects.

MNR: Your piece *Sweet Dreams* is very compelling because it suggests the blurred boundaries between men and women and between identities (fig. 12). The man's head opens up, and you see a woman's face at the back of his mind through shattered glass. Here is one person, but the real person resides somewhere within through all the dreams and memories. It's interesting for me because on the African side

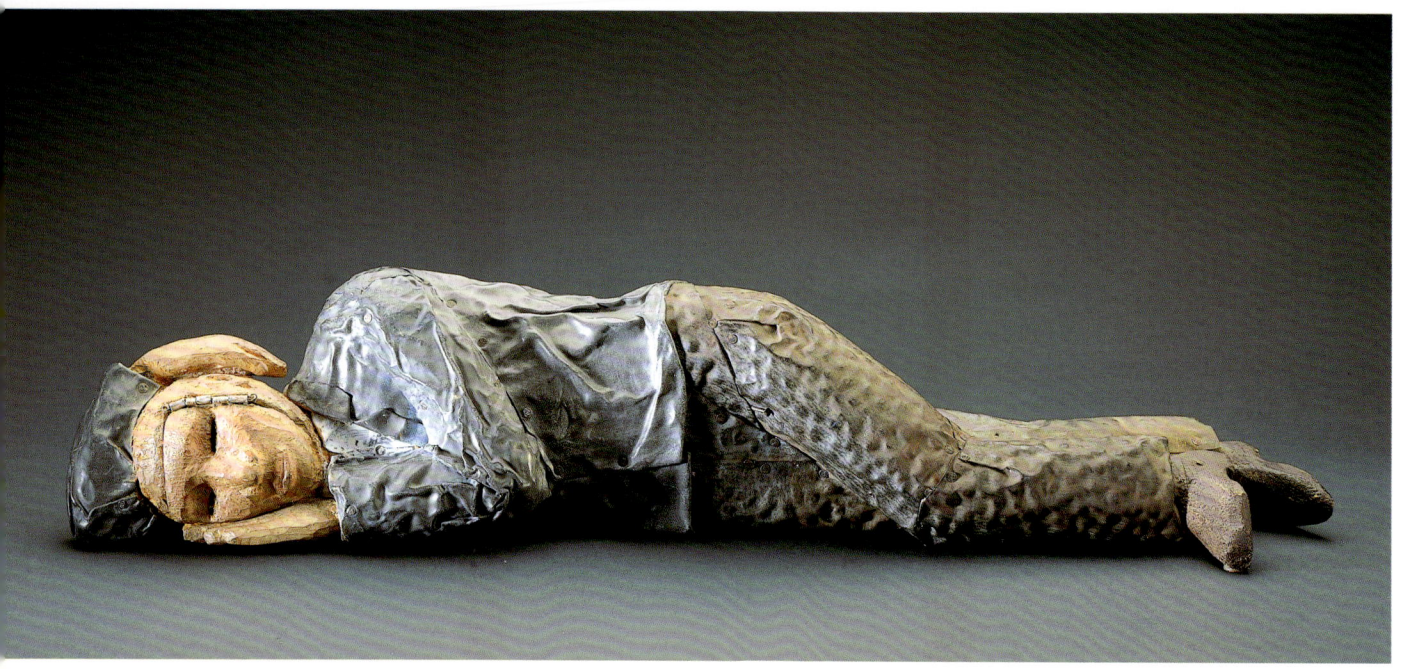

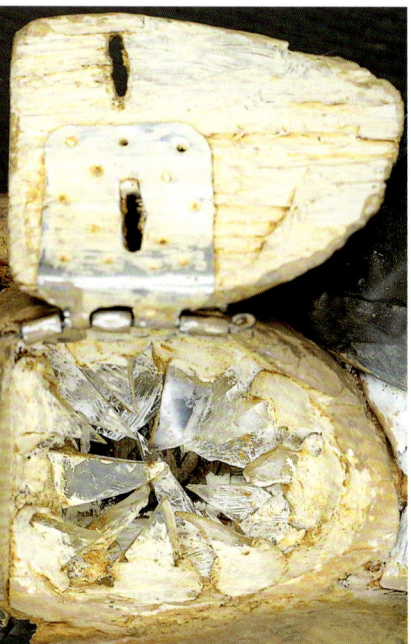

12 ABOVE, AND DETAIL, LEFT

ALISON SAAR,
***SWEET DREAMS*, 1983**
Mixed media
L: 53.3 cm
Collection of Dr. Richard and Jan Baum

The detail shows a woman's face through shattered glass.

there are wonderful, powerful male figures from groups surrounding the Luba that are actually references to women; unlike the Luba, these are matrilineal groups for whom descent *does* pass through the mother's line (fig. 13). Although their figures primarily represent men, the gesture of the hands to the abdomen is a reference to the navel and the lineage and the maternal origins—where you come from and where you're going (fig. 14). These present another point of view as to whose body this is, one that is certainly part of your work and that is part of the Luba story as well. So, it's all this mixing. Some Luba figures are even deliberately hermaphrodites, fusing male and female elements or placing them back to back (fig. 15). What is *Sweet Dreams* about for you?

AS: I made *Sweet Dreams* when I first moved to New York in the early '80s. It really deals with homelessness, and it's about people just lying on the street, and it's talking about, you know, the title *Sweet Dreams,* that you can still have hopes, but when you look to see what his hopes are, they're just shattered hopes and shattered dreams. It's also about yearning and loss. It's probably implying that this forlorn love has put him in this predicament. They relate to each other really nicely because their faces are really similar; they're kind of a nice response to each other.

MNR: Ultimately, the message in the Luba story is one of intense ambiguity. Through the female figure, Luba people are invoking this sense that power is both male and female; that is such an important dimension of what is happening here.

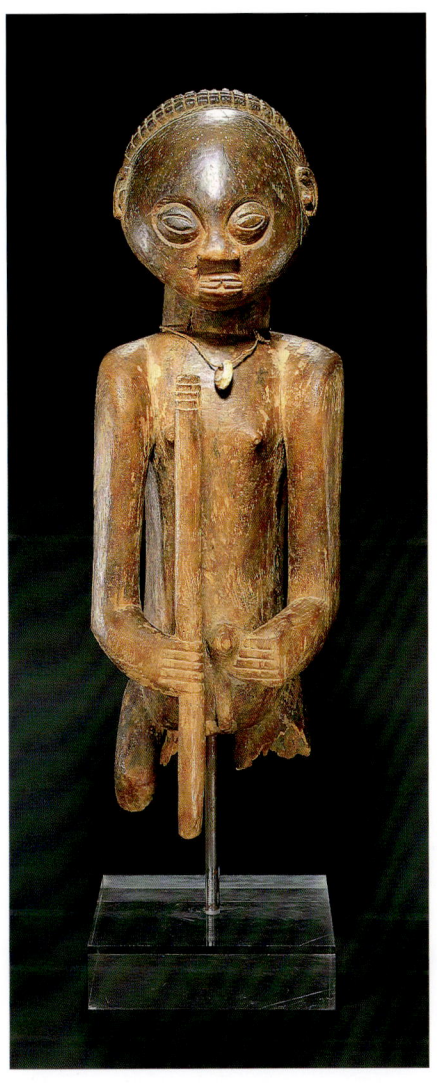
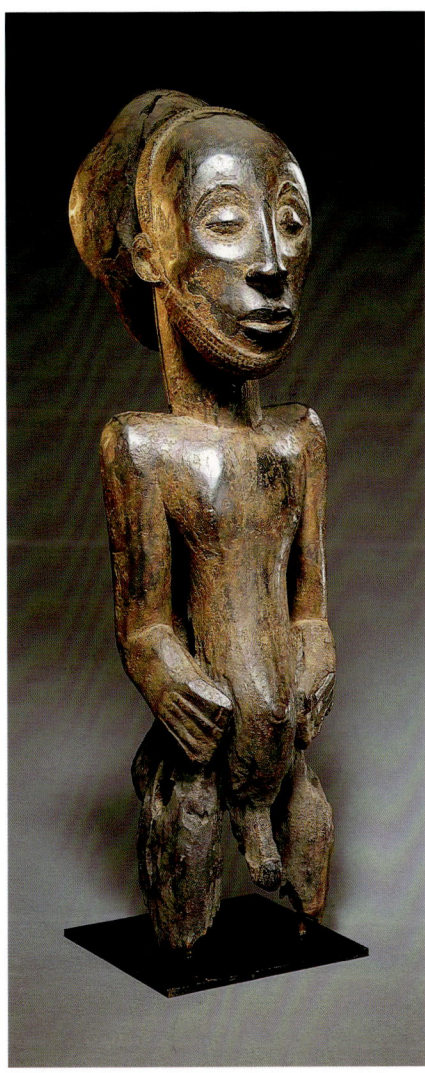
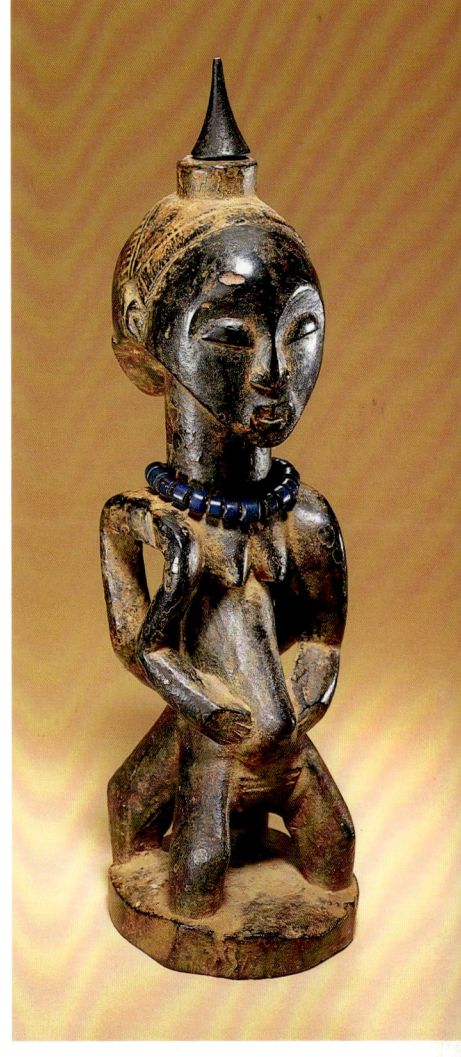

13

MALE FIGURE

Tabwa, Democratic Republic of the Congo

Wood, cowrie shell, fiber cord

H: 57 cm

Collection of Dr. Richard and Jan Baum

Whereas Luba female figures often refer to spirits of male rulers, the male figures of matrilineal groups surrounding the patrilineal Luba paradoxically refer to women. This majestic figure's gesture with a hand held to his abdomen is a reminder of his mother's progeny.

14

MALE FIGURE

Hemba, Democratic Republic of the Congo

Wood

H: 69 cm

Jerry Solomon Collection

The Hemba, cousins to the Luba, honor their mothers through regal sculptures of male lineage heads. This figure touches his hands to either side of his navel in remembrance of his maternal origins.

15

MALE/FEMALE FIGURE

Luba/Hemba, Democratic Republic of the Congo

Wood, iron, beads

H: 32 cm

Jerry Solomon Collection

The interdependence of men and women is exquisitely rendered in this janus sculpture, which was used as a power figure. The miniature iron anvil emerges from the top to "lock" or "close" the spirits within.

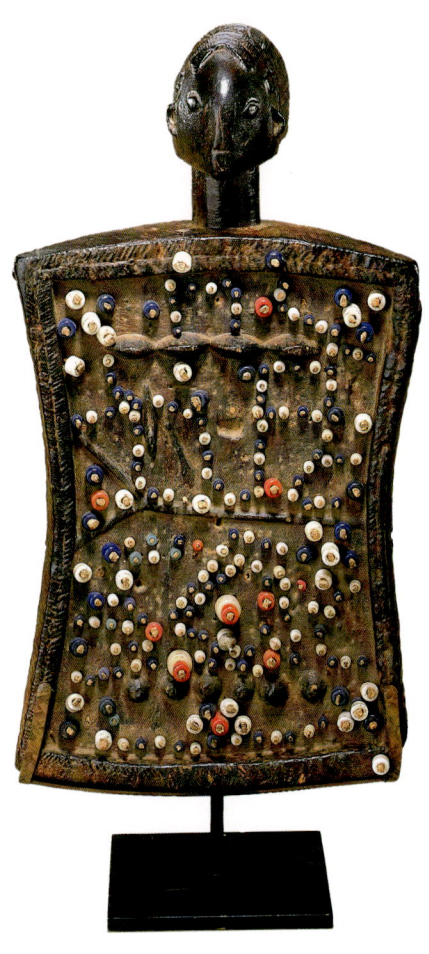
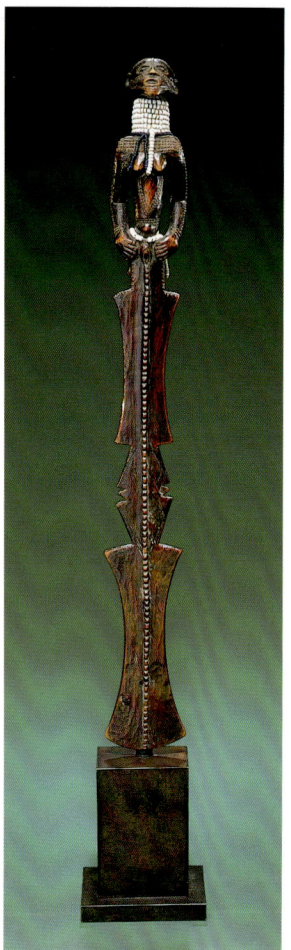
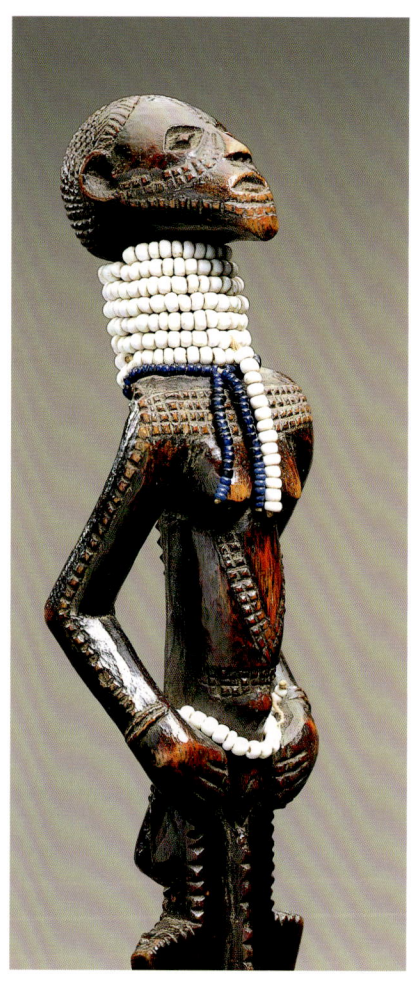

16 ABOVE, LEFT

MEMORY BOARD (LUKASA)

Luba, Democratic Republic of the Congo
Wood, beads, metal
H: 34 cm
Susanne K. Bennet

Luba emblems link women and the landscape itself. Court historians and other "men of memory" read the patterns of beads on a *lukasa* memory board as they narrate histories about Luba kingship. The board depicts a woman in the form of a tortoise; it maps and recalls the entire Luba landscape wherein each of the thirteen kings is still remembered by a sacred "spirit capital."

17 ABOVE, CENTER AND RIGHT

STAFF

Tabwa, Democratic Republic of the Congo
Wood, white glass beads
H: 50.1 cm
Collected before 1920 by an English administrator posted to northern Rhodesia
Saul and Marsha Stanoff

A staff is related to a memory board in form and content; but staffs reflect individual, family, and lineage histories. The scarifications on the magnificent female figure surmounting this staff indicate that she is Tabwa, a group closely related to Luba peoples.

Bodyscapes

In the past we didn't know that the minerals were so valuable, only the spirits understood their importance. And women knew because they have an intelligence that goes beyond that of we men.

Nsenga Ubandilwa
(a Luba male descendant of a chief)

It's going back to fertility stuff and this female figure being like the earth and something from which things spring....She has this allure and this ability to collect and attract often benevolent spirits.

Alison Saar

MNR: The *lukasa* memory board is about the connection between a woman's body and the earth or landscape itself (fig. 16). This wooden board is a mnemonic device for all of Luba history and is constructed in the form of a woman's torso, which serves as a metaphor for the earth, and for history, and how history plays out. Other Luba objects

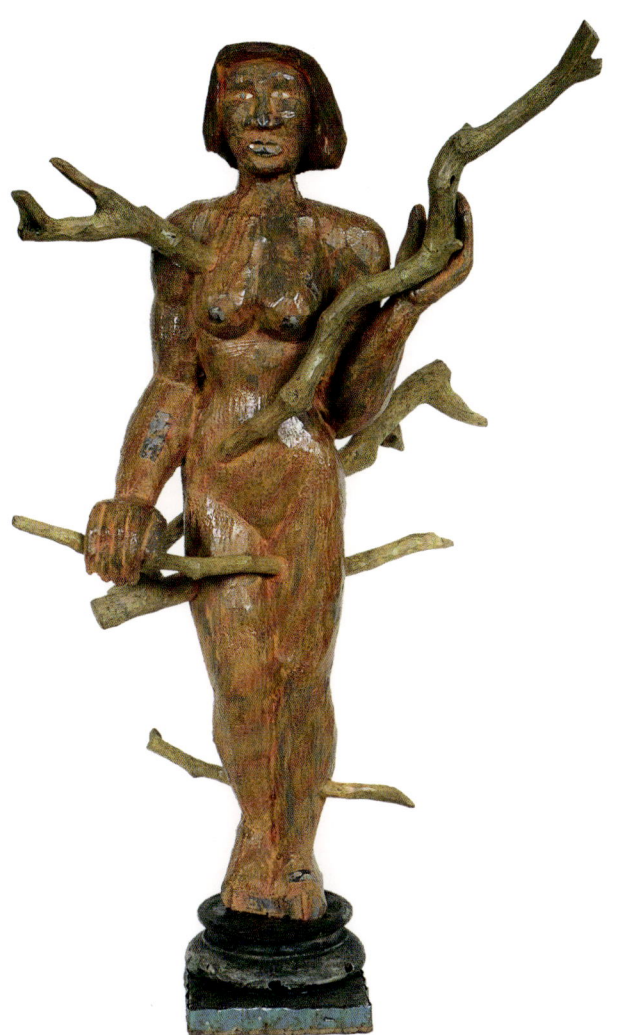

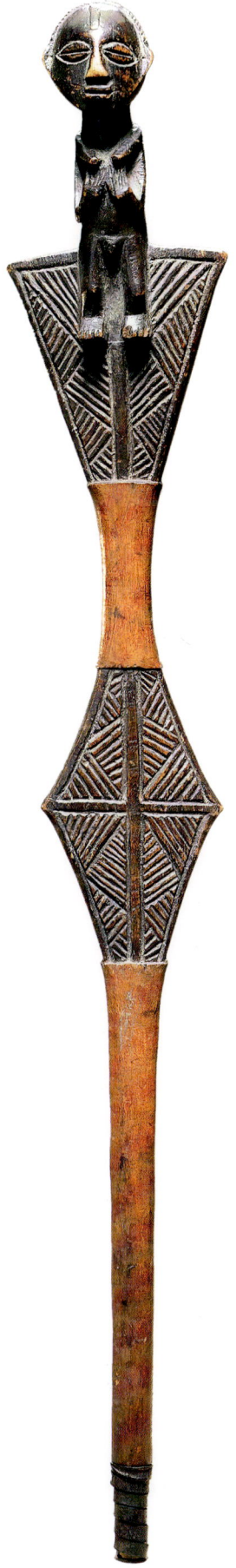

that would be in this section include staffs of office, because for Luba people, they are maps, geographical devices, three-dimensional histories (fig. 17). A Luba person will begin telling the family story by recounting a narrative that starts at the top of the staff and then goes all the way down to the bottom. It literally is a map, and each of the broad sections of the staff is a place like a chiefdom or an administrative center. The shaft is the road or the savanna, and sometimes staffs will have two or three or even four of those broad sections (fig. 19). So, it recounts how the "king," who is represented by the female figure but is referred to as the king, makes this journey through land and through time; it links memory and space. There will be as many as three staffs in this section, and I chose several of your works that struck me as being very linked to earth or to elements of nature or elements of land in some way, but I would love to hear you talk about them more. This one is *Bramble Dance* (fig. 18).

18 LEFT

ALISON SAAR,
BRAMBLE DANCE, 1988
Wood, encaustic
H: 63.5 cm
Collection of Linda and Reese Polesky

19 RIGHT

STAFF
Luba, Democratic Republic of the Congo
Wood, iron, paint
H: 76.5 cm
FMCH X87.628; The Jerome L. Joss Collection

Looking at a Luba staff is like looking at a sculptural map. The staff's broad sections depict administrative centers and spirit capitals, and the shaft represents the savanna connecting them. The female figure is either the king himself or a female representative, such as a daughter, sister, or wife, who ruled a territory.

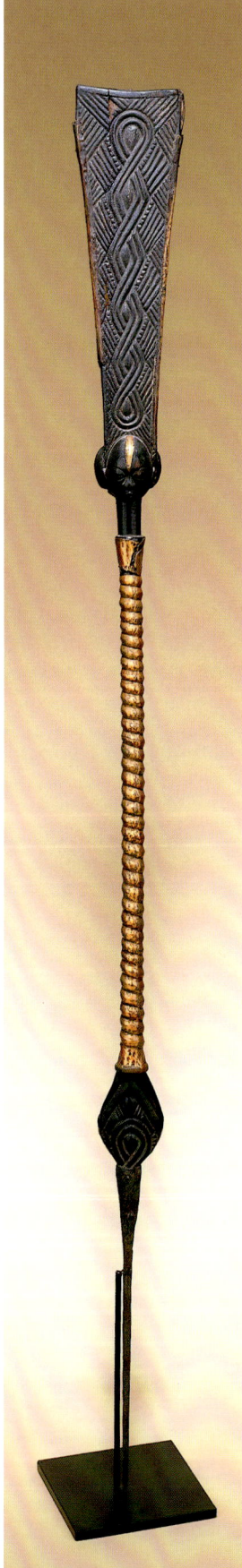

 LEFT

STAFF

Luba, Democratic Republic of the Congo
Wood, copper, iron
H: 137 cm
Terry and Lionel Bell

This elegant staff with its copper-wrapped shaft is a superb example of Luba aesthetic wisdom. Its janus heads refer to paired *bavidye* (the spirits of Luba kingship), and patterns of women's scarification on the upper plank contain secret knowledge about natural resources.

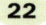 **RIGHT**

STOOL

Hemba/Luba, Democratic Republic of the Congo
Wood, fiber
H: 44.5 cm
Jerry Solomon Collection

A caryatid stool, which serves as a royal throne, is the most potent symbol of Luba kingship—a literal and metaphorical seat of sacred authority. This stool, which bears stylistic characteristics of neighboring Hemba peoples, still exudes oil from years of anointing by its original owners, and it wears a necklace of large wooden amulets, which may have served as containers for empowering medicinal substances.

 OPPOSITE

ALISON SAAR,
BRIAR PATCH, 1988

Wood, wire, nails, caulking, iron, wax
L: 83.8 cm
Collection of the Hodosh Family

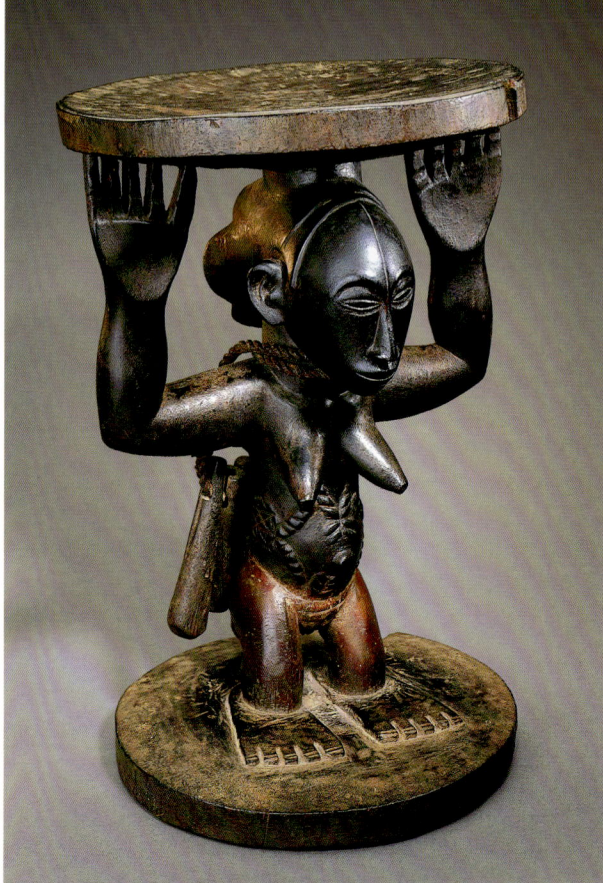

AS: It's going back to fertility stuff and this female figure being like the earth and something from which things spring, so she's got these branches coming out of her. She's about twenty-five inches tall. They're just branches that I drilled and inserted in her. It's basically talking about nature and women's relationship with nature as a sort of go-between, dancing with it.

MNR: For me, it resonates with Luba staffs that evoke tree branches and oars (fig. 20). The broad sections of Luba staffs have a weaving pattern referred to by Luba people as "scarification." Even when you have a staff with no explicit female head or no obvious female imagery, it will still have the broad sections with these patterns, which means that it's been feminized. Every Luba emblem has to be feminized. It has to do with this sense that women are the more able embodiments of spirit, better than men, better than a man's body, because of their child-bearing capacity and because of all the powers attributed to women. Every emblem has to be fashioned as a woman, whether it's explicit or just abstracted.

AS: My piece [*Briar Patch*] works next to the Luba staff because her eyes look dreamy and *Briar Patch*

also looks dreamy (fig. 22). I think the references in *Briar Patch* are to an *nkisi*, which is sort of bound and has these nails; it's about depression and torture. I think it's nice in the landscape section in that she's horizontal and looks like a mountain range. She's also in a strange state, and it looks almost as if she's caked in dirt. Whether it's libations that have been put on her or what, but she's bound within her own troubles, so she's tied up in this stickery situation.

MNR: With Luba, you have these generic object types; you'll see stools throughout the exhibition but for different reasons. In this section, the stool you see tells the story of why Luba people think that women are the best embodiments of spirit (fig. 21). In the past, when a Luba king died, his spirit became incarnated by an actual woman, a real, living woman who was possessed by his spirit. I have a photograph of one of the last titled women to have lived. She died in the 1980s, but she was the spirit medium for a king who died in 1931. So she took over his spirit at that time.

AS: So, they're quite young.

MNR: They can be very young, they can be any age, they can be from any family, they don't have to be royal, they don't even have to be from that village or that chiefdom.

AS: So, how do they find them?

MNR: Well, at some point after the king's death a woman just becomes spontaneously possessed by the ruler's spirit, and if she's deemed legitimate—she has to undergo a series of tests—then she is sent to reside in the ruler's former residence where she acquires all of his titleholders, all of his emblems, and even his wives, and she rules the kingdom of the dead as if she were the king himself. But this institution of the Mwadi spirit medium may be disappearing now because people say that this one was not replaced, and she may have been the last Mwadi in the Luba region.

AS: They would replace her with another woman but for the same spirit? So for a while there were a number of them?

MNR: Yes, there were a number of them because there were thirteen Luba kings and every Luba king had his own Mwadi spirit medium. When she died another woman in her lineage took over. The woman had to be unmarried and without children, and had to lead a celibate life, like a priestess. And so it would have to be a niece or a sister who succeeded her. It was a perpetual remembrance of the ruler through the body of a woman. The stools are symbols of that place, which is called *kitenta*, meaning "spirit capital." The new ruler would set up a new residence, but all the spirit capitals were out there on the landscape, interacting with the living ruler through these women, and they were absolutely sacrosanct. When the Belgian colonizers came in, they could not budge these territories, they could not find a way to bring them under the superimposition of colonization because they were so independent and so sacred. The Belgians then had to find a way to accommodate this system. The stools are symbols of those spirit capitals— within that single object is the entire remembrance of a king and his line of Mwadi spirit mediums. It's a very potent symbol of the linkage of women to a place that is a symbol of power, and that's why it's in

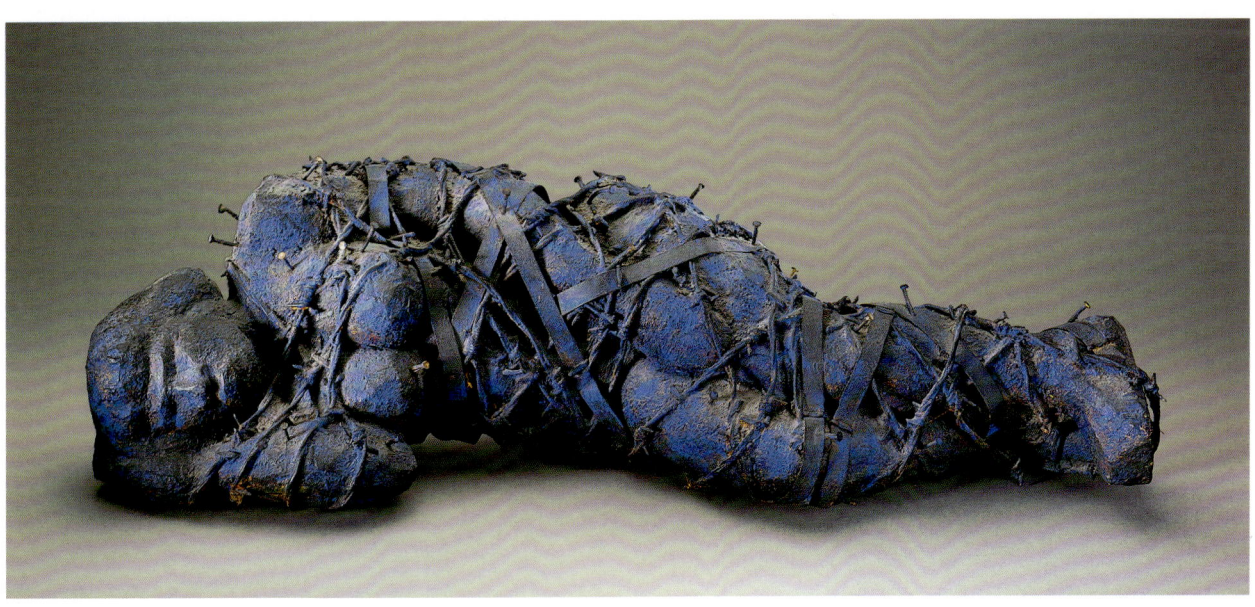

23 BELOW

ALISON SAAR,
***STONE SOUL II*, 1993**

Wood, tin, mixed media

H: 61 cm

Collection of Dr. Richard and Jan Baum

24 RIGHT

ALISON SAAR,
***TOPSY*, 1998**

Paint, tar, mixed media on wood

H: 123.2 cm

Ronald and JoAnn Busuttil

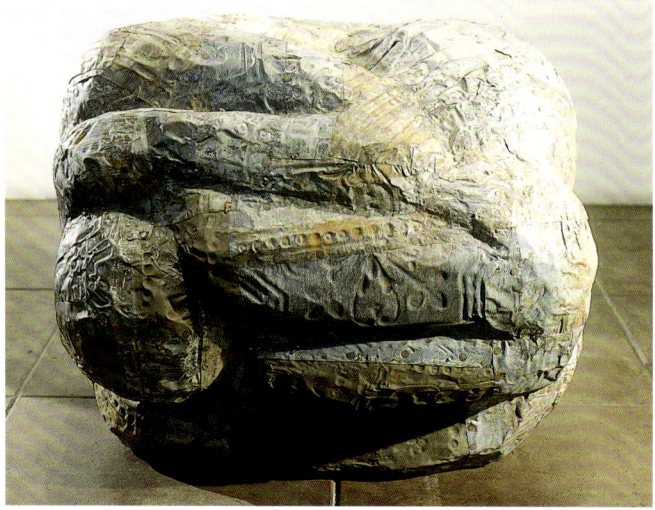

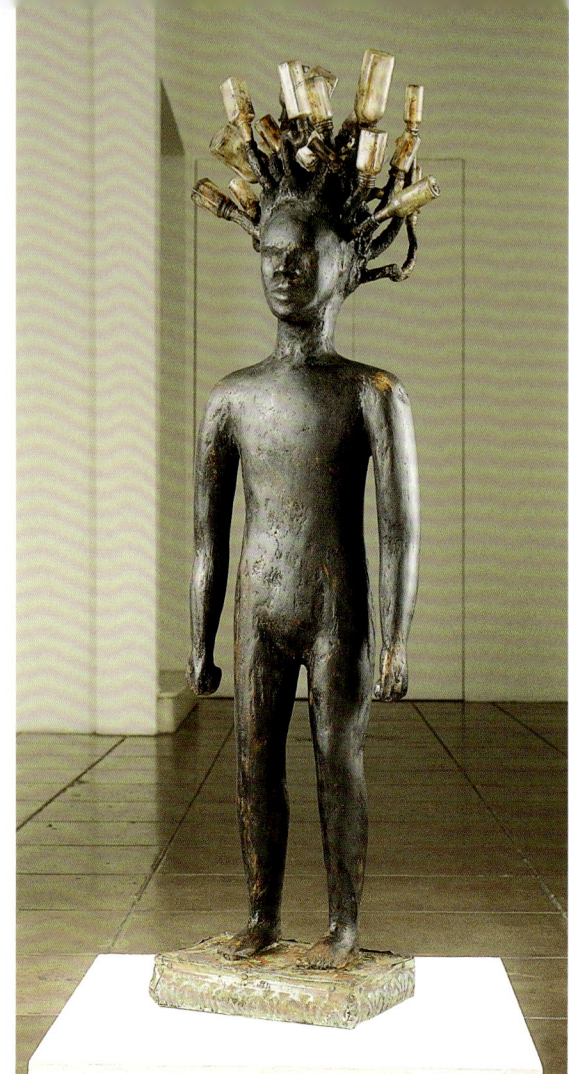

this section. This helps to explain why Luba people invest so much in these wooden sculptures and why they have to create them as female images. Your piece *Stone Soul II* also seems related to the concept of a sacred land (fig. 23).

AS: It's a female figure that was part of a group of three that represented male and female spirits within the landscape, and they're really about rocks that have these spirits attached to them; it was to give those spirits a form. And they went into an installation originally with *Tree Souls*.

MNR: And what about *Topsy* and her tree and bottle imagery?

AS: *Topsy* represents the spirit tree sort of thing (fig. 24). So, it is a tree figure in the sense that her hair becomes these branches, and it's about catching spirits, a relation between natural spirits and unnatural or supernatural spirits. It's sort of like this child who has this power—possesses this power to do these things—a female child.

MNR: She's supposed to be what age?

AS: Probably five or six. I think I had my daughter Maddy lie down on the board and I traced her.

MNR: Why is she called *Topsy*?

AS: Well. Topsy is the young female slave figure from *Uncle Tom's Cabin*. There's a stereotype of these "Topsy" types, these little mischievous, rebellious, Black "pickaninny" types, so she's involved in that, too. But it takes it beyond being naughty and frivolous, which in a lot of ways Topsy was viewed, but having a sort of strength to herself as well. So, she's covered in tar.

MNR: What about the tar? And what about the bottles? Are they plastic?

AS: Most of them are glass bottles, old liquor bottles, some are old medicine bottles, and again they have tar on them to dirty them and make them murky and mysterious. That way the spirits would come along and be entranced into going inside these bottles, and they'd get trapped. So, she has this allure and this ability to collect and attract often benevolent spirits.

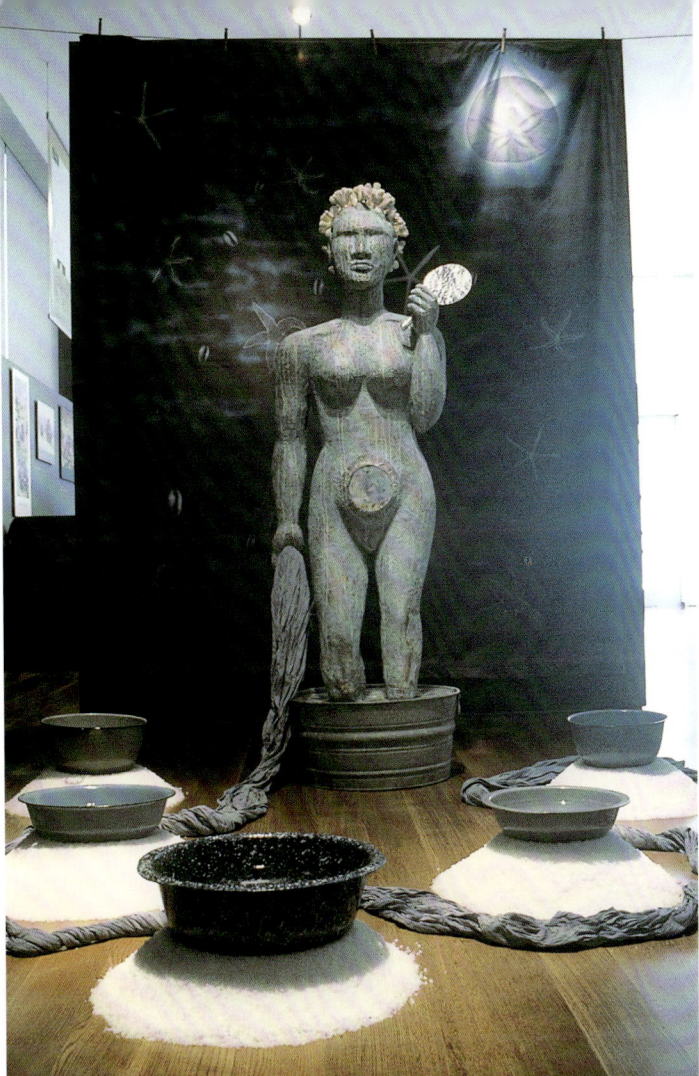

25

**ALISON SAAR,
AFRO-DI(E)TY, 2000**

Wood, copper, coral, and mixed media

H (of figure): 188 cm

Collection of Dr. Richard and Jan Baum

Installation view from the exhibition *Departures: 11 Artists at the Getty*

Photograph by Robert Pacheco, © 2000, The J. Paul Getty Trust

MNR: Actually, that works nicely with Luba material because one of the things about making the emblems female—as we are just about to see in the next section—is that you have to make them female in a very particular kind of way. They therefore become attractive to the spirits, and very specifically, they become almost like a magnet that the spirit is drawn to because the woman is created according to these aesthetic principles that aren't just "beauty." They're about this beauty with power, this kind of beauty that "works." So, there is that same sense of attraction.

AS: I think Topsy's posturing, too, is interesting in terms of some of the Luba hairdos—it looks like it's heavy, it looks like it's burdensome, but she's very steadfast. It's always very frontal, this very staid sort of posture, it's like standing strong. So, it's like strong vessels.

MNR: Exactly. In light of what you were saying about vessels, it seems appropriate to turn to *Afro-Di(e)ty* next, the installation that you made for the Getty's *Departures* exhibition, which takes the concept of bodyscapes to another level—that of the water and the relationships of spirits to water (fig. 25). Among Luba, spirits are thought to reside in pools, hot springs, and especially lakes. The twin spirits of Luba kingship inhabit sacred bodies of water, and still today these locales are worshiped and protected by female spirit mediums. It's also nice that it is the last piece you see before the next section on hair, since her hair as coral is such a nice variation on the hair concept.

AS: That does make sense. Actually, this piece really comes from a very different sort of place. This piece is consciously addressing different African deities. I did this as an homage to Yemaya [the Yoruba goddess of the sea]. I feel I owe her a lot in that I feel that I've had great success with my creativity and with my family, and that if there's anyone to thank, spiritwise, that is right up her alley. So, that's why I made her. It's a personal homage.

I made this piece for the Getty to respond to the lack of anything like it *in* the Getty. Specifically, the Getty is very European, and the piece I was responding to was the Lansdowne Herakles. If you look historically at Hercules's "heroic" acts, such as

the slaying the Queen of the Amazons—so much that Western culture idealizes I find so offensive—it's about men dominating women. The Getty needed a strong female figure that wasn't being raped or seduced. That was the basic inspiration, those two things combined.

MNR: I love the coral hair…

AS: There is a particular set of references in this piece. I felt that this was a portrayal of a specific deity, a goddess who is for childbirth and also rivers and a predecessor to Mami Wata [a female deity worshipped all over Africa and always depicted with a snake]. Devotees of Olokun and his wife Mami Wata and other òbá-né-àmé [gods of the sea] wore coral in their headdresses and hair to signify the red of childbirth. Only I used white—for Yemaya—I wanted to use only her colors of blue and white. And then, there are elements from other cultures—the mirror in the stomach…

MNR: Which is more of a Kongo reference…

AS: Right, I did that so that viewers would see themselves in her womb to signify her being the mother of us all. And the cloth coming out of her hand is the river that winds around the basins that are sitting on top of the salt. Salt signifies the seas, and the water in the basins is freshwater.

MNR: Salt has a lot of meaning in Luba contexts, as well, because one of the singlemost important natural resources that the Luba exploited for wealth was salt. Salt and palm oil were the principal sources of exchange in the long-distance trade networks that brought the kingdom to its height in the nineteenth century. So, the fact that the spirits of Luba kingship reside in lakes and other bodies of water may also be closely tied to the richness associated with salt. When Luba people live near iron-rich mountains, then the spirits inhabit the foothills of the mountains, so there is a definite connection between women, wealth, and the places where they find natural resources.

AS: That's really interesting. There are some really nice parallels. For the salt in the piece, first I went looking for kosher salt, but it turned out to be too fine. Then, I wanted to find the salt that you use for making ice cream, but the boxes were too small… I would have had to buy a hundred boxes to have as much salt as I needed! So then I found these large forty-pound bags of salt used for water purification at Smart and Final. Sometimes things just happen…

MNR: Who made the cloth backdrop and what is the story behind that?

AS: Tom Leeser, my husband, helped me design it. We did it on the computer. We had a video still of a lake in Maine, and then we superimposed drawn images of starfish from encyclopedias and then actual digitized cowrie shells. I wanted it to be simultaneously her world under the water and our world beneath the sky. Shrines to Yemaya often have moon and stars associated with her. For the moon, I used the sand dollar. We had that all digitally printed up on a machine used for making billboards.

MNR: That's great. So, would you say that you feel a personal connection to Yemaya?

AS: I recently did a lecture and I told an anecdote. When I was young, I used to have a recurring dream that I was floating down a river, face down, and I can see all the stones down on the bottom of the riverbed. Once I told my dad the dream, and he said that when I was three, we had gone camping and I had fallen into a stream, and I was floating downstream, and they had to fish me out. And when they did fish me out, I wasn't panicked. I was very calm, even though I couldn't swim; it was almost as if I had liked it!

It makes me think of Ben Okri's book *The Famished Road* [1991]. He's Nigerian but lives in England. And it starts out, "In the beginning there was a river. The river became a road and the road branched out to the whole world. And because the road was once a river it was always hungry." The spirits try to lure back this boy who was born by mistake and wasn't supposed to have left the spirit world. It's probably about the author's own expatriation. Anyway, that incident of my floating down the river makes me feel that I have an obligation to create and make things, as a kind of homage to Yemaya. So, this piece is different because it's very consciously drawing from African influences.

MNR: What about your other works?

AS: I think a lot of my work is informed by African ideas but not necessarily directly. And yet, there is this curious crossover that happens. I'll make a dog, and then Bob Thompson [renowned Africanist art historian Robert Farris Thompson] will call and say, "Wow, did you know that that dog is…." Things just seem to come together. None of the other pieces in the exhibition are a direct response to one specific thing in African cultures. It's kind of a combination of that and everything else.

Bodies of Knowledge

MNR: This section is about the nitty-gritty making of the parts of the female figure so that they "do" certain things. It's the largest section of the exhibition, with three subsections focusing on hair, breasts, and scarification.

Hair Apparent

In our ancestors' days, women were always expected to tress their hair in order to make the face radiant; a woman with a beautiful hairdo was married quickly.

 Ngoi Ilunga (a Luba female water healer)

It's about the complexity of women's lives and about how there's all this stuff that becomes entangled in your hair…that becomes apparent according to your bad or good hair days.

 Alison Saar

MNR: For Luba the hair is a locus of power. The Luba were called "the headdress people" by explorers. They had such incredible styles, and these styles are shown in the art, so we chose sculptures for this section—like this amazing piece—that show a lot of different hairstyles that were fashionable in the nineteenth century (fig. 26).

AS: But that has no function?

MNR: It does have a function. It's a cup, it's a double cup in the form of a human head, so you're actually seeing it upside down. During the investiture of the king, the ruler had to drink palm wine mixed with blood [from a sacrificial animal], and the blood symbolized the transfer of power from the ruler's predecessor. The king or chief drank out of one side and passed it to the group, and they drank from the other. There's an ambiguity here; although this is probably a female figure, on the day of a king's investiture he wore a female coiffure, so you can't really tell. Luba kingship is called *bulopwe* and is the realm of sacred royalty that is very much male and female; it has a gendering, but it's a dual gendering. The emblems are female, but the rulers are male. With these heads, you can't be sure which gender they are, and in fact they're both.

AS: But you wouldn't think of it as being male, because the ruler was masquerading as a female. It goes back to being able to attract, it still seems to be

26

CUP IN THE FORM OF A HEAD

Luba, Democratic Republic of the Congo

Wood

H: 11.4 cm

Felix Collection

Luba figures are always rendered with extravagant hair. This exquisite cup, which was used to effect a symbolic transfer of power, depicts a female hairstyle worn by a king on the day of his ascendance to the throne.

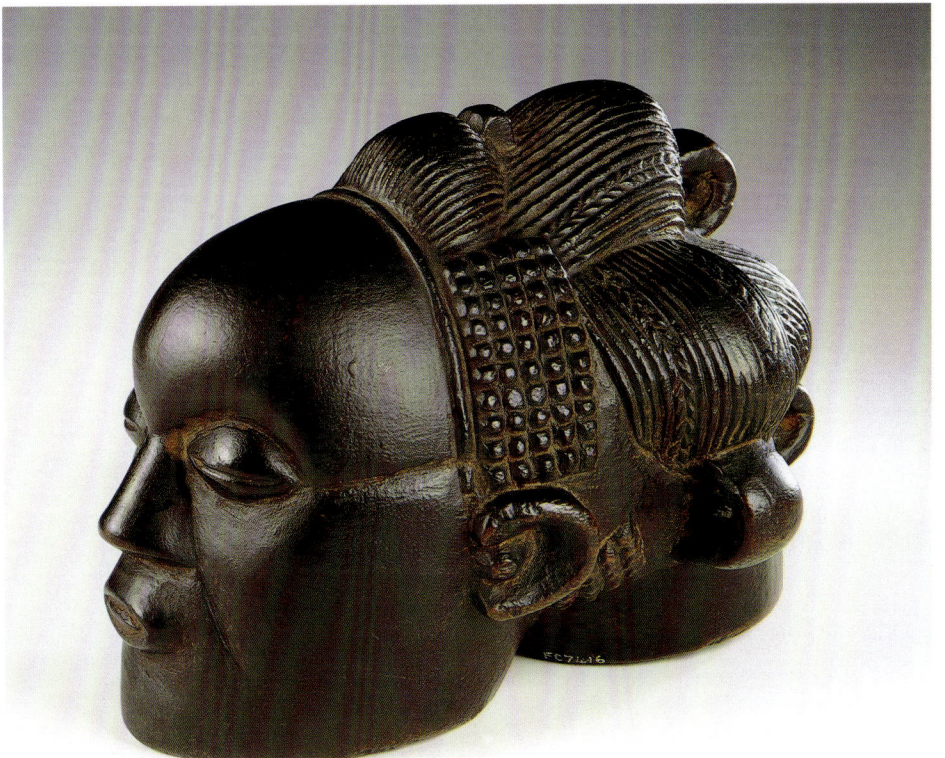

about attraction of the spirit, to receive that during their investiture, being able to receive as a female.

MNR: That the king himself became more attractive to the spirits by becoming feminized on his investiture day.

AS: That's so beautiful.

MNR: It's a very beautiful cup. So, what about this piece of yours? I absolutely love *Chaos in the Kitchen* (fig. 27).

AS: *Chaos in the Kitchen,* well you know the term *kitchen* is the curly part of your hair that's always breaking the teeth out of your comb. And it's about the complexity of women's lives and about how there's all this stuff that becomes entangled in your hair and all this stuff that becomes apparent according to your bad or good hair days. And you know, it's also this story that my mother would tell about a little girl who wouldn't brush her hair, and she started accumulating stuff—leaves, and then birds, and then rats—and all these things start living in her hair because she wouldn't brush it out. I like it because it's like a spirit catcher in a way, and that it catches your fears and it catches your dreams, it tells of your occupation. I think there are scissors in there and brushes in some of the pieces and fast cars and wash tubs, again her life history is mapped out in her hair. You can look at her hair and realize who she is or who she wants to be, and who people think she is and how people understand her and perceive her from an exterior sense. So, it's again that nappy Velcro aspect to your hair that kind of traps all these things.

MNR: Isn't there an Eiffel Tower in there?

AS: Yes, probably, that's a dream. She wants to go to Paris…wants to go to Paris.

MNR: And you know, for Luba people all these hairstyles aren't just pretty. They're "beautiful," but they're about memories, too, and they're also about identity,

27 OPPOSITE, LEFT

ALISON SAAR, *CHAOS IN THE KITCHEN*, 1998

Wood, wire, tin, tar, miscellaneous objects

H: 58.4 cm

Collection of Dr. Richard and Jan Baum

28 OPPOSITE, RIGHT

BACK OF LUBA FEMALE FIGURE (fig. 1).

29 RIGHT, AND DETAIL, BELOW

STOOL SUPPORTED BY A CARYATID WITH LONG HAIR

Luba, Democratic Republic of the Congo

Wood

H: 34 cm

Schorr Family Collection

Luba hairstyling ranges from the stately to the flamboyant, but it is always rich in meaning. This stool, by the same hand as another in the University of Iowa Museum of Art (CMS 457), celebrates the power of hair through the outward-curving thrust of an extended braid.

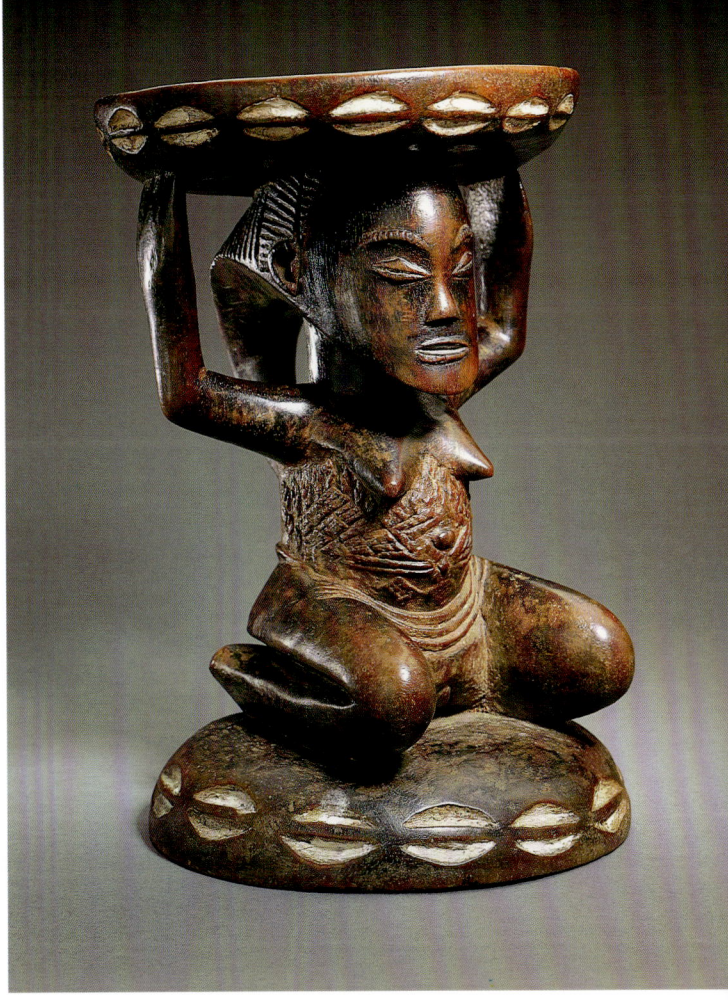

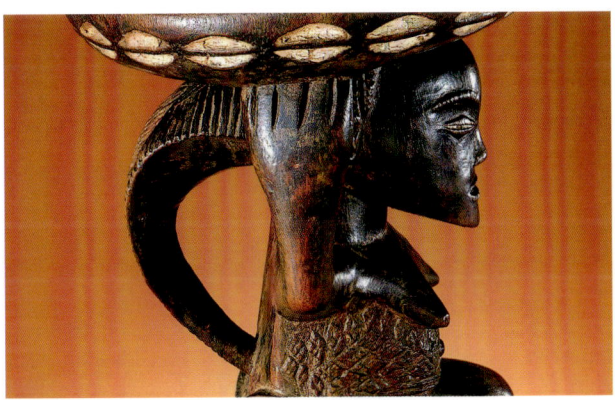

because they can tell you if a woman is married, if she has children, if she is a widow, or what profession she might have or what clan she might be from, so there's this whole sense of hairstyling as being a way of telling your story, a kind of biography, and it can change (fig. 29). It's also a way of emulating a person more important than yourself. People would apparently travel a hundred kilometers just to see what the king's wife's hair looked like and what her scarifications were, and they would copy them. There is an element of fashion, and the styles have changed. Luba still do their hair in really remarkable ways, but there are different styles now. These are really specifically nineteenth-century styles. One of the most common ones in the nineteenth century was the cross-shaped style (fig. 28). And the thing that's great about this style, which reminds me of a little bit of your work, too, is that a lot of the figures, including the Fowler's object that opens the exhibition, have medicines packed inside the tresses, so you'll see a cloth bundle that has medicinal substances jammed in there and iron pins that are meant to lock in the spirit. So it seemed to me that there is a nice interplay with some of your work.

AS: Yes, this one is called *Delta Doo*. It's really "Doo" as in hairdo (fig. 30). It's done specifically as a southern sense of style that also incorporates and recognizes the spirit world. It's funny that you mention the medicine pack, because *Delta Doo* has a lot of old medicine bottles, like old cough syrup bottles, so it's also got this feeling of medicinal, curing things as well.

MNR: Is this idea linked to the tradition of bottle trees in the south?

AS: Exactly. It's to attract these spirits and bring them into you. But as well as bringing spirits in, I also see it as containing and retaining spirit, leaving yourself, emanating from her life dreams. Hopes and thoughts get trapped in these bottles, and she carries these things around in her hair as well. So, that's why she has these sort of dreadlocks.

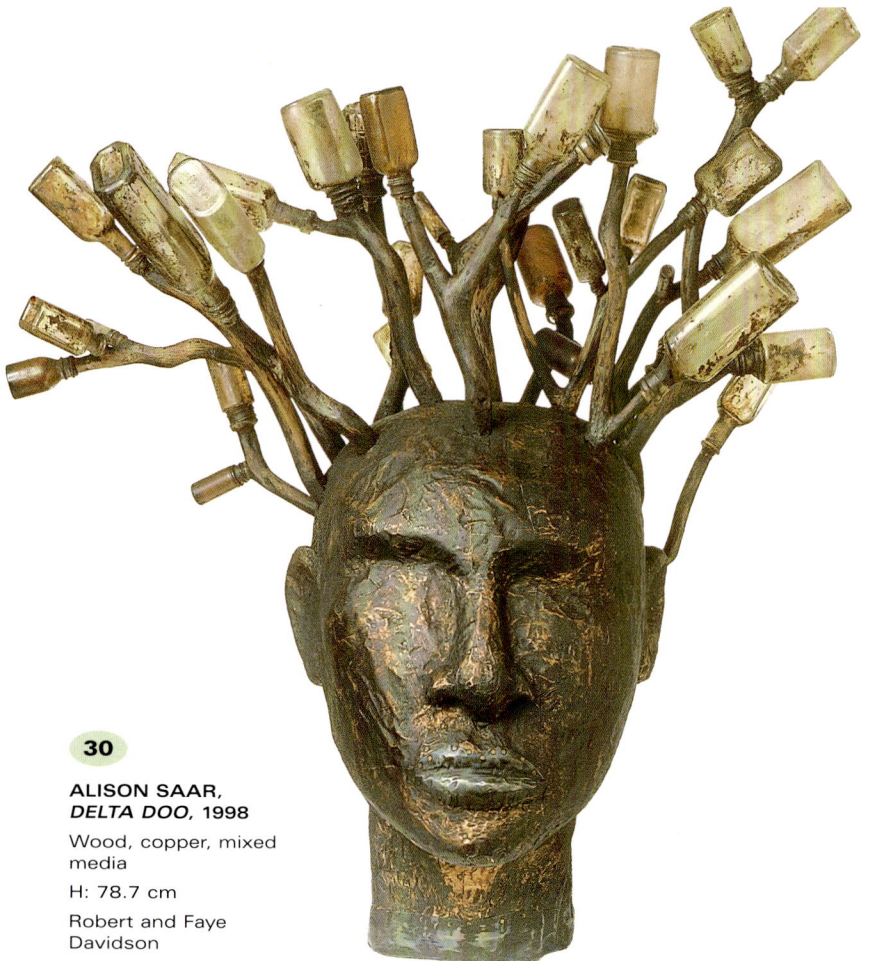

30

ALISON SAAR,
DELTA DOO, 1998
Wood, copper, mixed media
H: 78.7 cm
Robert and Faye Davidson

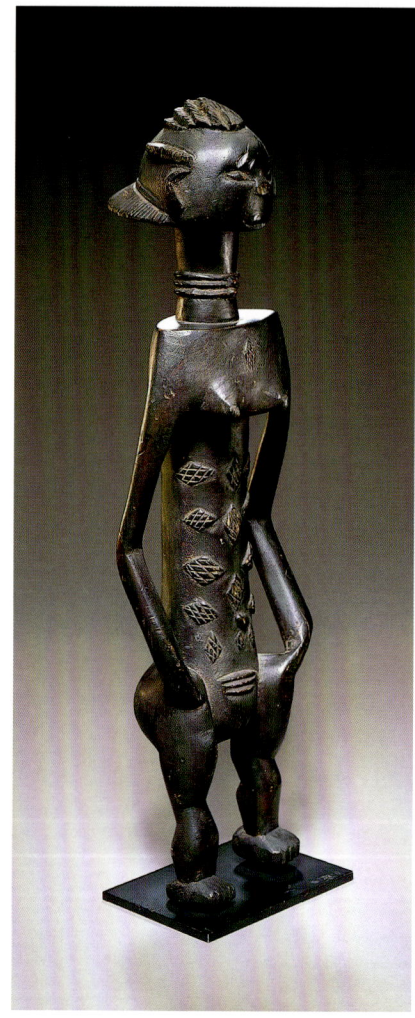

MNR: So, there's a play of both containment and emanation at the same time.

AS: Right, attracting spirits and then containing and withholding your own spirits and your own ideas.

MNR: That's such an important concept for Luba people, too, this idea of locking in and enclosing spirits within an object.

AS: Now when they do the medicine packs on the head, is that to secure health for someone?

MNR: It's sort of like *nkisi*s for Kongo people, only Luba call them *nkishi*s, meaning "power objects" (fig. 31). They have medicine in the hair and sometimes on top of the head. It's that the back of the head for Luba people is where a lot of power gets centered. You'll see that some objects have these iron pins in the back of the head. In the precolonial period, people used these pins as a hairstyle, as a way to create beautiful coiffures. But beyond that they were also symbols of anvils, and the anvil is considered to be the secret of the success of the kingdom. It was because of black-smithing and the technologies of black-smithing and the wealth of iron that the kingdom rose to power, so the idea of locking in spirits with these iron pins that are miniature anvils is critical. And when archaeologists excavated in this area, they found a grave where a skeleton had clusters of these iron pins at the back of the head, suggesting that the deceased had been buried with the pins lodged in the coiffure. Present-day Luba explain that it's to contain the spirit; they were buried that way so that the body would hold the spirit in an enduring way. There's another hairstyle called the "step" or "cascade" coiffure, and those are the two most prominent styles of that period (fig. 32).

AS: Well, *Conked* parts with and also talks about ancestry at the same time (fig. 33). It's talking about hairstyles and Blacks trying to process their hair so that it becomes an Anglo hairstyle, Western "Anglosaxophied," so she's straightened her hair, but she's invested so much in trying to change herself

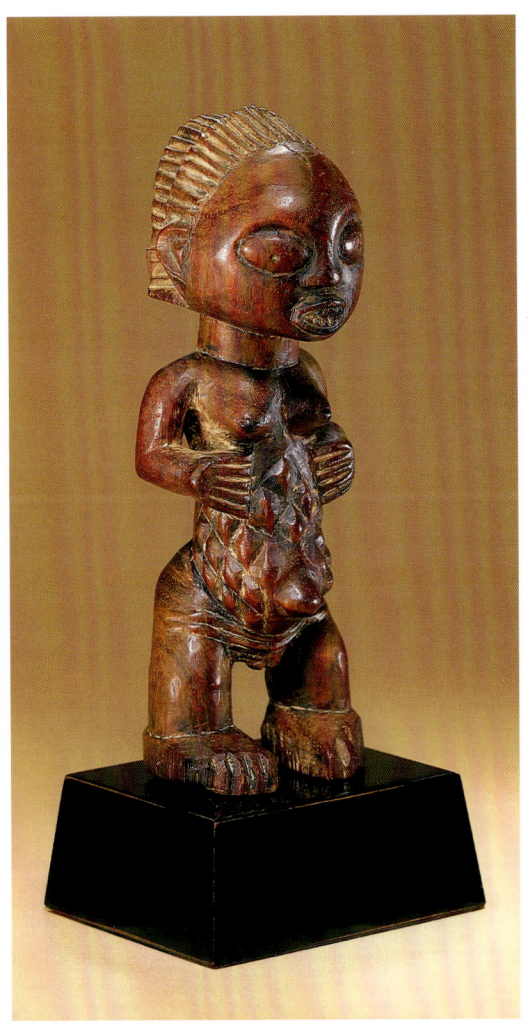

into something else, that she is forcibly eating and feeding this false image to herself, and in feeding this false image to herself she severs herself from who she really is, so this hair that she's eating becomes this blood that is running off. Her ancestry and ancestral blood is running out of her at the same time. So, it's like chewin' it and eatin' it and feeding herself this lie.

MNR: It's very powerful. And so, it's meant to be shown on its side like this?

AS: It lies on its side. I have another one with these irons in her hair, hot irons, which actually is kind of interesting. She's also to the side, and her hair is pulled back, and when you go behind it you see that it's all being held down by these irons. But it's the same idea. It's called *Pressed*, it's about weighing yourself down with other peoples' ideas of what beauty is. It's about different things, but it's also about the importance of hair as a mapping of ancestry, but it's like the other end, where if you don't maintain

31 OPPOSITE, RIGHT

FEMALE FIGURE
Luba/Shankadi, Democratic Republic of the Congo
Wood
H: 55 cm
FMCH X87.1412; The Jerome L. Joss Collection

Luba hairstyles can be situated regionally. The style shown here, which features tresses arranged in cascading steps, is associated with a subgroup of Luba peoples referred to as Shankadi, who are located near the town of Kamina. Luba hairstyles communicate other aspects of identity, as well, such as profession, marital status, and clan.

32 ABOVE, LEFT

SMALL STANDING FEMALE FIGURE
Luba, Democratic Republic of the Congo
Wood
H: 20 cm
Dr. and Mrs Ernest Fantel

Every detail of a Luba female figure expresses the merging of Luba aesthetics and efficacy. An elaborate hairstyle, intricate scarification patterns, and chiseled teeth are marks of Luba beauty, identity, and spiritual grace.

33 ABOVE, RIGHT

ALISON SAAR, *CONKED*, 1997
Wood, paint, ceiling tin, wire
H: 71.1 cm
Collection of Eileen and Peter Norton, Santa Monica

34

ALISON SAAR,
NAPPY RED HEAD, 1997
Wood, paint, tar, objects
H: 66 cm
Collection of Robert A. Roth

that respect for your hair then you turn yourself against that, in turning your back to that culture, so it might be a nice piece in response to that.

MNR: Very nice.

AS: And then there's *Nappy Red Head* (fig. 34). There are two nappy heads, one is *Nappy Head Blues* and one is *Nappy Red Head*. And it's the same idea as *Chaos in the Kitchen* in that they have these elements in their hair that kind of talk about who they are, who they want to be, and how people perceive them. So, it's the same idea basically. A basketball player, a crucifix, a boat to take her somewhere, a winged Victory, a wrench maybe to style her hair, and there's a marcel curling iron in the front, so there are all these things in there. And the heads are big, they're larger than life. Much larger than life. They're not life-size. It kind of plays the opposite off the Luba stuff.

MNR: Is there any particular reason why she's red?

AS: Oh just because the one that's blue is *Nappy Head Blues*, and it's about the blues, and this one's hair is red, so it's just to suffice the pun.

MNR: For Luba people, there's this whole stress on hair, and hair as a place of dreams. Luba headrests are used for sleeping. But they also depict the hairstyles that the headrests are there to protect (figs. 35–37). By keeping your head on the headrest at night you're preserving the hairdo itself, which can last up to two months if taken care of properly and if one uses the wooden pillow. And then *Blonde Dreams*…

AS: This is called *Blonde Dreams,* and she's like a skillet blonde, so it's Blacks who have dyed their hair blonde, and again it's about instilling so much power in your hair that you think if you change your hair to be something Anglo then you become part of that

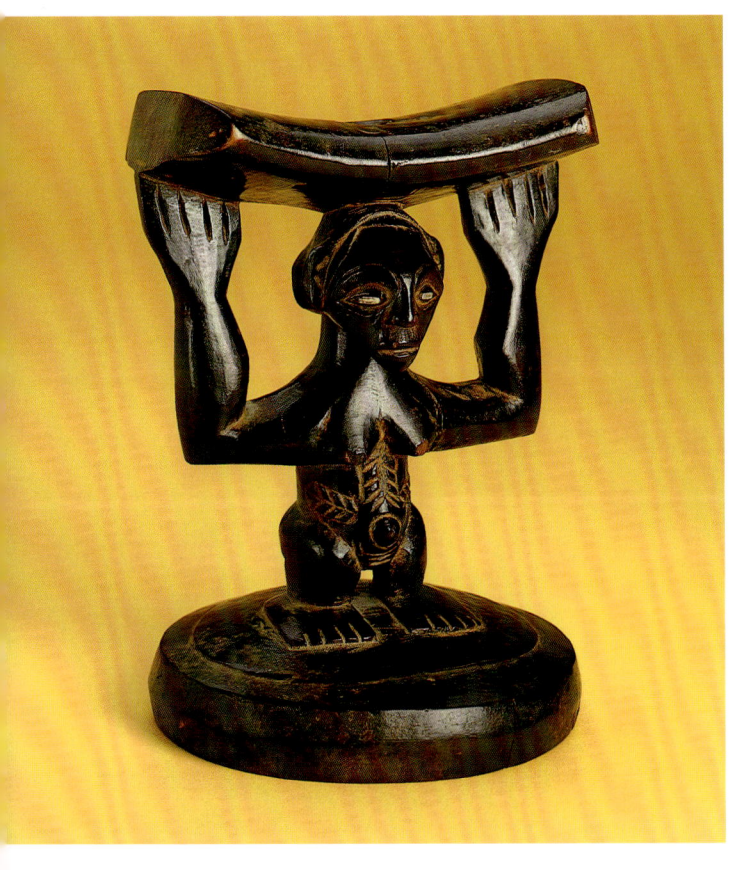
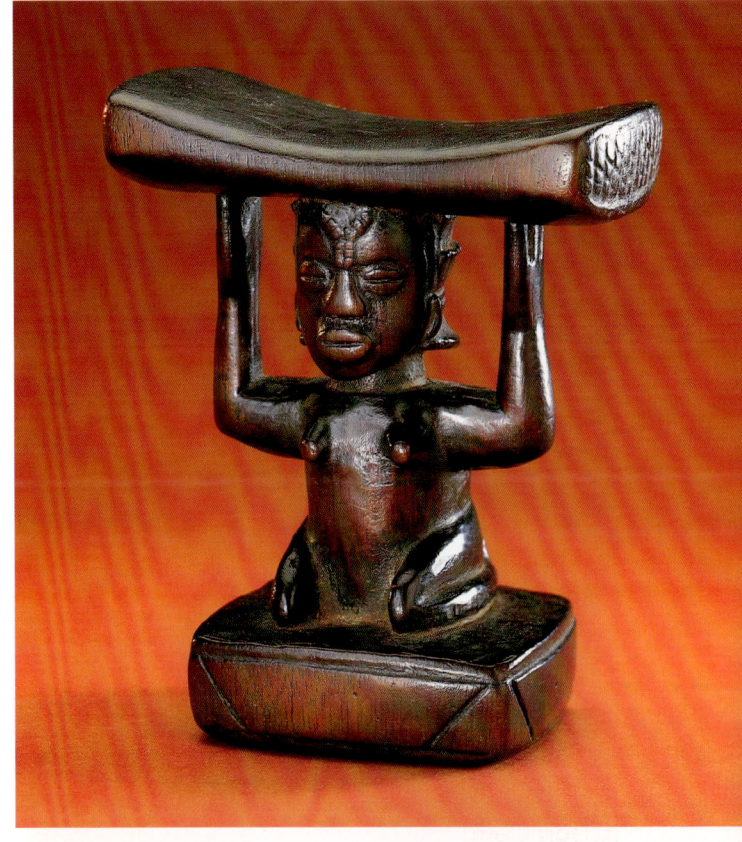
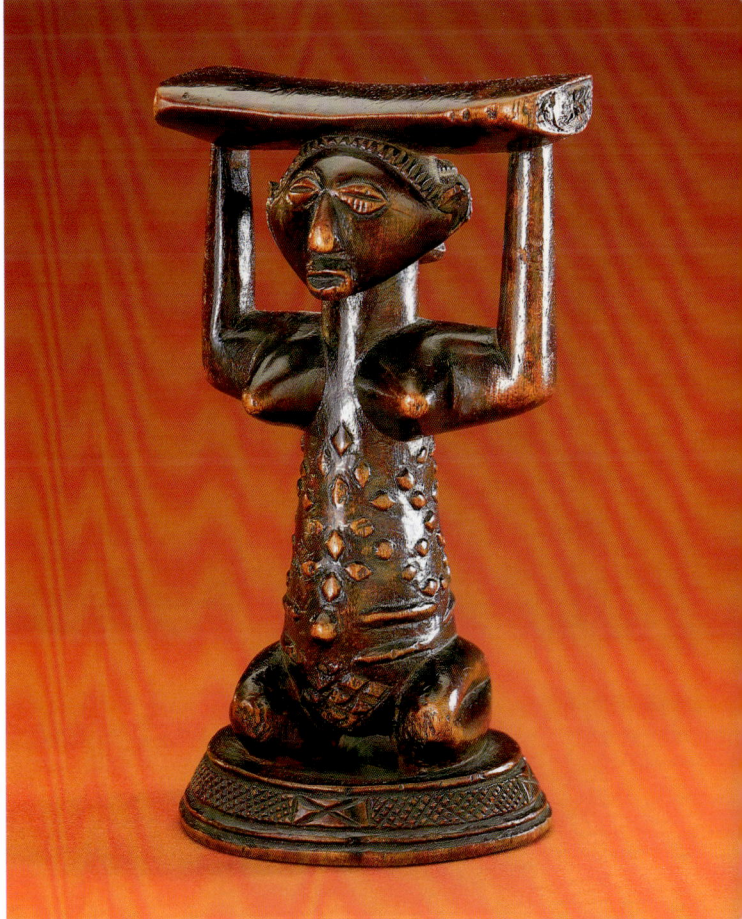

35 ABOVE, LEFT

HEADREST
Luba, Democratic Republic of the Congo
Wood, metal
H: 16 cm
FMCH X91.67; The Jerome L. Joss Collection

Headrests are wooden pillows that were commonly used by Luba peoples of earlier generations to protect elegant hairdos during sleep. The hairstyles of the figures supporting the headrests reflect actual nineteenth-century fashions. Headrests were articles of extreme intimacy and had great personal value for their owners, who considered them so sacred that they were sometimes buried with them.

36 ABOVE, RIGHT

HEADREST
Luba, Democratic Republic of the Congo
Wood, metal
H: 14.9 cm
FMCH X88.929; The Jerome L. Joss Collection

37 RIGHT

HEADREST
Luba, Democratic Republic of the Congo
Wood, metal
H: 17.5 cm
FMCH X86.1721; The Jerome L. Joss Collection

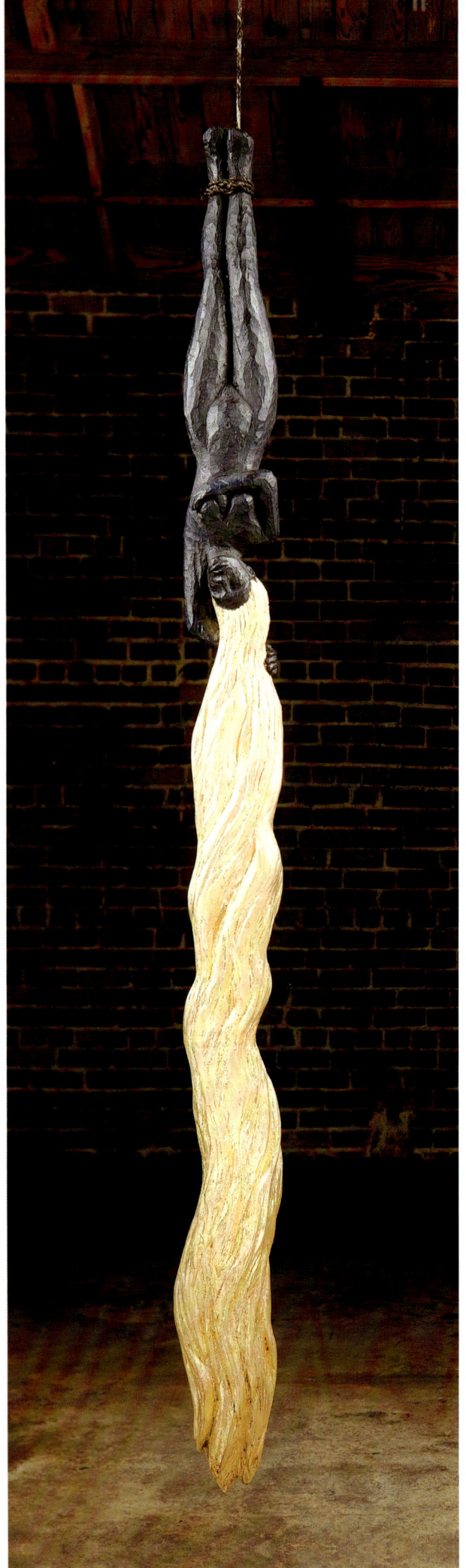

culture or society (fig. 38). And also the Rapunzel story, that this long blonde hair, she threw it out and a prince climbed up and she was on easy street thereafter. That this hair has the power to completely change your life. So, it's interesting in the sense that it's still a really powerful element, maybe it's taking a different point of view, but it's still about the power of the hair. And so she's hanging by her feet because she's sacrificed herself to this idea, and she's covered in tar so she's very dark skinned, and then the hair is actually gold leaf so there's this golden value to it, and she's about seven feet tall.

MNR: Is the gesture of the hand under the breast or touching herself anything in particular?

AS: Oh, I think she's trying to make herself look good. You know, I think it's a flirtatious gesture.

Secret Sanctuaries

The chief's mother has a very large responsibility to protect the secrets of her son's power, therefore, to guard the royal prohibitions within her breasts.

 Ngoi Ilunga (a Luba female water healer)

The breast becomes a portal to this secret inside of her....Her breast becomes a revealing mechanism.

 Alison Saar

MNR: Well, that leads into the next section, called "Secret Sanctuaries." Now, if you have any other ideas for titles of this section that deals with breasts...

AS: Well, I like the idea of what you said about the breasts being a source of knowledge.

MNR: Right, it's that Luba consider the secrets of royal knowledge to be held inside the breasts, the secrets are held within the breasts, so a woman gestures to her breasts (fig. 39). So, it's not really about fertility but [rather] that specifically within these sanctuaries women hold the secrets, and they are the holders and custodians of esoteric knowledge. You have a number of works relating to the breasts. What is this one about?

AS: *Love Zombie* (fig. 40). She actually was part of a grander installation called *Love Potion #9,* nine pieces that dealt with different aspects of love and voodoo, specifically. It was a response, it was kind of a play on New Orleans capitalizing on voodoo. Her little story is that she's a zombie because she's at this state when you're so infatuated with someone that you can't see,

38 OPPOSITE

ALISON SAAR,
BLONDE DREAMS, 1997
Wood, tar, gold leaf, rope
H: 241.3 cm
Collection of Eileen and
Peter Norton, Santa Monica

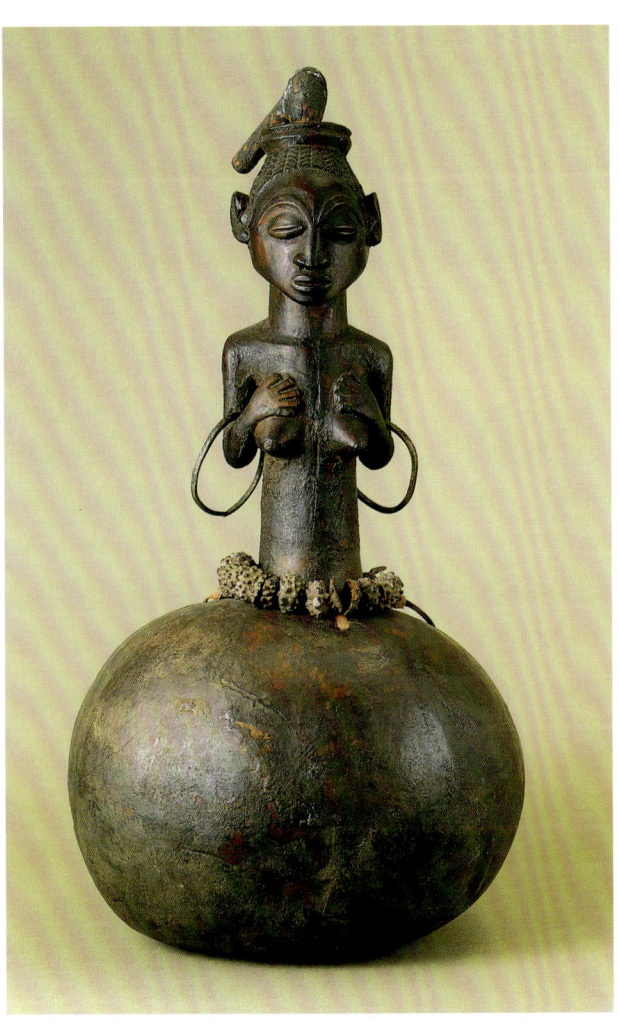

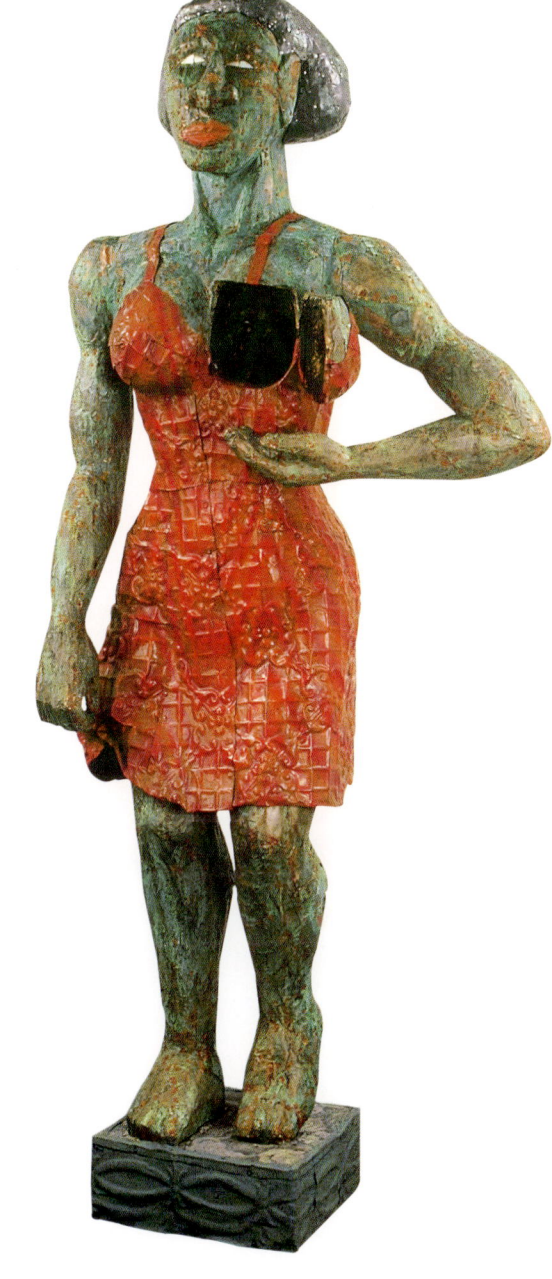

39

FEMALE FIGURE
Luba, Democratic Republic
of the Congo
Wood, gourd, seeds, metal
H: 41.3 cm
Walt Disney—Tishman
African Art Collection

The gesture of hands to breasts is seen frequently in Luba art. Rather than being a reference to fertility, it is a sign of the secrets that women protect within their breasts. This figure on a gourd is called *kabwelulu* and may have been owned by a healing and hunting association called Bugabo. It would have been used for inducting new members into its teachings.

40

ALISON SAAR,
*LOVE ZOMBIE, A POTENT
HEX THAT ROBS 'EM
OF ALL SENSE,* 1988
Wood, tin, copper
H: 61 cm
Gai Gherardi and Rhonda
Saboff

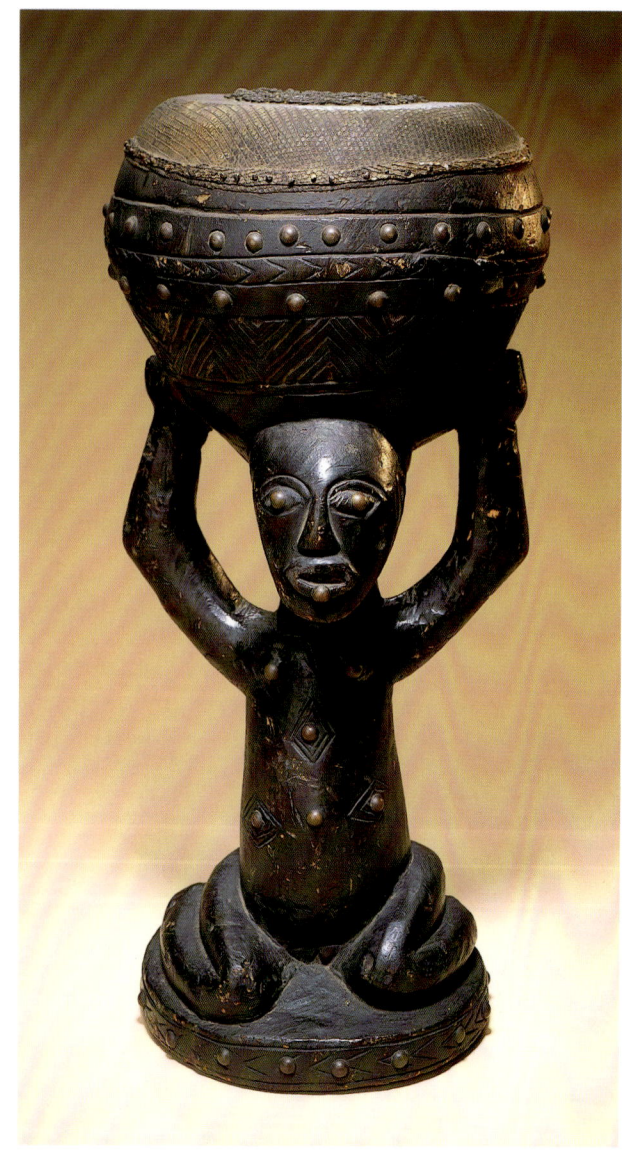

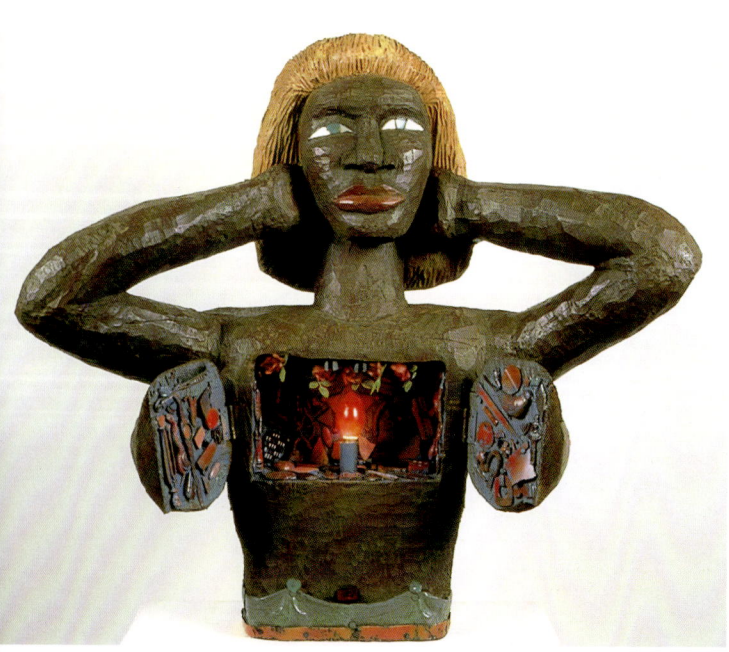

so she doesn't have pupils in her eyes, and you can't hear. So you can't see him cheating on you, and you can't hear your friends saying what a dog the person is; you have this kind of bronze skin so you can't feel anything and you're sort of impervious to anything outside of your infatuation for this person. The breasts lift open. This is more about the heart than the breast per se; a kind of charred sort of heart that's been bound and there's a heavy whammy on this heart that has this power over her. Her heart has totally cut her off from everything else. The breast kind of flips open and then flips back down, so it's like a little case. But again, in a way, the breast becomes a portal to this secret inside of her—she's like this because her heart is all charred and torn up. It is about a revealing. Her breast becomes a revealing mechanism.

MNR: I like the juxtaposition of the Luba figures with *Love Zombie*'s gesture of offering, and in many African cultures when you see that, it is a gesture of offering, a gesture of devotion. For example in Yoruba art, when you see a kneeling female figure with hands to breasts it is a sign of devotion to the gods, so there is that nice interplay.

AS: It's also like—what's that show with Vanna White? Where she puts her hand under her breast and says, "Behind curtain number 3…"

MNR: Now that you mention it, I see it perfectly. So, the other piece of yours is *Sapphire,* and it will be juxtaposed with this Luba-related drum where the woman has her arms up, holding the drum (fig. 41).

AS: That's a great juxtaposition. That's really nice, and again it sort of relates to the headrests in the sense of support. *Sapphire* is about passion, a shrine to passion (fig. 42). These breasts open up and reveal these secrets about her, that she has this passion inside her. And it's a bunch of bits of red plastic for the heat of it. It has this little light, so it actually needs an outlet. It's also like red-light district allusions. When it's closed, she's flaunting her breasts. It's the power of a woman's sexuality. And not in a negative sort of way. It's not that you have to sell yourself sexually to have power, but that there is a power to that as well.

MNR: I think those will be beautiful side by side.

AS: It's kind of neat because it's got the same kind of rim at the bottom.

MNR: What is that?

41 OPPOSITE, TOP

DRUM
Zela, Democratic Republic of the Congo
Wood, metal, hide, snakeskin, bamboo
H: 52 cm.
FMCH X86.1114; Gift of Helen and Dr. Robert Kuhn

Drums of Luba and related peoples are used for every sacred event associated with politico-religious life, and they play a critical role in the epic that recounts the origins of Luba kingship. Drum tones encode secret messages that are guarded and enshrined by female spirit mediums. Still today, people speak of a famous Luba drum, the sounding chamber of which was made from the scarified skin of an actual woman.

42 OPPOSITE, BOTTOM

ALISON SAAR,
SAPPHIRE, 1985
Wood, mixed media
W: 78.7 cm
Gai Gherardi and Rhonda Saboff

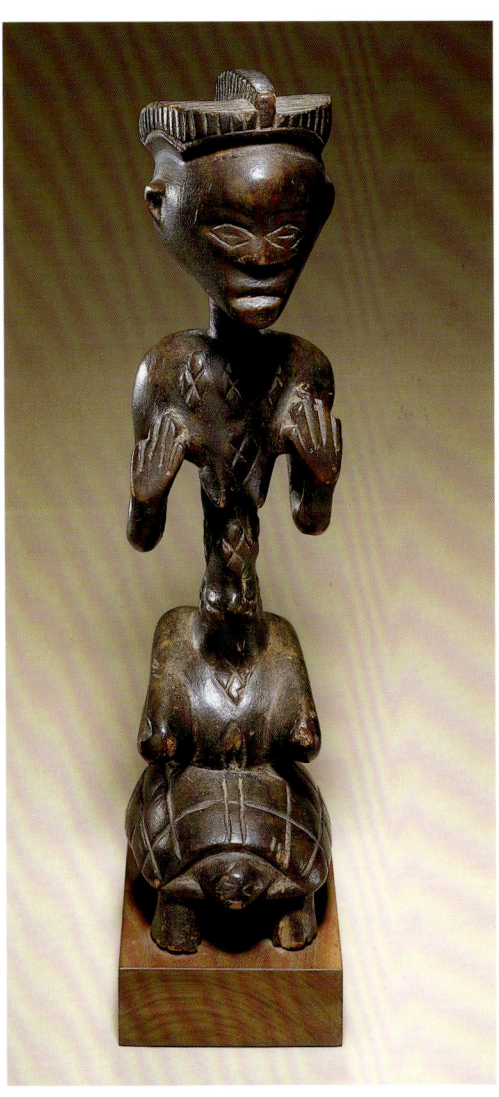

AS: It's ceiling tin; it's just a decorative cornice.

MNR: So, what is her gesture?

AS: Her gesture is just kind of like puttin' it in your face sort of thing, puttin' her chest out as far as she can and messin' with her hair sort of thing. That's a pretty early piece, '85 or '86.

MNR: So, do you like the title "Secret Sanctuaries" for this section?

AS: I like the idea of revelation, and revealing the secrets and the containing of secrets (fig. 43).

MNR: And I like the idea that it's the opposite of what you think about when you think about breasts. "Breasts" make people think about sexuality, or being exposed, or femininity, or fertility. When in fact it's really much deeper, it's really a very interior kind of sense (fig. 44).

43

FEMALE FIGURE ON A TORTOISE
Luba, Democratic Republic of the Congo
Wood
H: 40.5 cm.
Joseph and Barbara Goldenberg

The image of a female figure on a tortoise expresses the connection that Luba make between women's secret knowledge and the ability of the tortoise to conceal itself within its shell. The founding ancestor of the Mbudye association, which protects Luba royal secrets enshrined in the *lukasa* memory boards (see fig. 16), was a woman in the form of a tortoise.

44

PENDANT
Luba, Democratic Republic of the Congo
Hippopotamus tooth
L: 10 cm
FMCH X87.1321; The Jerome L. Joss Collection

The hands held to the breasts are a reference to women's secret knowledge and a sign of honor to the ancestral realm. Carved ivory and bone pendants in the form of female figures with their hands held to their breasts were worn by men along with other talismanic articles on a string across their torso. The worn features and soft surfaces of such pendants reflect years of close contact with the bodies of owners who treasured them.

AS: But I'll look. I might do some research because there might even be some spiritual terminology in terms of the bosom, like "bosom of Abraham," but maybe we can come up with some sort of play about bosoms and secrets.

Writing on the Body

When people worshipped in the past, they always removed the clothes from their upper torso. All the women had scarifications and spirits responded above all to women; they were more favorable to women.

Ngeleka (a Luba male titleholder)

It's about scars on your skin in terms of reference to your life experience and in reference to how people perceive your position in culture.

Alison Saar

MNR: I have called the next section "Writing on the Body," because it is about writing your life story on your body, which is what Luba people do when they scarify themselves. It begins at adolescence, and then after every childbirth a woman renews the scarifications and adds more information as experience grows. It becomes an accumulation of a woman's experience and her contributions to society. So, it really is a kind of scripting, where your skin becomes a sort of a canvas (fig. 45).

AS: It also calls to mind the expression "writing on the wall." So, if you wanted to think of it as "Writing on the Body," because then it's also the publicizing and exteriorizing of information.

MNR: But also a keeping out, it's always that play of in and out that the body affords. So, for this section I just chose one of each, one Luba stool covered with scarification and one of yours, *Scar Song*.

AS: And that is really specifically what *Scar Song* is about (fig. 46). It's about scars on your skin in terms of reference to your life experience and in reference to how people perceive your position in culture; it's about what her real experiences are and how people see her as a sexual object and how people see her as something domestic and all these other things. So it's about looking at women from all different points of view, all within that one same body, so it's great that it's here. It takes that idea of scarification and expands it to other things, negative perceptions and other peoples' perceptions on top

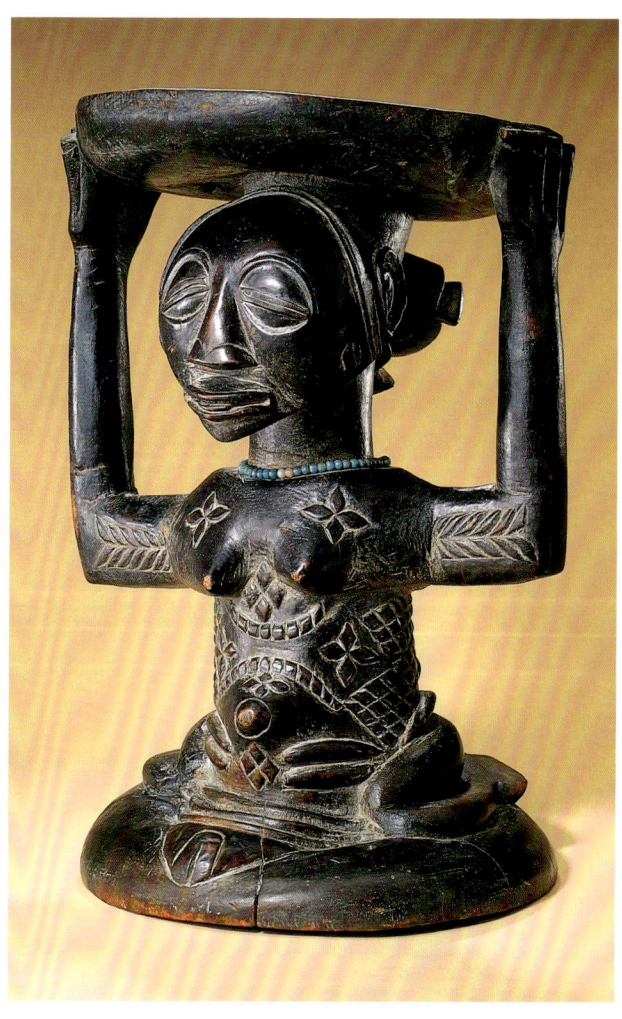

45 ABOVE

STOOL
Luba, Democratic Republic of the Congo
Wood
H: 46.3 cm
Private Collection

Scarification on Luba figures is far more than a cosmetic practice. Luba royal womens' scarifications contain arcane messages about the sacred powers of kings and are believed to make a woman a more effective receptacle for spiritual embodiment.

46 OPPOSITE

**ALISON SAAR,
SCAR SONG, 1988**
Wood, ceiling tin, mixed media
H: 193 cm
From the personal collection of Robert F. MacLeod

of it, instead of being so strictly its positive sides as a form of embellishment and meaning.

MNR: What about your ceiling tin? It comes into your work again and again. Do you have anything in particular to say about it and why you use it. Is it just because you like the texture of it?

AS: A couple of reasons actually. Well, you know they're all carved wooden figures underneath, but I like sort of putting a skin on them, and I love the ceiling tin because it's patterned, and it becomes at once decorative and also this sort of scarification. A lot of the ceiling tin I found in New York was from the turn of the century, and I loved the wisdom of the material. I had my studio in Harlem in '83 and I'd find the stuff and I'd realize this stuff was on ceilings since the Harlem Renaissance, and so it saw babies being born and people making love and people dying. And so it had this wisdom in that all my materials were new, but by putting this surface on it, in a way it's sort of like libations because it gives it a strength that the other materials sort of put on it. So the coats of paint were testimony to the history of the people that have lived within that space and testimony to all the accumulated wisdom of all these different activities, so I liked that it had this wisdom and age to it as well.

MNR: That's wonderful. I like the idea of the skin, and one could extend the scarification section to include skin a little more. Because I always just stress what people do *to* the skin, but you're actually *giving* your works a skin.

AS: It also comes back to the idea of an exterior shell around this vessel, and the skin contains these spirits and holds all these things within them, too. So maybe we could just have that as a little aside. Have the eyeballs and the skin as a little aside! I don't know if there are some Luba objects in the exhibition that show things in the eyes, because it is a consistent relationship between the works, that they are either eyeless or pupilless, or that there is a distancing, a cut between these two realities.

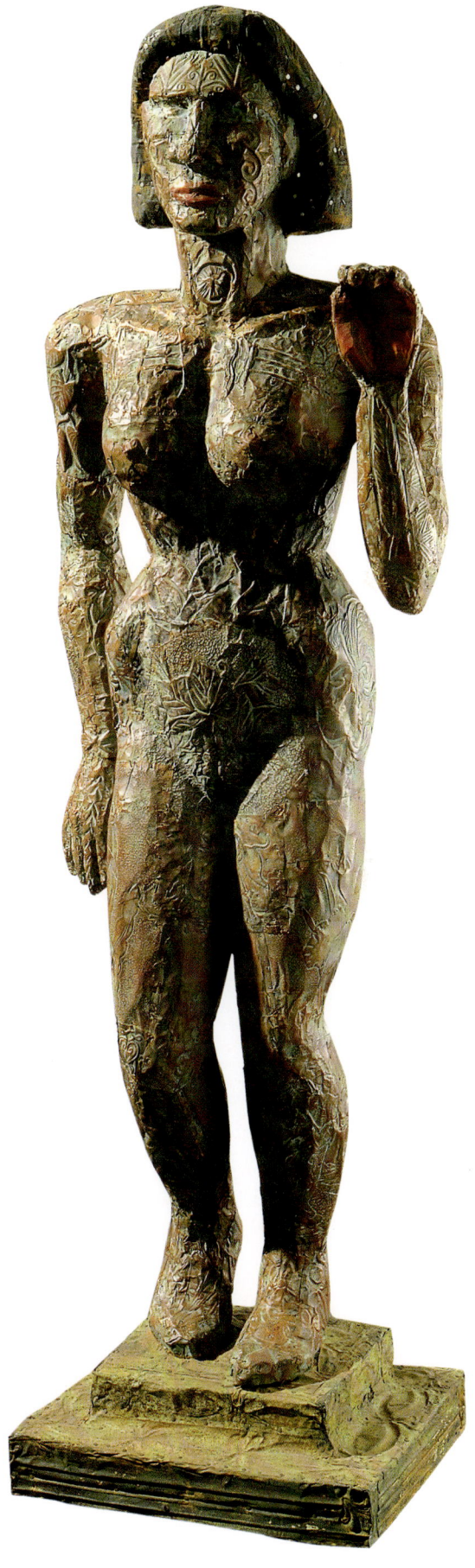

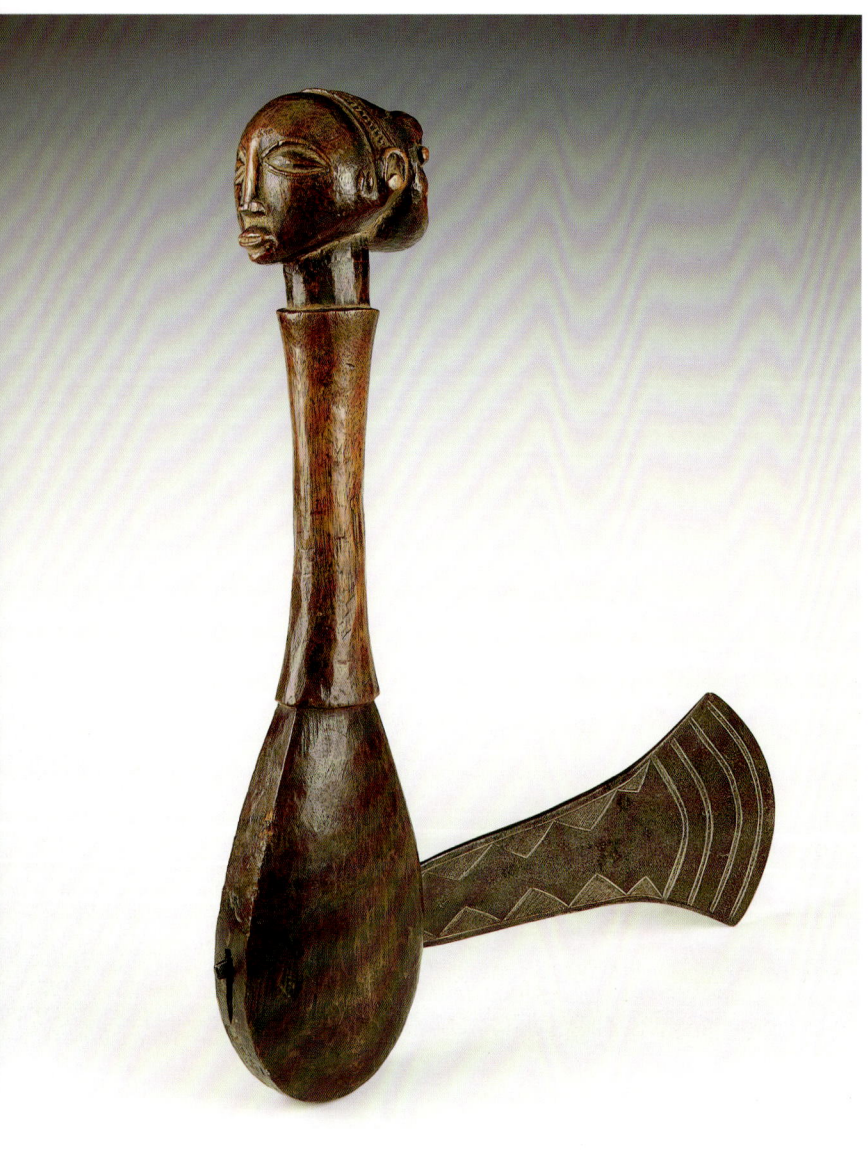
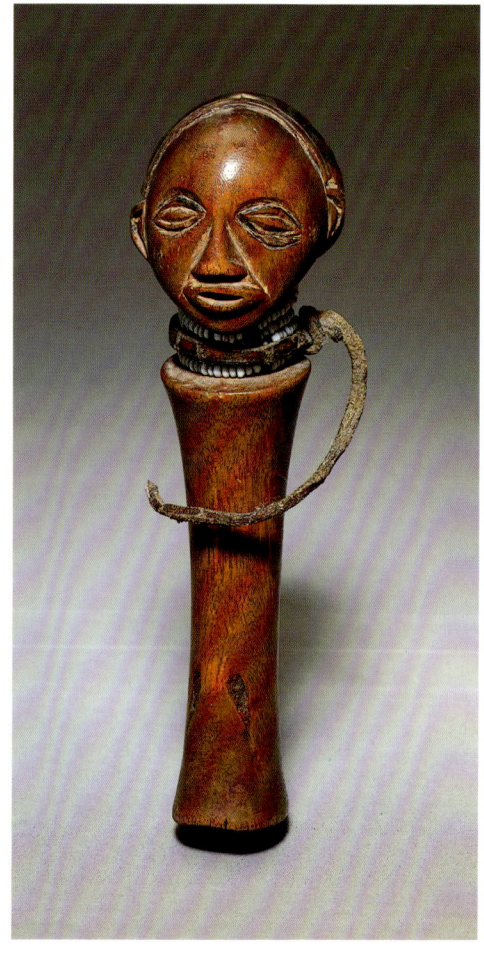

47 ABOVE, LEFT

AX

Luba, Democratic Republic of the Congo

Wood, metal

H: 137 cm

Felix Collection

Many Luba royal emblems assume the form of weapons or tools merged with the female form. Ceremonial axes are worn over the shoulders of high-ranking officials to convey status and to recall that their power emanates from the bodies of women.

48 ABOVE, RIGHT

KNIFE HANDLE

Luba, Democratic Republic of the Congo

Wood, beads, leather

H: 14.7 cm

FMCH X87.627; The Jerome L. Joss Collection.

This elegant female figure once surmounted a Luba royal knife, a symbol of sacred authority. The blade of this knife is missing, but undoubtedly it was adorned with scarification patterns incised into the metal.

49 OPPOSITE

ALISON SAAR, *SLEDGEHAMMER MAMA*, 1996

Ceiling tin on wood, nails, sledgehammer

H: 81.3 cm

Los Angeles County Museum of Art. Purchased with funds provided by Paul and Suzanne Muchnic and Reese and Linda M. Polesky in loving memory of Herbert V. Muchnic. Additional funds generously provided by Times Mirror. AC1996.161.1

Photograph © 2000 Museum Associates/LACMA

Working Women

The chief will put a female figure on the staff to prove that his kingdom comes from this woman. It is like a sign or a memory of the woman who brought royalty to us.

 Nsenga Ubandilwa (a Luba male descendant of a chief)

With her kind of physical strength she is forging her place in society, and she's able to punch anyone's lights out.

 Alison Saar

MNR: The next section is "Working Women." The objects that constitute Luba royal treasures include axes (fig. 47), knives (fig. 48), and bow stands to hold bows and arrows; but they are never meant to be used solely as utilitarian objects. They are symbolic, they're ceremonial, the axes are meant to be worn over a person's shoulder as an emblem of status. But again, the female form always adorns them. You can see the scarification patterns on the handles and even on the blades. Those are literally referred to by a Luba word that means scarification. But when you ask, "Why are they there?" They say "to beautify it, to embellish it, and to make it beautiful." But if you press further—"but what does beauty mean?"—it's always this sense of beauty that "works," beauty that *does* something. This is the beauty that attracts the spirit so that the object can invest a person with power and can also be a receptacle where a person places his power. So it just seems like such an obvious point of comparison with your works, which are very much about tools and objects of utility that are merged with the female form.

AS: And they're also about power. *Sledgehammer Mama* is about her physical strength and her spiritual strength and this power and how she has this sledgehammer attitude (fig. 49). And then again, she's with that ceiling tin so the scarification comes into it as well, because it's the scarification and embellishment of the surface, which is that tin that's already pressed like that. It's just about her physical strength and toughness, and it's kind of interesting in terms of what we were saying about the anvils and that ability to forge, being malleable, being able to reform and re-create your environment. With her kind of physical strength she is forging her place in society, and she's able to punch anyone's lights out.

MNR: You know this forging idea surfaces again. When a Luba king is invested, they say he goes through this

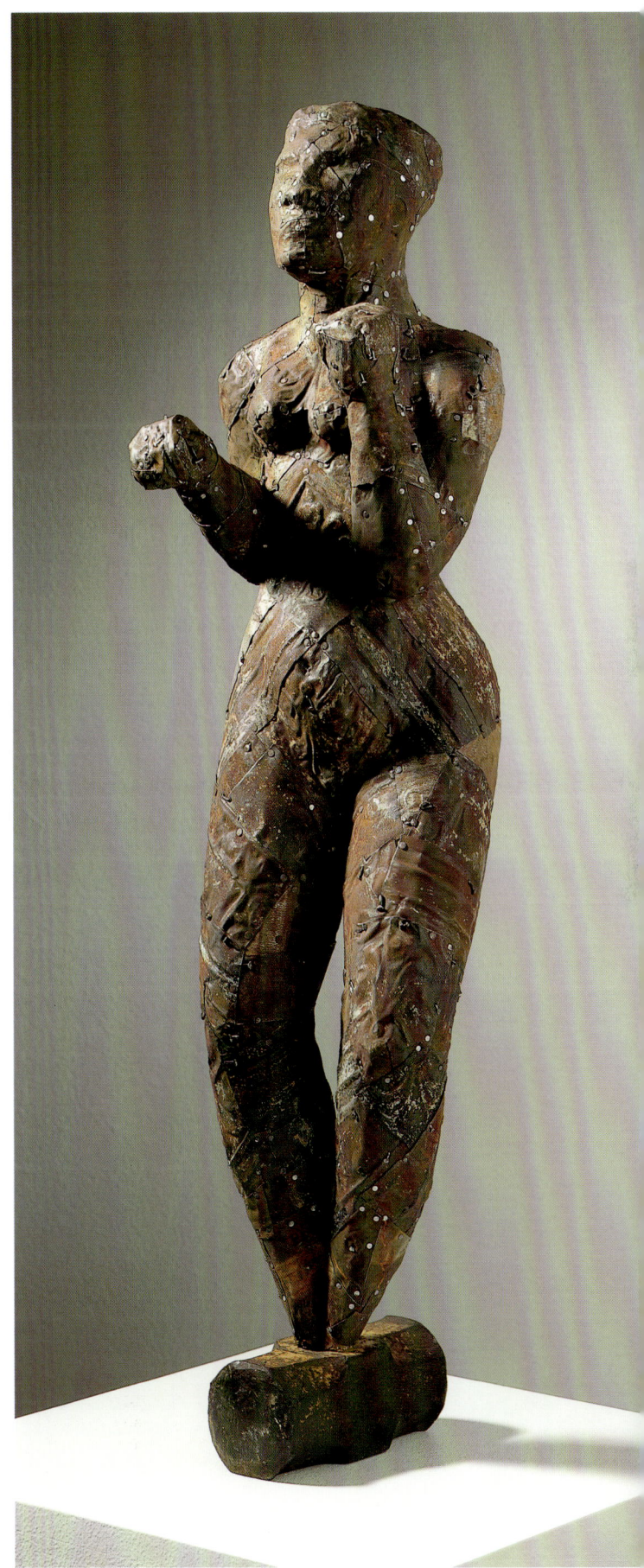

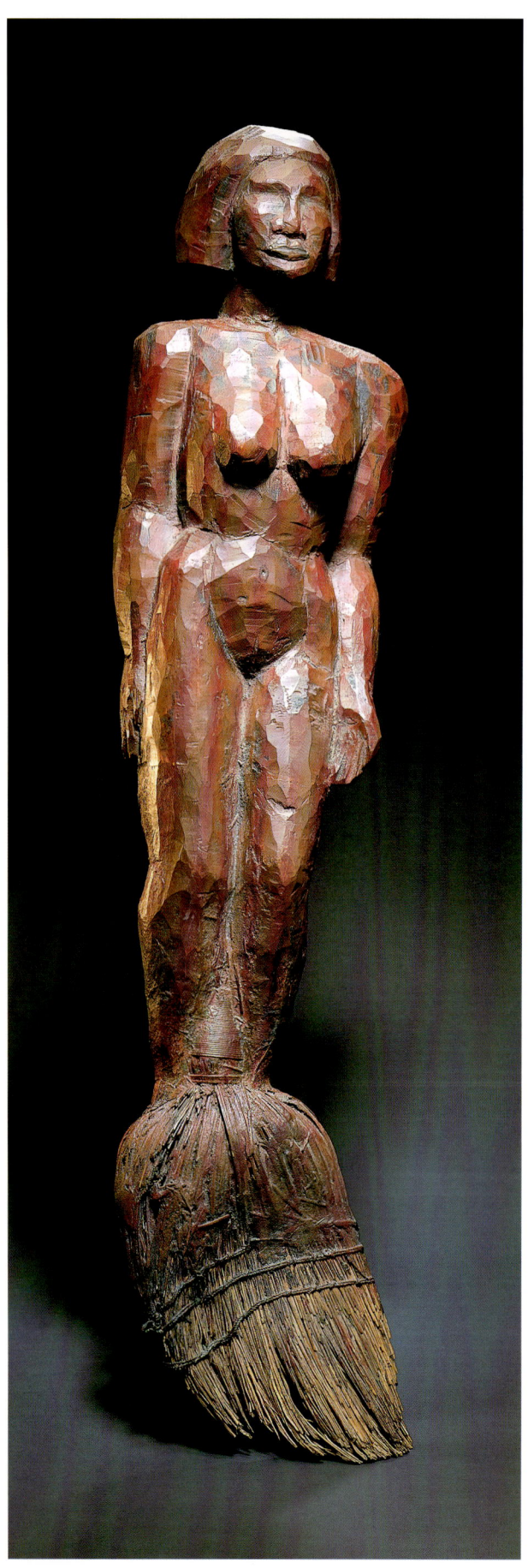

ceremony called "the beating of the anvils," where they sit him on a stool and symbolically beat on his knees with an anvil, which Luba blacksmiths also use as a hammer. The sense is that—like a piece of unformed metal that is forged—the king undergoes a transformation and becomes something greater. He is transformed from an ordinary mortal into a superhuman being (fig. 51).

AS: It's also about fortification, and the process of forging metal makes it stronger. I think that's so beautiful.

MNR: It is, it really is, so that's a nice parallel to your piece. What originally gave you the idea to do these works that merge the female form with tools?

AS: A fly whisk was really the instigator of all these pieces. It's a play on matriarchies and patriarchies, taking off from this functional thing that represented kings and chiefs and this very aloof sort of attitude. Whereas the female figure that is this broom [*Clean Sweep*] is very much subservient and domestic, and having the same sort of power within the family but never being recognized as that power (fig. 50). There's a crisis and something critical within the family, then the woman comes in and sweeps all the dirt, and whether it's Band-Aids on the knee or talking a distraught husband out of a tree, you know, it's about being the psychic strength within the family and being able to pull all these things back to ground and clean up the mess. I also like the idea—I don't know if it's true in African culture per se, but it's true in New Orleans and voodoo—about using the broom to clean out bad spirits. By cleaning the house you're ridding yourself of that sort of thing, and you have the power to sweep all that stuff away, a sort of purification power. That and the way she's displayed—just sort of sitting in the corner of the room, she just leans in the corner of the room, like a broom would—so, it's about this power of sweeping and doing all these things, these grand gestures, which are never recognized, and you're really just seen as this tool to do these things and never recognized as the power to mend and heal; so it's also about being a healer.

MNR: You know, this is so amazing because in Luba divination, sweeping is critical. Both men and women can be diviners, and they say that in the past more women were diviners because it comes to them more easily, more readily. These days more men are diviners, but women are the ones who call the spirits and who sing religious songs throughout the divination session to make sure the spirit stays

there while the consultation is happening. The way they call the spirit is either through singing or through percussion. And one of the ways that you can create a percussive sound that will attract the spirits is by sweeping.

AS: Oh wow. Woooooh, that's nice. See, this is why I like these things; they give me shiver shakes.

MNR: It's amazing. I have a photograph of a Luba woman who is sweeping the sand in front of the doorway of a house where her husband is on the inside entering into trance. So, they're singing the "songs for twins" [religious songs that venerate the twinned spirits of Luba kingship], and she's sweeping and sweeping, and the repetitive percussive sound of the rhythm of the broom is bringing the spirits into the realm of the house.

AS: Wow, that's cool. That's really interesting. Too bad we can't get [my piece] *Compton Nocturne* because the video that goes with it has sweeping on it. It's footage of me sweeping barefoot, but you can only see the broom. It's really contrasty, grainy, it looks like old film.

MNR: And I love the play of thinking that this is about the hard work, the submissive dimension, and yet it has this complete other side of sweeping out the spirits. You know that within that work—of resolving crises and coming to the rescue and fixing all the problems and cleaning up all the mess—there's this other side that transcends, that goes beyond…

AS: Right, that there's a spiritual half to it, or talking about something beyond it…

MNR: Exactly, and there's always that play that I see in your work over and over: there's a part that draws you in, and then you see another side; and it can work in either direction. It can seduce you and entice you and then show you something gory or something difficult or something hard; or it can draw you in thinking that it's about submission and degradation, and then it takes you beyond it…

AS: Somewhere beyond it. Yes, right. It's all about these appearances and dualities, which is part of what really got me interested in African art. That's what really got me interested. It was fascinating going to school and hearing these scholars come out and say "this is what it is" and put it in a strong little box, and yet what's wonderful is that it's constantly evolving and constantly changing and can never be pinned down, because it means so many things simultaneously, which I think is what is so

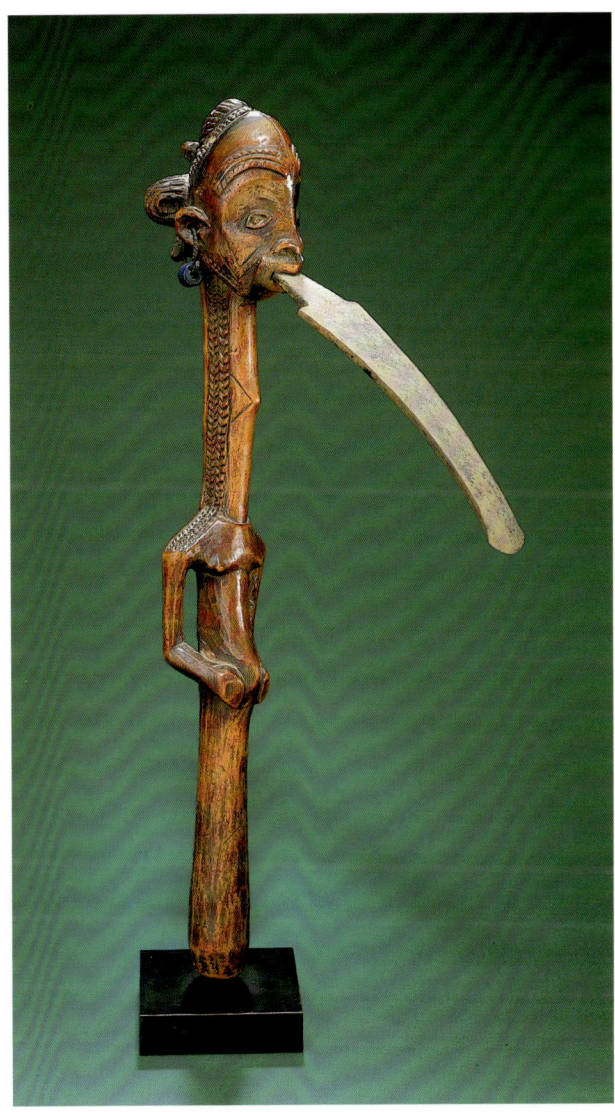

50 OPPOSITE

ALISON SAAR,
***CLEAN SWEEP*, 1997**
Wood, paint, tar
H: 82 cm
John Hughes, Rhythm and Hues

51 ABOVE

ADZE
Luluwa, Democratic Republic of the Congo
Wood, metal, beads
H: 43 cm
Joseph and Barbara Goldenberg

An adze with a blade emerging from the mouth is a common leadership emblem among Luba and other central African peoples. This one has stylistic attributes and scarifications associated with Luluwa, former Luba peoples who migrated west several centuries ago to form new communities in the Kasai region.

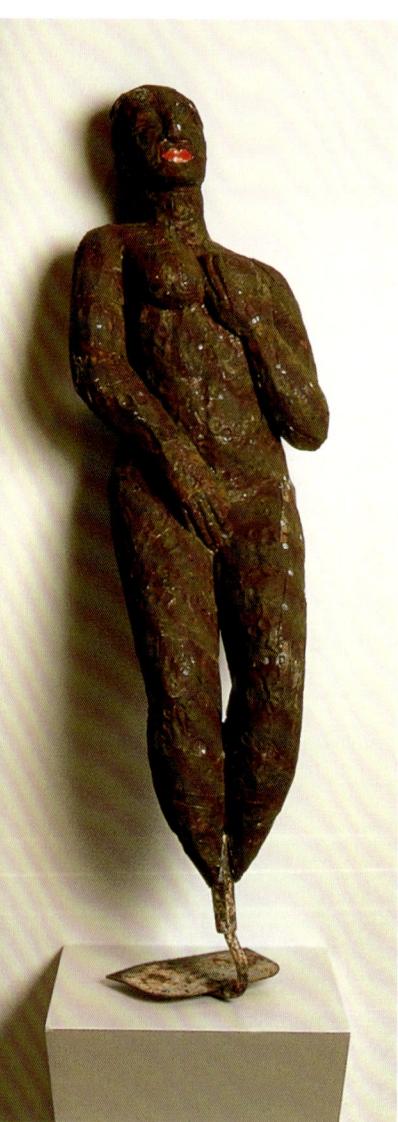

52 LEFT

ALISON SAAR, *HO,* **1995**
Wood, plaster, ceiling tin
H: 86.4 cm
Collection of Robert A. Roth

53 RIGHT

ALISON SAAR,
PITCH, **1995**
Wood, tin roofing, iron
H: 116.8 cm
Collection of Philip Messinger

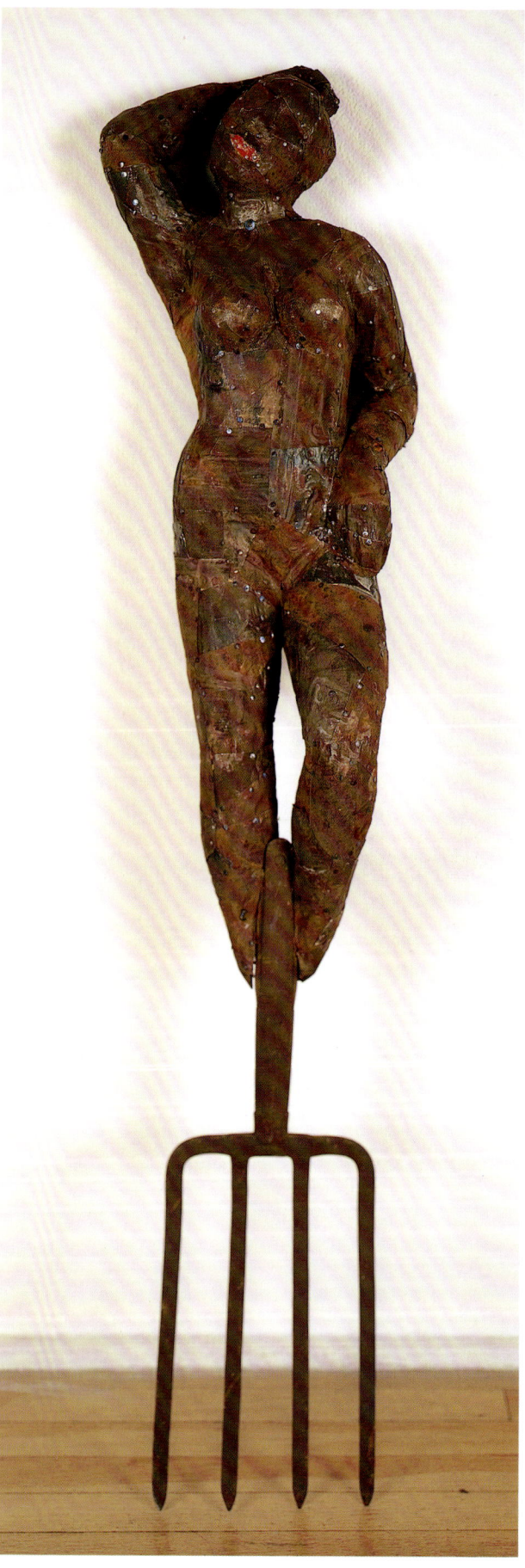

wonderfully rich about art in general, but specifically African art. So, I find that really inspiring.

This piece is *Ho* (fig. 52), and the title of that show was *Strange Fruit,* and again it was about these stereotypical perceptions of women, whether they're turning into a broom or what, but *Ho* is a play on *whore,* and specifically women of color, and these sexually promiscuous ideas of women of color and women of labor; and then it also plays back into slavery and hoeing. I hadn't even thought of it as a tool for turning over and breaking ground until now. Sometimes I get really bored talking about my work when I do lectures, but the meanings for these pieces change for me constantly in terms of how I'm currently feeling about being a mother and a wife and all those things, it has a real power for me.

MNR: Well, on that score, to what extent would you say that your work is autobiographical? Because at

46

54 RIGHT

BOW STAND

Luba, Democratic Republic of the Congo

Wood

H: 64 cm

Private Collection

A bow stand is literally a rest for holding bows and arrows, yet its true purpose is to contain spiritual essence. While most have three branches, this virtuoso example has only two. Bow stands refer to the original culture hero, Mbidi Kiluwe, who brought kingship to the Luba and was a masterful hunter.

55 FAR RIGHT

BOW STAND

Luba, Democratic Republic of the Congo

Wood

H: 82.5 cm.

FMCH X65.7489; Gift of the Wellcome Trust.

Bow stands are among the most potent symbols of Luba royal culture. Although they are beautifully carved and emphasize the female form, bow stands were almost never seen by human eyes. They were kept in a sacred shrine house or next to the ruler's bed and were viewed only by privileged officials.

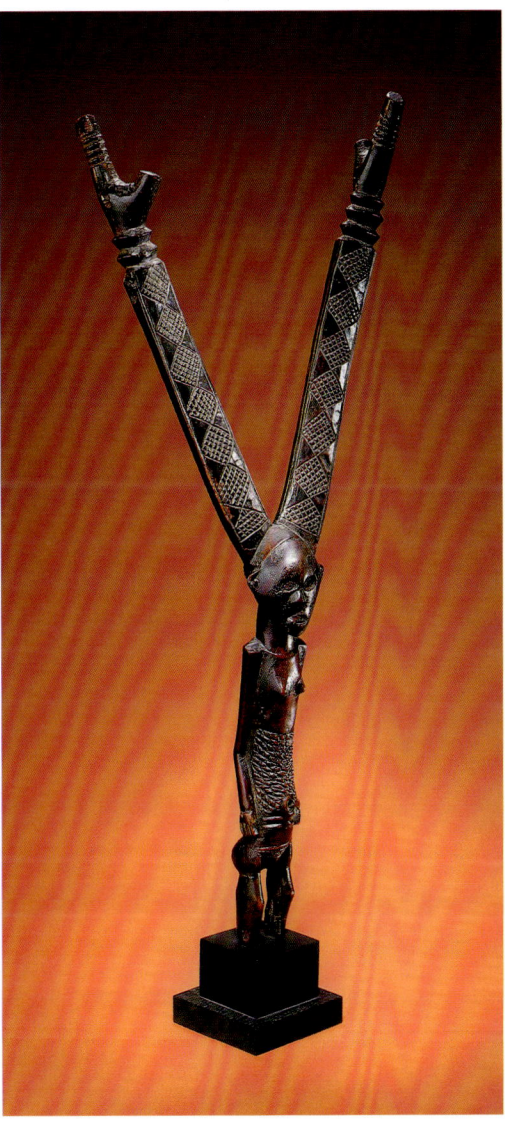
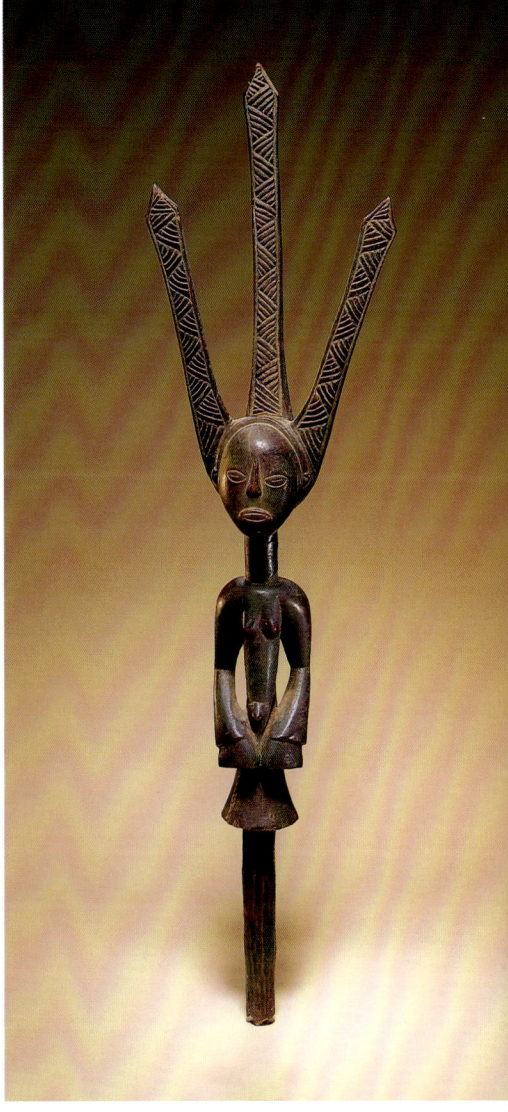

one point you told me that you primarily made male figures in the past and that now your work has moved more and more toward female images, almost to the exclusion of the others. Is that right?

AS: Yes.

MNR: And then I think you also said that it has to do with the fact that your work is becoming more autobiographical.

AS: Well, no, I see all of the work as autobiographical, male and female, and I once said—and this highly offended a group of college students at NYU—that I saw the male figures as very much about the cerebral half of my life and the female figures as very much about the emotional and the physical aspects of my life, and that I think that because I am now a mother and more of my life really circles around being female—because 90% of my time is dealing with that sort of stuff—that maybe that's why those figures are becoming more prominent. But I guess this last year I did that bell piece, *Travelin' Light,* which is a male figure, and it's about emptiness and apathy, and it came from a piece that I had done in 1980 and '81, but again it's about very psychological aspects of my life that are divorced from the body, that don't have any real sort of specific tie with the body, so that's sort of how the split is…

Ho and *Pitch* (fig. 53) were put together in terms of viewing women of color as being sexual and whores and pitching for johns, and—it's sort of a jump aside, but it's a response to Black women and women of color being suddenly fashionable and about this sort of adoration of exotica, and that because they're Latin hot lovers or they're Sapphires, and they're sassy and they're sexy, and you're liable to

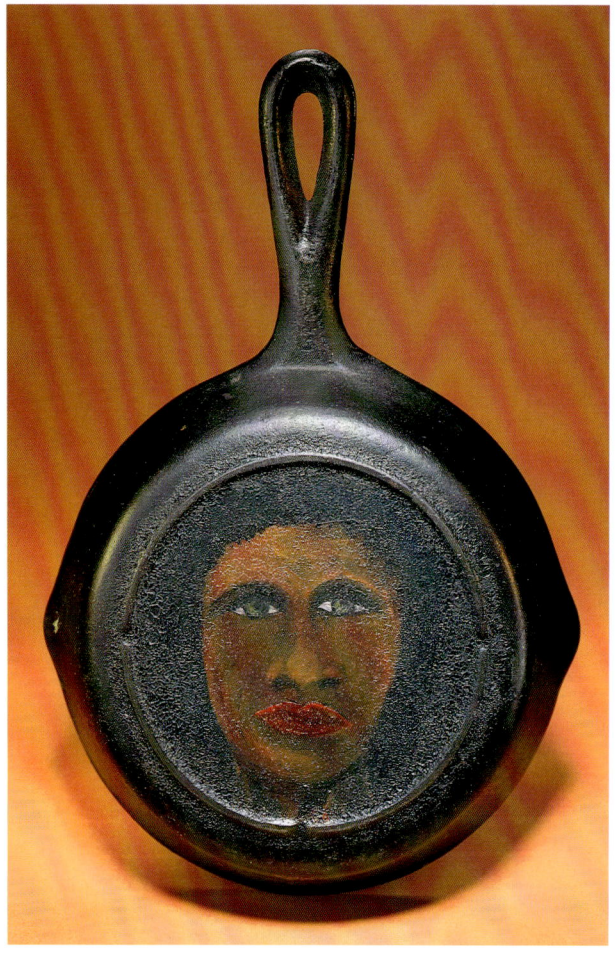 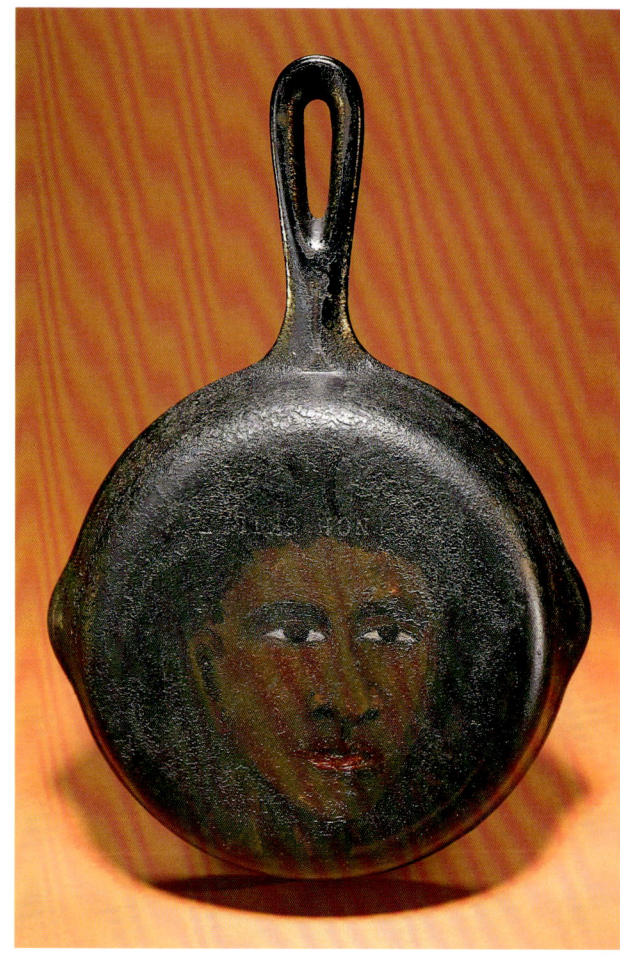

get bit—whatever or however you want to look at it—that this became an attraction, and it became this very sort of imperialistic view of people, of women of color. So, I did these, and then I backtracked again and tried to internalize it and tried to recognize how we respond to that and how maybe we pull back sexually and pull back in terms of the image that we put out of ourselves in response to that. And I think that in my grandmother's generation and my mother's generation, women were constantly trying to pull back and trying to be very prim and proper and dispel that mythology. And I then came in questioning well how does that keep me from fulfilling my own sexual desires? So, that's the long story. So, that's why these are all these very alluring sexual sort of images.

MNR: And what about the connection to the pitchfork here, which resonates so much with the form of the Luba bow stands (figs. 54, 55)?

AS: It's just a pun, "to pitch for a john" is standing on a corner and trying to get someone to come and take your bait, baiting yourself.

MNR: So, now for the skillets (figs. 56–58). You had told me that these are named after actual domestics. Are these people you have known?

AS: They're just paintings I did, and I give them names, and a lot of them are either names of women that I've known or women who were domestics or names of friends of my grandmother's who were domestics or of that era when that was primarily what was available to them. So they're old-fashioned names, or actually some are island names since that was what a lot of the domestics in New York were, from the Caribbean, like Fiona, Hattie, Nesta, and Lyona. They're portraits of this invisible population within your household. These women bathe your children and feed your children and take your children to school and pick your children up and watch them until you get home; sometimes they feed them dinner and tuck them in bed. Sometimes the parents have no interaction with the children whatsoever. But come Sunday, they're invisible. They're never recognized as a person or as a part of the family even though they have more to do with the family than

56 OPPOSITE, LEFT

ALISON SAAR,
SKILLET: "LYONA," 2000

Iron skillet, oil, paint

H: 25.5 cm

Carole Cole and John Ernsdorf

57 OPPOSITE, RIGHT

ALISON SAAR,
SKILLET: "NESTA," 2000

Iron skillet, oil, paint

H: 26.5 cm

Carole Cole and John Ernsdorf

58

ALISON SAAR,
SKILLET: "CHERRY," 1999

Iron skillet, oil, paint

H: 34 cm

Collection of Dr. Richard and Jan Baum

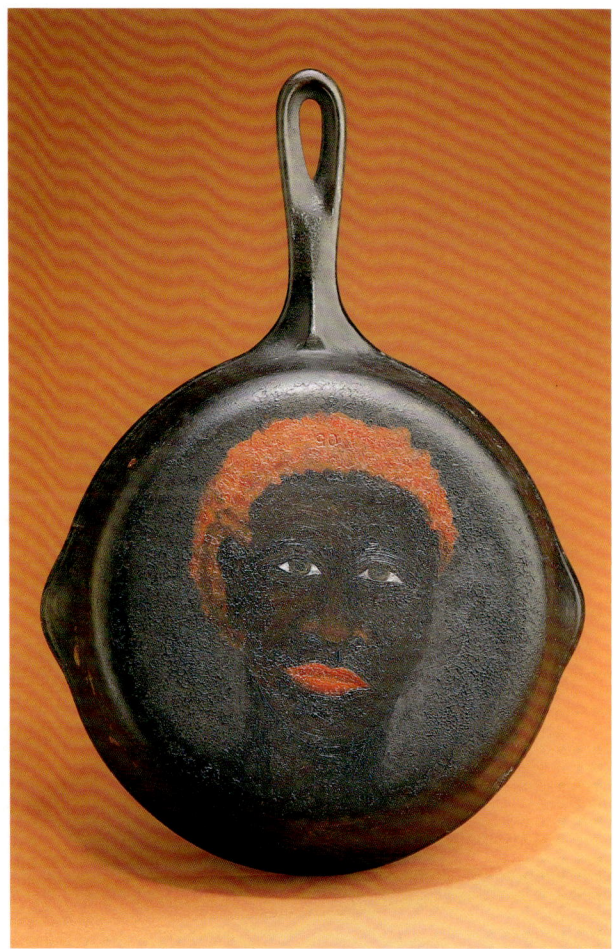

anyone else in the household for the most part—whether it's cooking or housekeeping and being such an integral part of what that home is, and never being seen as a person. So again they're this invisible population, and they're tools for the house, just viewed as being a utilitarian object; they're not really recognized as having a family or a life beyond that. A lot of the ones from the islands have families and last saw their children when they were three years old. It's so painful to me. There was this one story where a woman lived with a family, and I guess she would have one day off a week and go to church and hang out with her friends. But she cared for these kids since they were infants, and one day, the younger one used to come climb into her bed at night and sleep with her instead of going to the parents, who of course couldn't be bothered or anything, and when the parents found out they were livid, like it was something dirty, that it was this strange trespassing. There was a personal love and connection between them that the parents couldn't recognize, and when the boy got older he was very derogatory toward her, calling her "nigger," and it was so painful because this woman was their mother all this time. And the parents could relinquish all of those duties and at the same time they're constantly feeding these racist ideas to their kids so that when they became a certain age, they could just completely turn off any affection or connection they had with these people who cared for them so long. So it's really intriguing to me, and so that's what these pieces are—the sort of glorification, that they're still invisible but to give them some visibility, this kind of dark on dark…

MNR: And the whole sense of them emerging from the soot, the charred underside of the part of the skillet that hits the flame, that's hidden and face down most of the time. Also, isn't there a connection to the hand mirror?

AS: Yes, it's also like a hand mirror, and you see your reflection, and being black and the term "skillet black" or calling the skillet black, and you see yourself reflected in the grease and grime…

MNR: Those are very powerful.

AS: There are more on the way.

The Anatomy of Dreams

Spirits became incarnated in the bodies of women. Their role was to applaud and adulate the king when he spoke. It was from two women who found Mbidi Kiluwe at the source that kingship came.

Banze Mukangala
(a Luba male office holder)

I always see [the turned head] as being either in reverie or in limbo, trancelike between two worlds…that you're not here but haven't trespassed into the other thing.

Alison Saar

MNR: I like having this section follow on the tool section, because after we've discussed why women "work" and what it is through the aesthetic fashioning of a woman's body as sculpture that makes her apt as a spirit medium, then this section really gets into very specific objects that deal with spirit mediumship, divination, healing, and dreams (figs. 59, 60). I think sometimes in the show there will be a really nice visual connection between Luba works and yours, and other times there won't be, but there's a thematic connection, and this is one of these cases where the connection is more conceptual. These bowl figures are one of the object types that you see in Luba divination, and they show the gourds used for sorting out problems (figs. 61, 62). The gourds are called "a little world," and they contain bits and pieces of all the potential problems that a person could ever have, contained within the space of this tiny gourd or basket. A diviner agitates the gourd and reads the way the objects fall next to one another in order to be able to solve problems. Whether you're male or female, when you go into a state of trance, you may leave your own gender—you might stay the same or you might be different. Often the gourds that the diviners hold bear the same patterns around the rim

59 ABOVE

ALISON SAAR,
***PARADISE BOUND,* 1997**
Wood, paint, tar, synthetic hair
L: 76.2 cm
Phyllis Kind Gallery, New York

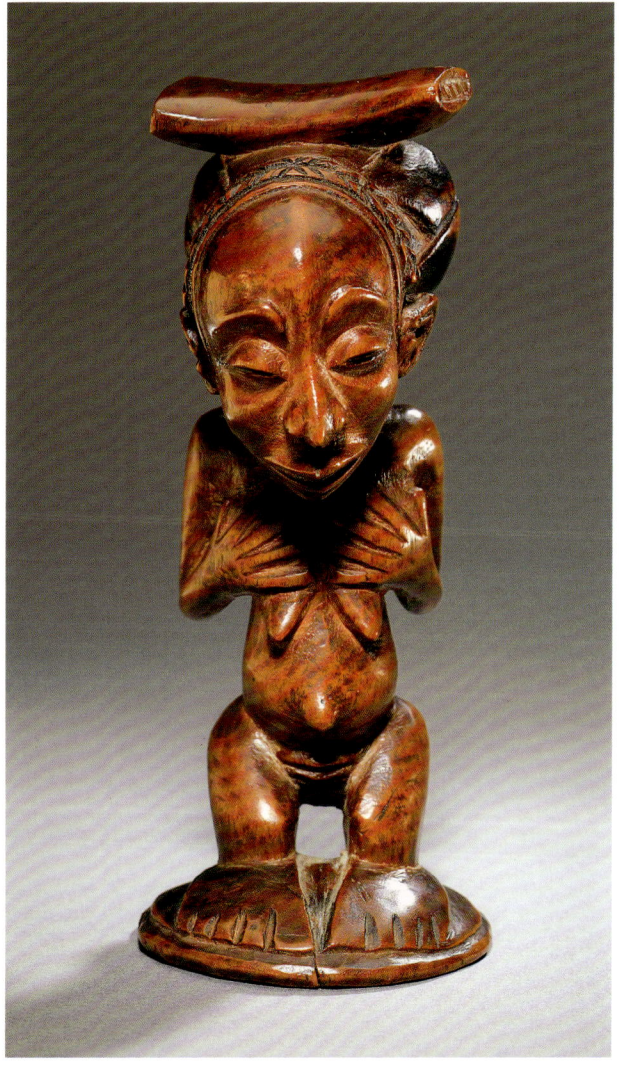

60 OPPOSITE, BELOW

HEADREST

Luba, Democratic Republic of the Congo

Wood

H: 19 cm

Private Collection

This headrest was carved by a highly accomplished Luba sculptor known as the Buli Master, or the Master of Kateba, in reference to the towns where he is thought to have lived and worked in the early to mid-nineteenth century. The notion of scale is transformed as this otherwise miniature work of art assumes a conceptual grandeur through its sculptural strength and its emotional sensitivity.

61 BELOW, LEFT

BOWL FIGURE

Luba, Democratic Republic of the Congo

Wood

H: 46.5 cm

Dr. and Mrs Ernest Fantel

Luba diviners use bowl figures during consultations with the spirit world. The figure is said to depict the wife of the spirit who possesses the diviner or that of the first Luba diviner, Mijibu'a Kalenga. This figure was made by the same hand as figure 62.

62 BELOW, RIGHT

BOWL FIGURE

Luba, Democratic Republic of the Congo

Wood

H: 53 cm

Ex-collection Maurice Matton, former Belgian Congo police commissioner, collected prior to 1930

Joseph and Barbara Goldenberg

A series of bowl figures was produced in the Kamina area in the early twentieth century by a master sculptor referred to as Kitwa. A photograph exists of Kitwa carving a bowl figure identical to this one (see Roberts and Roberts 1996, 198, fig. 192). The bowl figures were used to communicate with the otherworld.

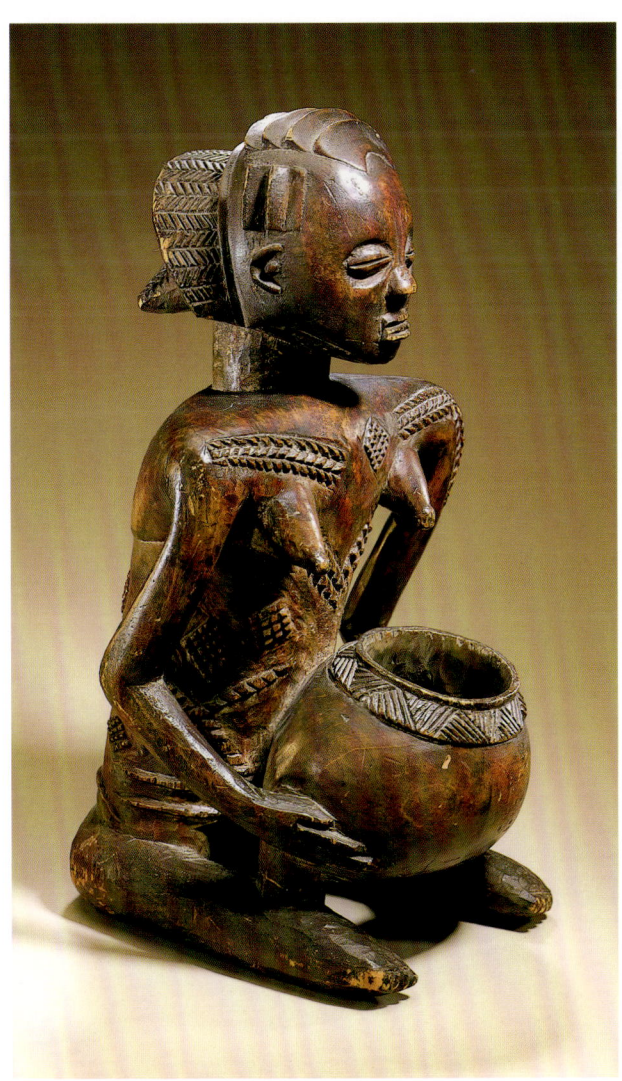

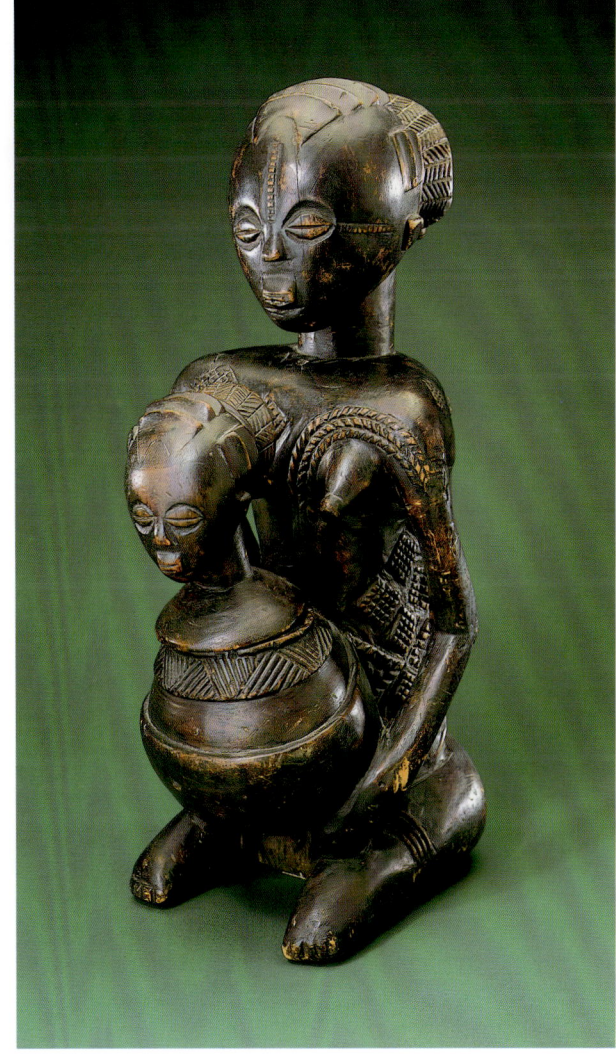

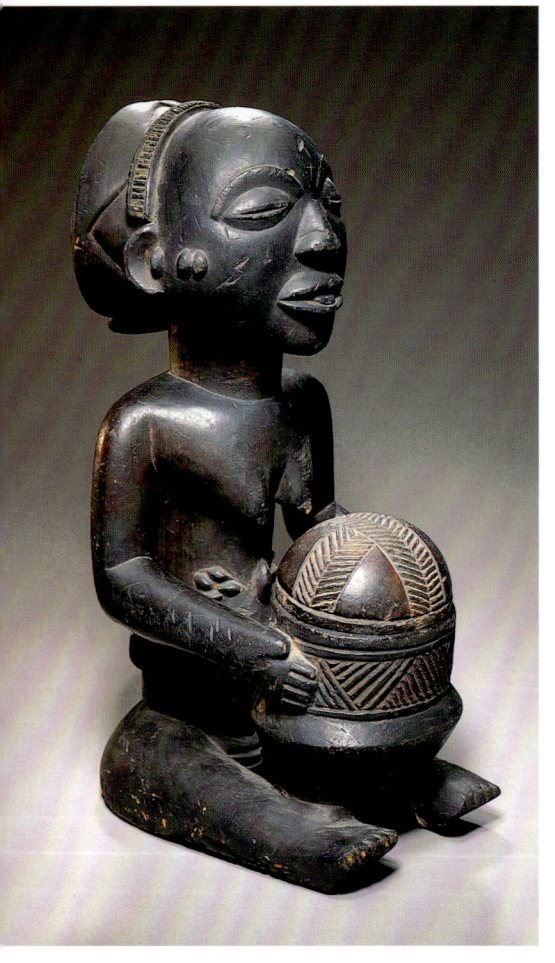
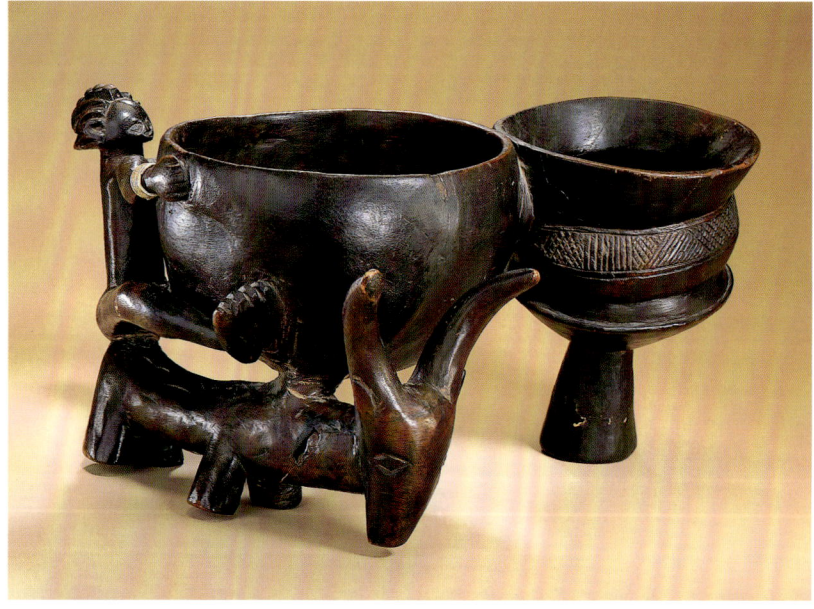

as shown in the sculpted bowl figures (figs. 63, 64). These are scarifications. When you talk to diviners today about these bowl figures and what they represent, some say that it's the "wife of the possessing spirit." Because when they go into trance, it's not only their own wife who calls the spirit but the wife of their spirit has to be there, too. So, there always has to be this dualism.

AS: And do they say why? I mean is it girl talk or something?

MNR: Again, it's because the woman is what contains the spirit, so her presence is absolutely critical. Now this is another kind of divination called *kashekesheke* that's not as dramatic looking, but it's very moving.

AS: Is it like Ouija?

MNR: It is, it's a lot like that. It's a little sculpture that responds to the diviner's questions (figs. 65–67). In one case I know of, a female diviner interceded for a male client who had lost eight children in a row. So, these are not minor issues that they come here for. She got her profession through a dream.

63 ABOVE, LEFT

BOWL FIGURE
Luba, Democratic Republic of the Congo
Wood
H: 42.2 cm
FMCH X65.9117a,b;
Gift of the Wellcome Trust

Luba bowl figures have scarified patterns around the rims of their bowls, which once contained chalk, a symbol of beneficence and spiritual blessing. Chalk is applied to the skin by diviners when they enter a trance, by titleholders when they pay respects to the king, and by all individuals who undergo ritual states of transformation, such as initiation and investiture.

64 ABOVE, RIGHT

BOWL FIGURE WITH ANIMAL
Luba, Democratic Republic of the Congo
Wood, metal
W: 37 cm
Joseph and Barbara Goldenberg

This bowl figure is one of several by an innovative artist who experimented with the genre to produce daring and exciting results. Here, he has merged the bowl figure with an animal, possibly an antelope, in reference to Mbidi Kiluwe, the culture bearer and master hunter who married a Luba woman to produce the first legitimate Luba king.

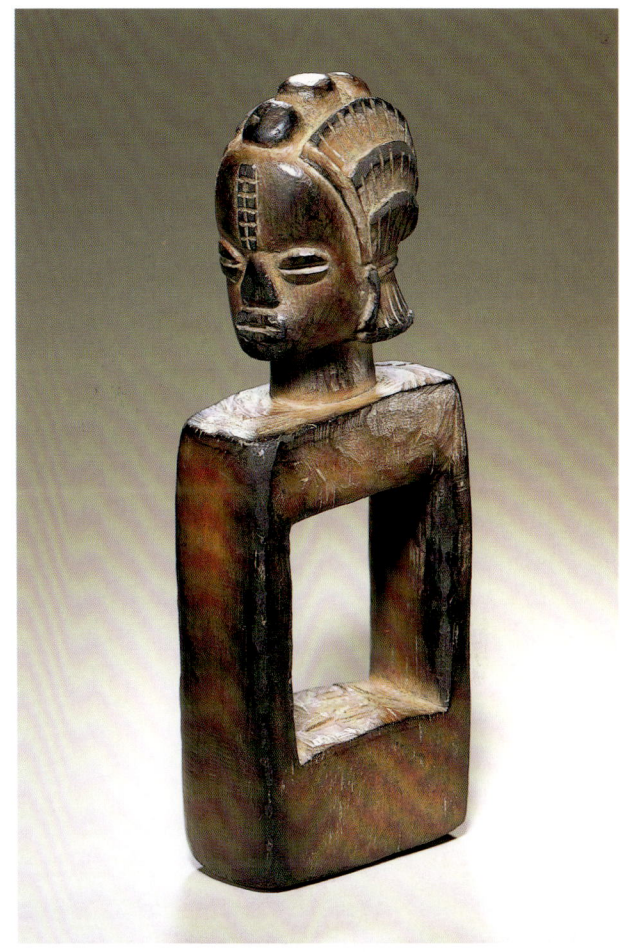

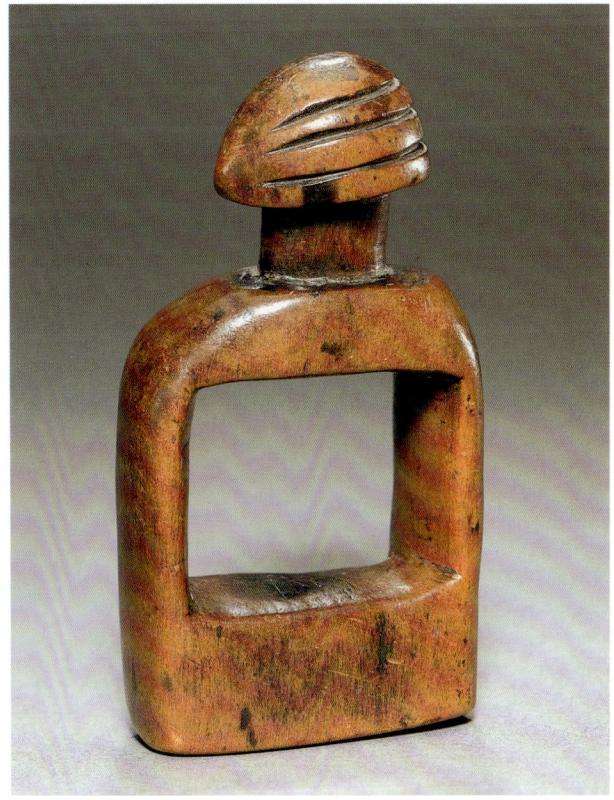

65 ABOVE, LEFT

DIVINING INSTRUMENT (*KASHEKESHEKE*)

Luba, Democratic Republic of the Congo

Wood, beads

H: 16.5 cm

FMCH X92.140;
Gift of Mrs. Shirley Black

Kasheksheke is a small wooden instrument held by a diviner and a client to determine the cause of illness, death, or other misfortune. Women are considered especially apt for *kashekesheke* divination and may receive a calling to join the profession. The wooden figures always depict women, in recognition of their greater facility for spiritual communion.

66 ABOVE, RIGHT

DIVINING INSTRUMENT (*KASHEKESHEKE*)

Luba, Democratic Republic of the Congo

Wood

H: 14.3 cm

FMCH X66.955;
Gift of Daniel Biebuyck

67 RIGHT

DIVINING INSTRUMENT (*KASHEKESHEKE*)

Luba, Democratic Republic of the Congo

Wood

H: 9.5 cm

Collection of Dr. Richard and Jan Baum

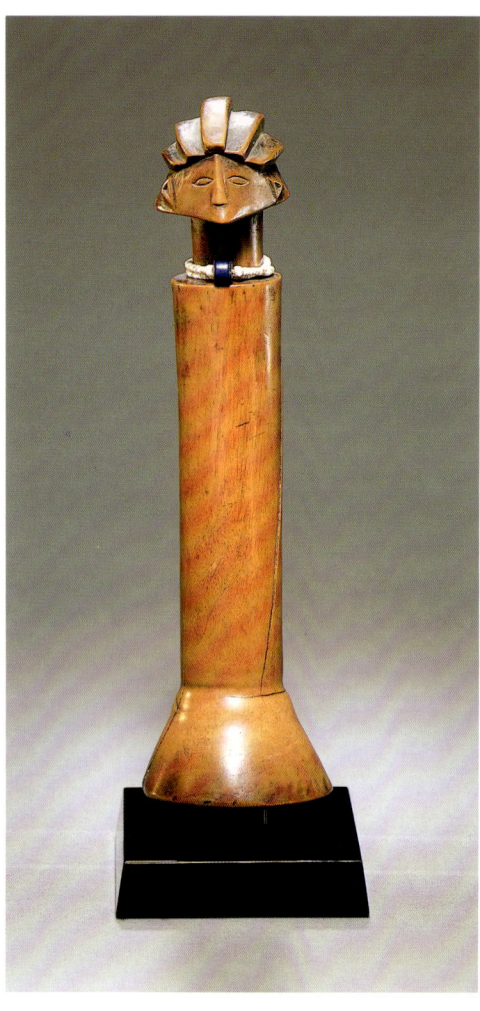

68

DIVINATION PESTLE
Luba, Democratic Republic of the Congo
Wood, beads
H: 24 cm
Felix Collection

Adorning this divinatory instrument is a female figure remarkable for her finely chiseled face and coiffure. This pestle was used as an intermediary to channel information provided by the *bavidye* (the spirits of Luba kingship).

It came to her in a dream, that she was supposed to take this profession on. And women can do this without any external input. They don't need…

AS: An apprenticeship…

MNR: Nothing. They can just become a diviner. A man has to have all these medicines inserted into his skin and go through all this training, so it's a much more direct relationship to the woman. And that's the object that they use, which is always fashioned as a female figure.

AS: Are they always so abstract (fig. 67)?

MNR: No, sometimes they show a more realistic female head. But this one abstracts that cascade hairstyle, and they're often really worn down on the bottom because the object moves in response to the diviner's questions…

AS: So she's asking questions…

MNR: She's asking questions…

AS: So, it's just like a Ouija.

MNR: Exactly.

AS: And they both hold it…

MNR: They both hold it.

AS: How cool.

MNR: And there's a saying, "There is not one liar alone in the *kashekesheke* divination, because you are holding it and so am I." So, in other words, you can't cheat because the other one would know it, they would feel it…

AS: It would move both your hands, it's not pulling one way or the other.

MNR: It can only be the spirit that moves it…. I absolutely adore these two objects of yours and wanted them in this section because when I was with you the first time, you said that a lot of the time when you make figures with turned heads it's a reference to in-between states or dreams.

AS: Right, sleeping or trancelike…

MNR: So, tell us more about them.

AS: My only thought is that *Muddy Water* (fig. 70) and *Bain Froid* (see fig. 2) are kind of redundant.

MNR: They are similar. Only *Bain Froid* doesn't have the turned head.

AS: It's a different positioning, but the idea is the same.

MNR: But given that there are multiple Luba stools, it's interesting that you also do these multiples— even though each one is different—that there are recurring themes in your work.

AS: *Delta Blues* though is perfect for this. It relates again to the hair thing. That's her hair that's twined around her (fig. 69).

MNR: I always think it's a snake, but it's her hair…

AS: But it's supposed to be like a snake and Eve-like and that your hair is like a serpent that's drawing you into trouble and pulling you different ways and guiding in different directions. I like this piece because she's kneeling. It's nice to have her because she really responds to all the Luba stools that are on their knees. And it's an interesting sort of positioning. It was just a sort of curious reverie, and you're kind of tied up in all these aspects of yourself. I guess I haven't been enlightened as to what this piece is all about just yet.

MNR: So, what about the turned head?

AS: I always see that as being either in reverie or in limbo, trancelike between two worlds, and I think that dream state is also between two worlds, that you're not here but haven't trespassed into the other thing. And, hmmm, *Delta Blues,* I guess in a weird sort of way also this hair, this snake becomes a river that's wrapping around her as well, and like the serpent in Adam and Eve guiding her; but it also could be a river guiding her, too. It's like she's twined up and caught up in this sort of thing, she's in this insulated world of her very own.

MNR: It makes me think of Mami Wata.

AS: It wasn't conscious when I made it, but now that I look at it, it does involve that in a weird sort of way.

MNR: And *Muddy Water* is a similar play on the kinds of themes that *Bain Froid* is about?

AS: Yes, it's about drawing your water from a well, washing yourself and trying to clean yourself and cleanse yourself in an impoverished situation where

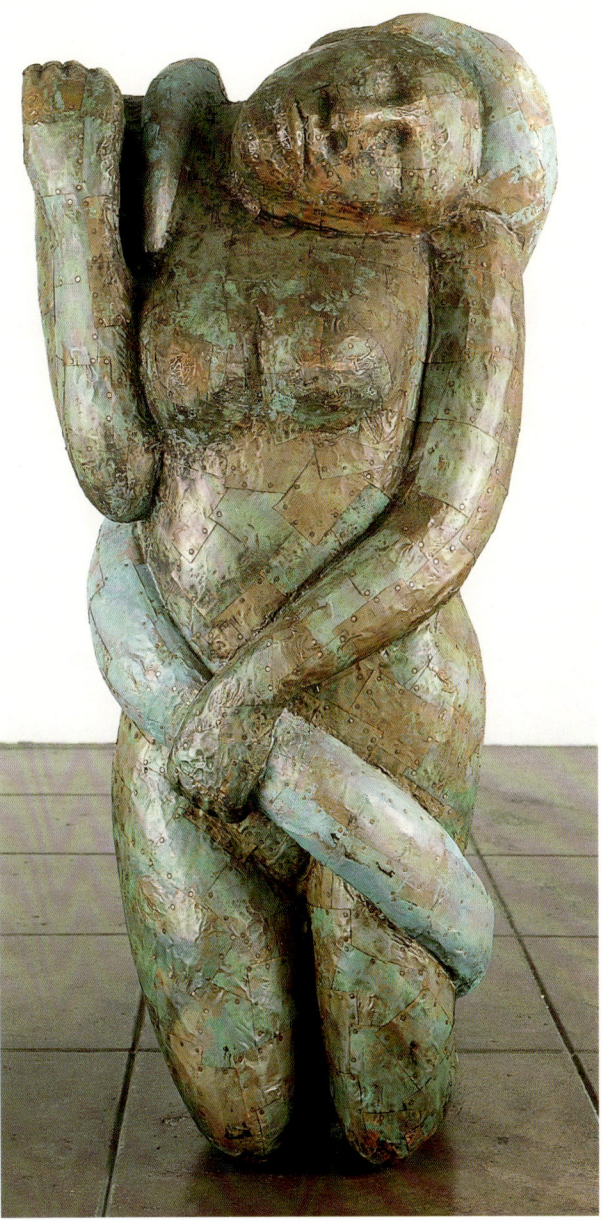

69

ALISON SAAR,
DELTA BLUES, 1998
Wood, copper, tar
H: 96.5 cm
Paul J. Sheehan and Associates

70

ALISON SAAR,
MUDDY WATER, 1998
Wood, copper, mixed media
H: 108 cm
Iona Benson

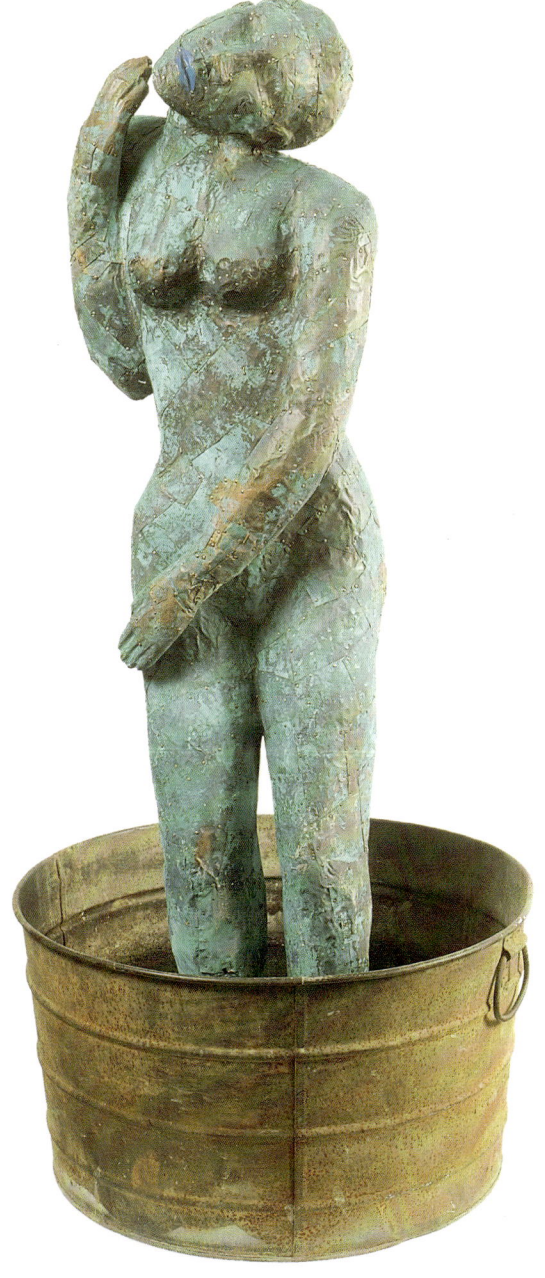

you can never really wash that away and you're always kind of part of that; but at the same time, it's also a kind of communication, or a communion, with that soil, not that it's all completely negative. It's just about washing the dirt away, and I think the water on it is dirty. I think there is tar and dirt on there, so it's like dirty water. And *Bain Froid* is a made-up wash pan, but this one is actually a real wash basin.

MNR: Her color is really interesting.

AS: Again, that blue of cold water; it's not heated plumbing or clean plumbing. The lips are a different metal, it's a different tone blue. I think it feels more like the cold. It's about her being cold as opposed to it just being the color of the copper.

MNR: In Luba spirit mediumship, not only are women the mediums but often two women are the mediums. And even today, there are a lot of sacred spots around the Luba region, like hot springs or grottos or at the foot of mountains, where two elderly women will live like priestesses. And the reason for this is that the spirits of Luba kingship are twins; there are eight pairs of male/female twin spirits, but the real humans that represent them are always two women. These are two examples of Luba objects that are supported by paired female figures, a headrest and a stool (figs. 71, 72).

AS: But they don't do twin figures?

MNR: They do, actually, they do make twin figures, because twin births are considered to be dangerous and powerful at the same time. But these figures are more specifically related to the twin spirits, as opposed to twin children. And you do a lot of that, too, pairing female forms. You have these two, *Dark Roots* and *Sole Sister.* I like this one because I like the alter-ego idea…

AS: Well, you know, this [*Sole Sister*] is specifically about looking White and having Black ancestry, and having this sort of hidden self, this hidden twin to yourself (fig. 73). But it's also like a dual world, they're conjoined twins, but they're not conjoined twins; it's like a reflection, it's like a spirit reflection, too. The shadow is your spirit, and the spirit is your true identity, so your shadow is who you really are. So it's nice in terms of divination and being mounted by a spirit, because it's kind of like they're walking on each other's feet, they're riding each other…

The other one, it's called *Dark Roots,* and it's about being light skinned and being entangled in this African or African American history and having

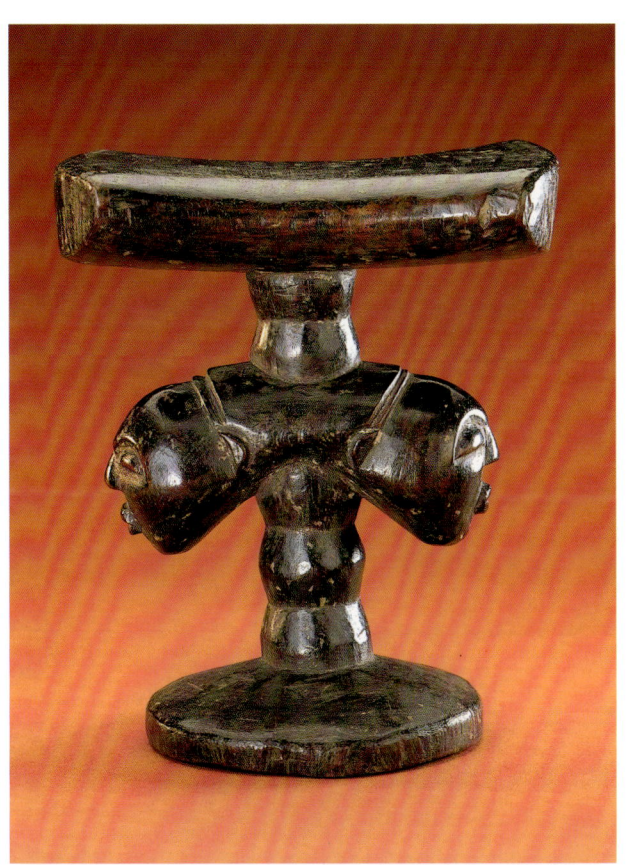

71 LEFT

HEADREST

Luba, Democratic Republic of the Congo

Wood

H: 17.4 cm

FMCH X89.781; The Jerome L. Joss Collection

This headrest depicts janus female figures that recall the most important Luba spirits, Mpanga and Banze. "When a new chief is invested, he must pass another initiation of Mpanga and Banze at Kalui. Mpanga and Banze were two sisters of the king who were invested with the powers of a king," according to Banze Mukangala.

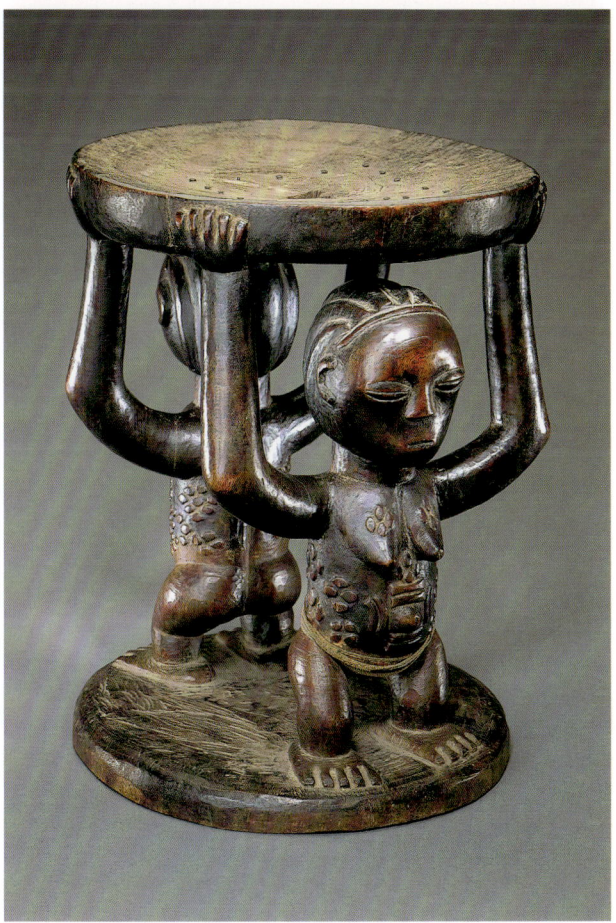

72 LEFT

STOOL SUPPORTED BY TWO FEMALE FIGURES

Luba, Democratic Republic of the Congo

Wood

H: 37 cm

Jerry Solomon Collection

It is very common to see Luba objects supported or surmounted by double female figures made in honor of spirit mediums who watch over sacred spirit sites.

73 RIGHT

ALISON SAAR, *SOLE SISTER*, 1998

Wood, plaster, paint, copper

H: 213.4 cm

Shelley Silverstein and Robert Quintana

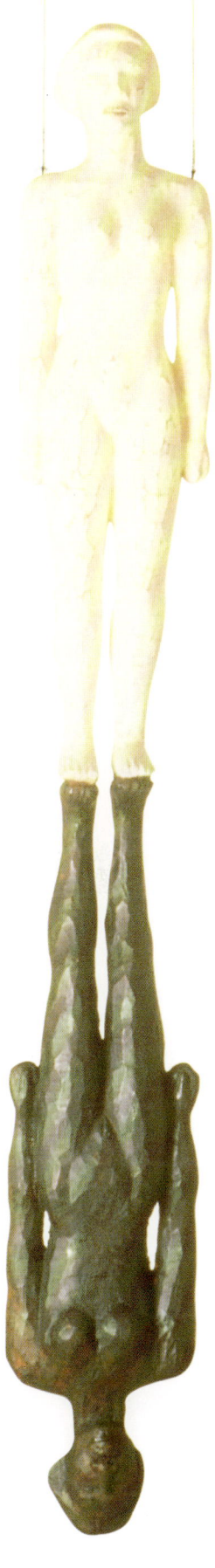

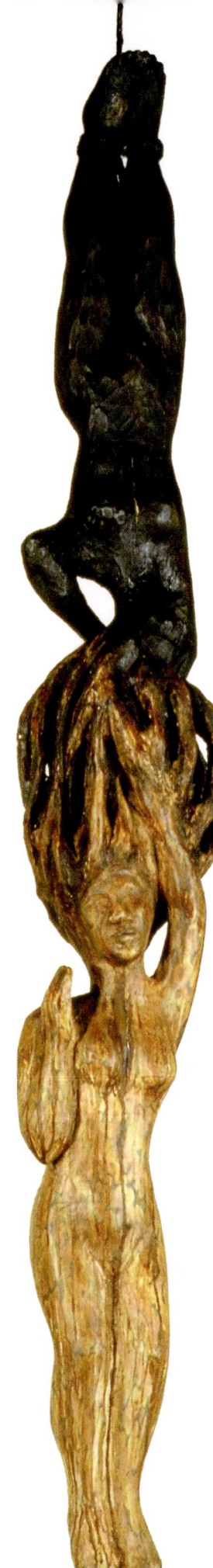

74

ALISON SAAR,
DARK ROOTS, 1999
Wood, plaster, tar, rope, paint
H: 180.3 cm
Courtesy of Phyllis Kind Gallery, New York

a Black history although you may be light skinned (fig. 74). It's basically a White figure that is conjoined with this Black figure that's covered with this tar, and the tar is washing down and running over her and tainting her and coloring her. But it's nice in terms of dreams because it's like they're dreaming each other, so it kind of fits into that section. So, it's a somewhat different idea, but they both fit in, in terms of divination and dreams. So there are a couple of things that hang from the ceiling.

Spirit Vessels

The power comes from women. Even if a man reigns on the throne, one recognizes nevertheless the dignity of the woman as a source of power. It is from her that power emanated.

Banze Mukangala
(a Luba male office holder)

It's like she's serving as a medium....She's vessel-like or possessing someone else's spirit.

Alison Saar

MNR: The conclusion is a kind of mirror image of the introduction. The final two objects bring the idea of a spirit vessel to a culmination (fig. 75). The ultimate message in the Luba story is that beauty—and the spirituality thus implied—is created, and that the preparation of the body and the self as a vessel of supernatural strength is a process of aesthetic self-invention and perfection. Beauty, according to Luba people, is not innate. One is not born beautiful or ugly. Rather, beauty is something that one creates over the course of a lifetime.

AS: Basically, the idea of that piece, she's called *Diva*, is that she's a portrait of the power of the song, specifically in response to Kathleen Battle singing (fig. 76). It's not a portrait of Kathleen Battle, but that ability to just open your mouth and have this power in this music and this beautiful song. It's almost like she's possessed in some ways, and that it's not really like her voice. I remember seeing this program on her, and they were saying, "Oh, it's that the angels are singing through her," so she is like a medium. There's a little bird in her, so it's like she's serving as a medium for this bird voice, this voice that's not hers that's coming out of her mouth. So you get a window, that she's vessel-like or possessing someone else's spirit. It fits into the idea of a spirit vessel. She's bringing this out to other people through her.

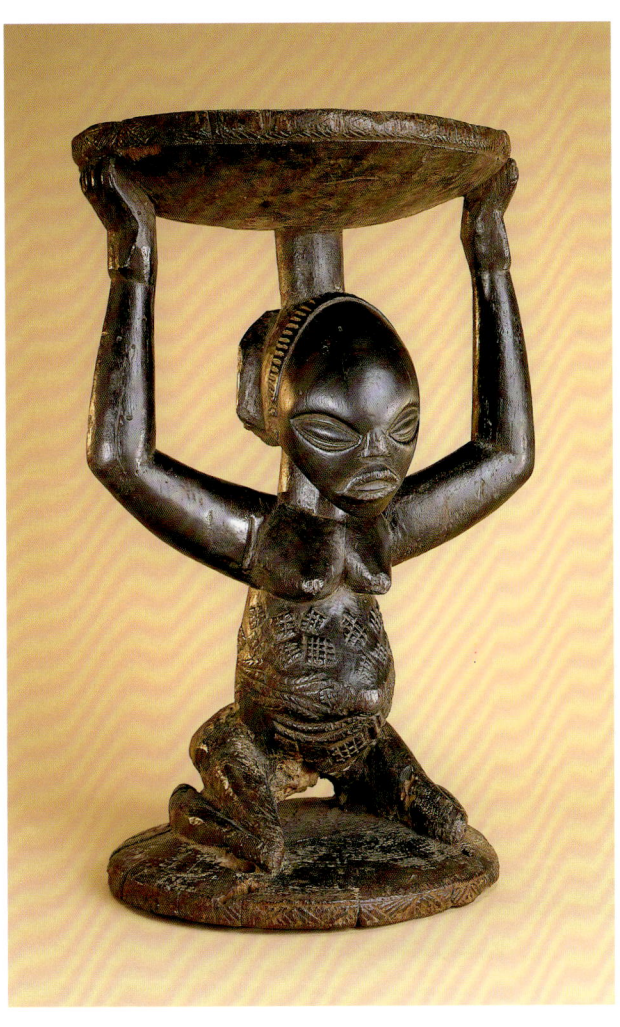

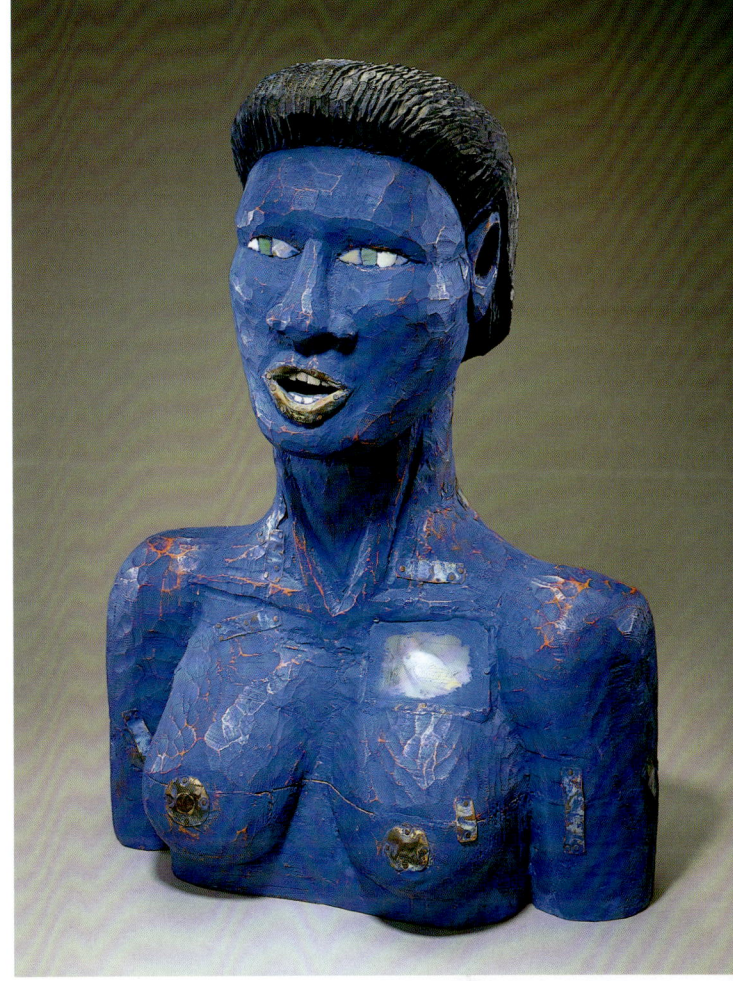

75 ABOVE, LEFT

STOOL

Luba, Democratic Republic of the Congo

Wood

H: 29 cm

Collection of Dr. Richard and Jan Baum

This serene Luba stool enshrines the essence of Luba political authority through its finely rendered female figure with downcast gaze, scarified torso, and four-lobed coiffure. As the most important insignia of a Luba ruler, it imparts the complexities and ambiguities of Luba power, which is perceived to be both male and female, both of this world and the other.

76 ABOVE, RIGHT, AND DETAIL

ALISON SAAR, *DIVA*, 1988

Wood, tin, paint

H: 81.3 cm

Collection of the Hodosh Family

Imaging WOMEN in African Art

Selected Sculptures from Los Angeles Collections

Mary Nooter Roberts

The female forms presented here—from a svelte, almost minimalist, Dogon *togu na* post to a majestic, multicolored dance ensemble from Nigeria—demonstrate that Africa and its arts do not lend themselves to facile classification or generalization. Despite the fact that no single explanation can characterize the female images that abound in African art, outsiders have often categorized them simplistically under such rubrics as "fertility figures" or "ancestor figures." This is not to say that these functions are never served, for some African female sculptures are indeed used to help overcome infertility, and others embody ancestral memory. Nevertheless, each female representation belongs to its own highly complex philosophical legacy, and in this context it has varied roles to play.

The works in *Imaging Women* offer an astonishing range of forms and ideas about womanhood. The corpus does not include contemporary arts or artworks made by women, even though these are inexhaustible areas of artistry in Africa. Instead, the selection criteria are analogous to those used in choosing the Luba figures presented in *Body Politics*. They are sculptures made by male carvers largely for male patrons and primarily during precolonial times. Some of the works have visual themes in common, such as the mother and child; the high-status, seated woman; and the youthful standing woman displaying marks of beauty and identity. Yet, grouping by themes is not as instructive as looking at each object as the bearer of its own compelling stories, which offer a glimpse into a world of practices, perceptions, and aesthetic criteria. It is this individual examination that can illuminate and emancipate narrow understandings of gender in these African cultures.

Gender is culturally constructed, as are the relations between men and women, the concept of beauty, and the extent to which power and authority are aligned with masculinity or femininity. These cultural constructions also change over time. Sometimes there are striking similarities between unrelated cultures, as in the convergence of Yoruba and Luba perceptions of the mystical powers of elderly women and their connection to twinning. Yet, more often, the cultural differences surge into high relief. *Imaging Women* celebrates these differences and the extraordinarily inventive ways that every culture fashions femininity.

A great deal is known about perceptions and representation of women among some African ethnic groups, such as Yoruba of Nigeria and Bénin, Mende of Sierra Leone, and Baule of Côte d'Ivoire. For other peoples, little can be said due to a lack of research. Nevertheless, a few observations emerge from a cross-cultural exploration within Africa: the body communicates knowledge; beauty—like art—is *made*; and female representation is often closely linked to divine attributes and powers. It is hoped that *Imaging Women*'s feast of forms and ideas will give readers a sense of the complexity of gender in African art and will encourage research into the places occupied by women in African societies and the ways in which their roles and responsibilities are represented in art.

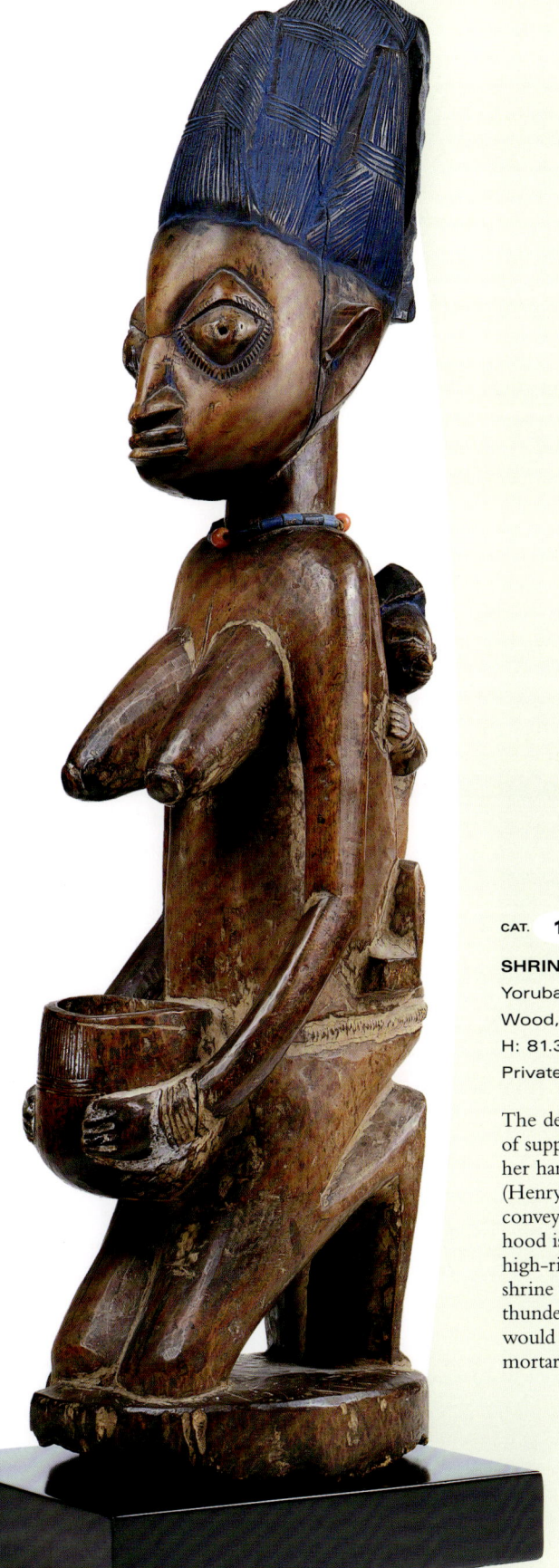

CAT. 1

SHRINE FIGURE
Yoruba, Ogbomosho area, Nigeria
Wood, pigment
H: 81.3 cm
Private Collection

The depiction of a woman in her prime, kneeling in a posture of supplication with a baby on her back and an offering bowl in her hands, is a classical genre sculpture made for Yoruba shrines (Henry Drewal, personal communication, 1997). The posture conveys blessing and thanksgiving, while the state of motherhood is a sign of the social importance of women. This figure's high-rising coiffure suggests that it may once have graced a shrine dedicated to Oya, the favorite wife of Sango, god of thunder and lightning. If the figure was dedicated to Sango, it would have been surrounded by shrine articles, including rattles, mortars, and dance wands.

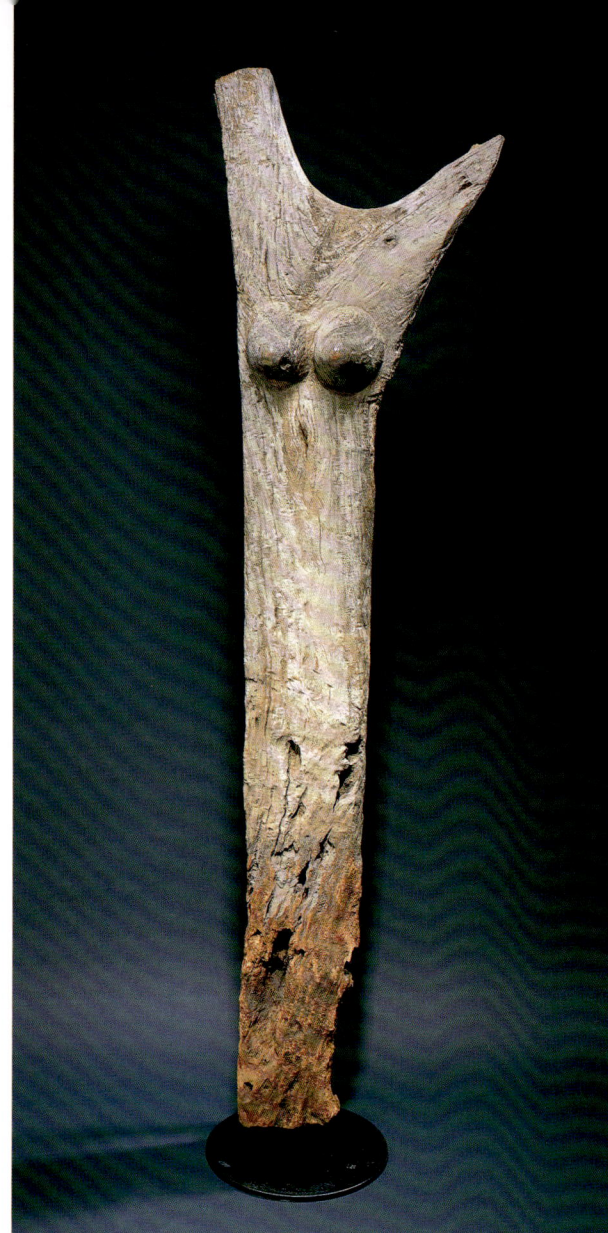

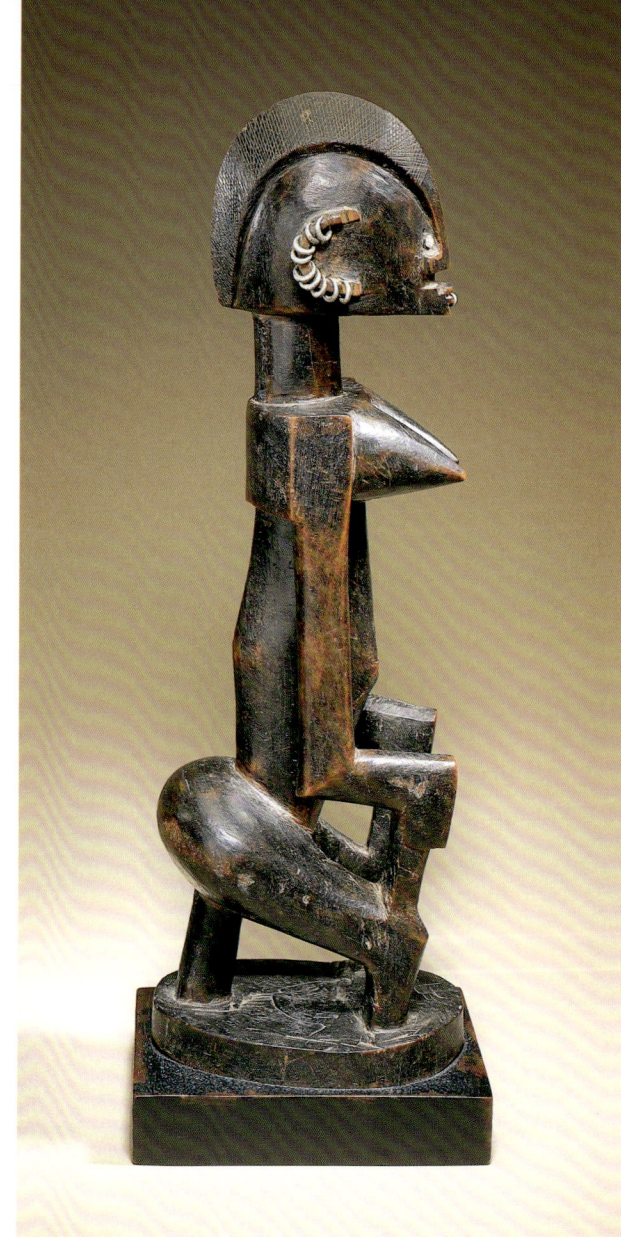

CAT. **2**

SUPPORT POST
Dogon, Mali
Wood
H: 212 cm
Diane Steinmetz Wolfe and Ernie Wolfe III

This gracefully undulating post once helped to support a Dogon men's meeting house called a *togu na*. Men congregate in the shade of the *togu na* to discuss community affairs and resolve conflicts. The support posts of such structures frequently depict female figures—often through the delineation of breasts—alluding to the vital importance of women in Dogon society: "Along with rain and millet, the most common requests in Dogon [men's] prayers are for wives and children…who will help to create future harvests, thus perpetuating the family" (Ezra 1988, 92).

CAT. **3**

SEATED FEMALE FIGURE
Dogon, Mali
Wood, metal
H: 53 cm
Schorr Family Collection

This figure articulates femininity through a geometry of form and spirit. Balance and symmetry combine with horizontal and vertical thrust to transcend ordinary modes of representation. The figure may have served as a memorial placed on a deceased person's rooftop terrace during the funeral. It could also have been used on an ancestral altar. A labret and multiple earrings punctuate the figure's sleek lines and bring to mind a Dogon funeral verse: "Thank you for yesterday, she was [pretty] as a statue" (Ezra 1988, 46).

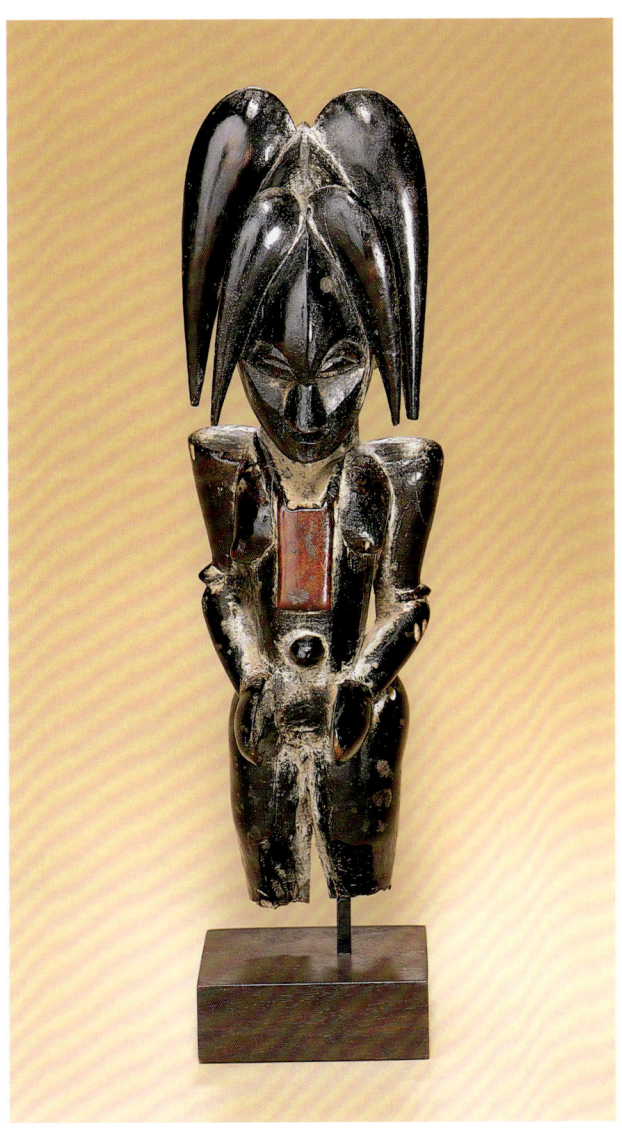

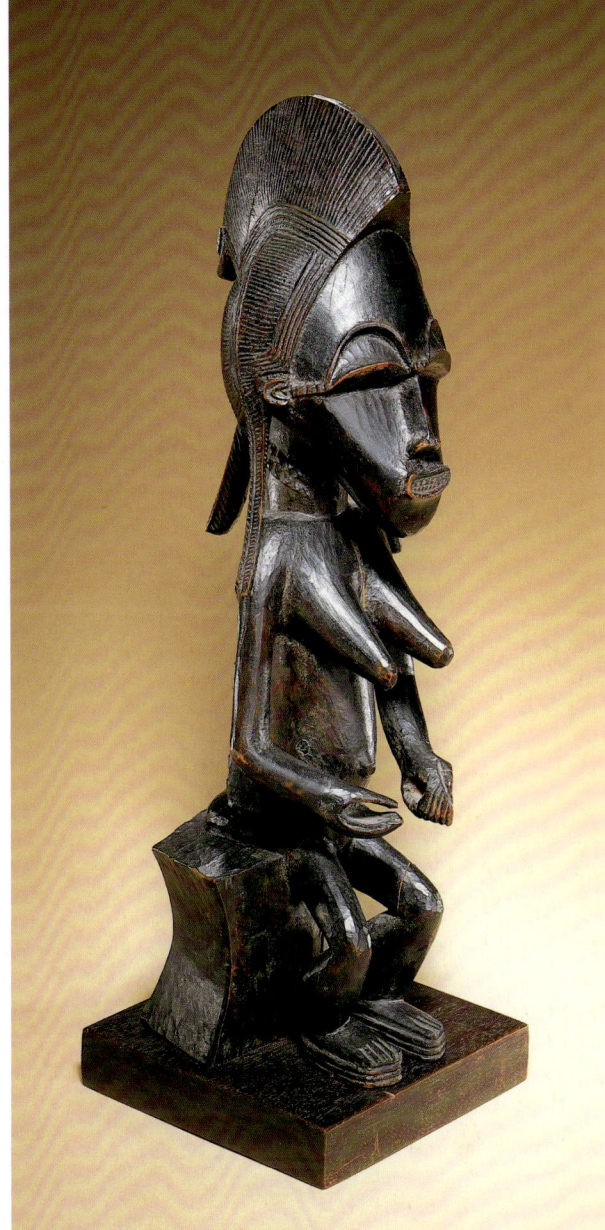

CAT. 4

FEMALE FIGURE
Senufo, Côte d'Ivoire
Wood
H: 22.5 cm
Saul and Marsha Stanoff

Senufo art reflects religious and social concepts concerning the ideological import of women. The phrase "at our Mother's work" is a greeting and password used by Senufo initiates to Poro, the men's society, to honor the female deity who presides over both male and female realms (Glaze 1981, 53). From champion cultivator staffs, made to inspire farmers, to female diviners' display figures and the posts that are swung to and fro during funeral processions, the female figure predominates in Senufo art. The figure shown here tells her story through her hair, the swelling tresses of which crown a figure with a quietly modest demeanor. The smooth and glowing surfaces of her muscular body are hallmarks of pride and beauty.

CAT. 5

SEATED FEMALE FIGURE
Baule, Côte d'Ivoire
Wood, glass beads
H: 43.5 cm
Private Collection

Baule philosophy holds that each human being has a spouse in the spirit world. This otherworld spouse may follow an individual through life; it may be benevolent, or it may bring misfortune. Diviners often recommend that a person experiencing difficulty commission a figure to embody the spirit of an otherworld mate (Vogel 1997, 246–67; Ravenhill 1994). It is not always possible to discern the precise function of a Baule figure from its form. This one could have served as a spirit wife, or it might have been placed in the shrine room of a trance diviner. The Baule women's deity is Adyanun, whom some spirit spouses are able to invoke for the benefit of their human partners. This figure's inward gaze and particular gesture suggest her role of mediation with the spirit world.

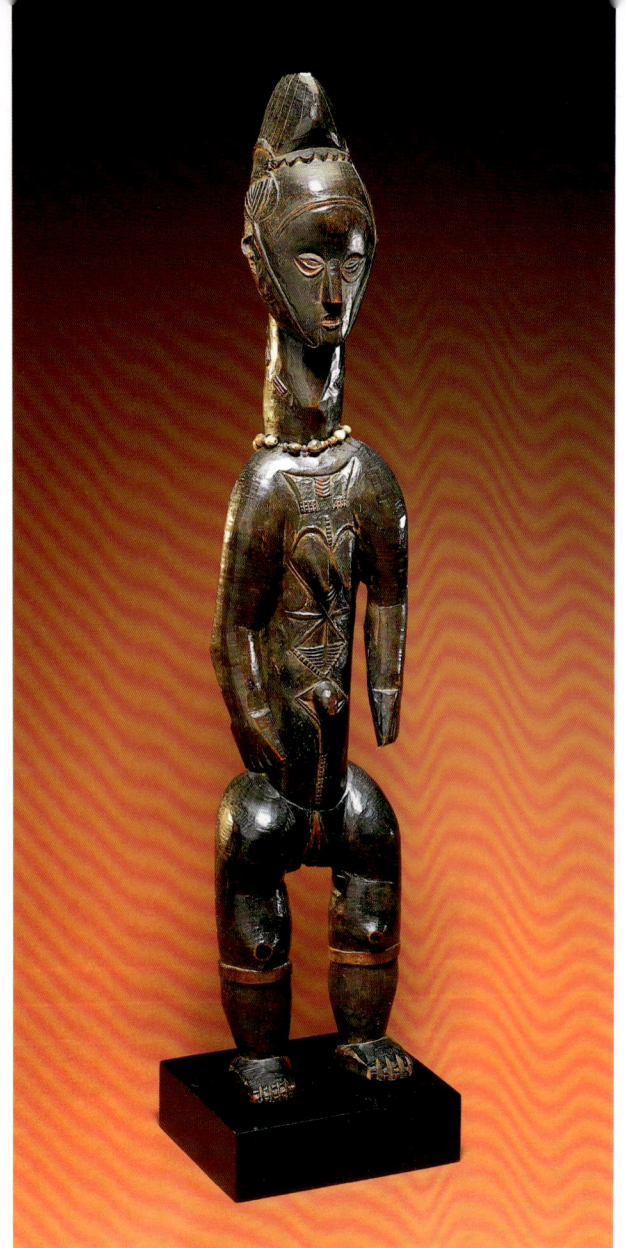
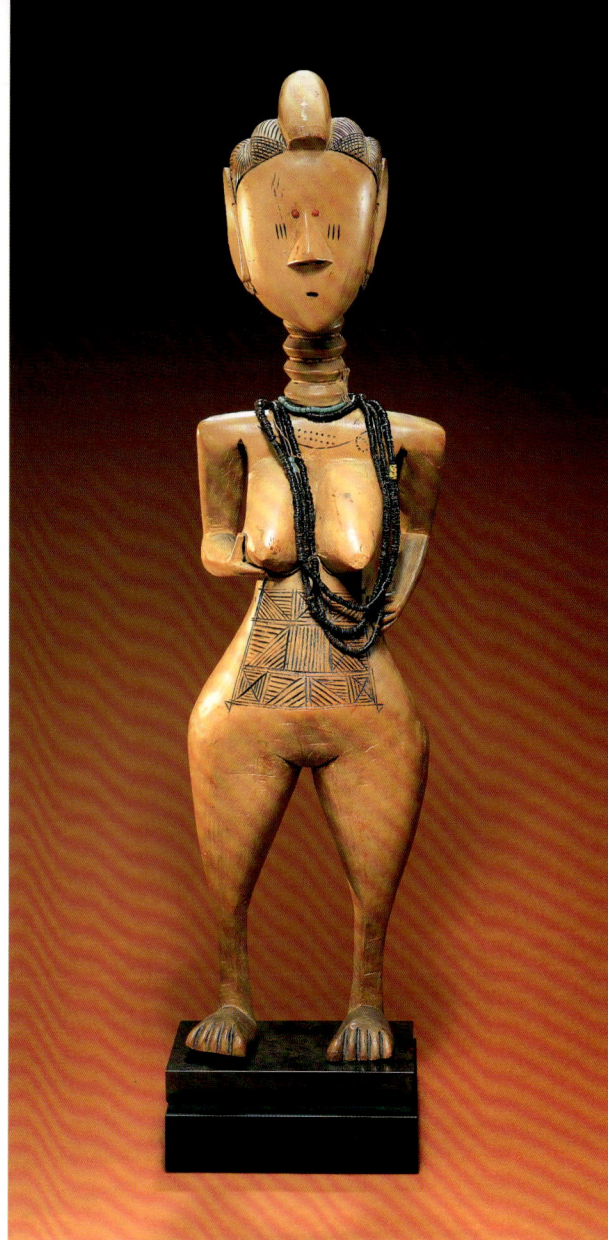

CAT. 6

FEMALE FIGURE
Bete, Côte d'Ivoire
Wood, pigment, seed beads
H: 64 cm
Private Collection

Bete female figures are striking for their bold sculptural solutions. The body is rendered as a series of volumes and inscriptions. By means of its fine, elevated coiffure, long neck, and precisely delineated beauty marks, which run from the shoulders to the abdomen, the figure communicates self-worth and social belonging.

CAT. 7

FEMALE FIGURE
Temne, Sierra Leone
Wood
H: 79 cm
Private Collection

This is one of several almost identical female figures (others are in the collections of the British Museum, London; the Natal Museum, South Africa; and the National Museum of African Art, Washington, D.C.) by an artist whose hand is recognizable in the very particular treatment of the curving hips, teardrop-shaped ears, ringed neck, and tapered chin. Frederick Lamp suggests that the figures were used around the turn of the last century by the women's medicine association known as Ang-bon and that they were similar in purpose and ideology to the medicine figures of the Bullom (Sherbro) Yassi society. The figure's ringed neck recalls Sande masks of the Mende peoples, which reflect ideals of beauty and feminine widom. In this instance, the proferring of the breast may relate to female nurturing, and the scarifications are signs of a lifelong process of achieving status (Lamp, personal communication, 2000).

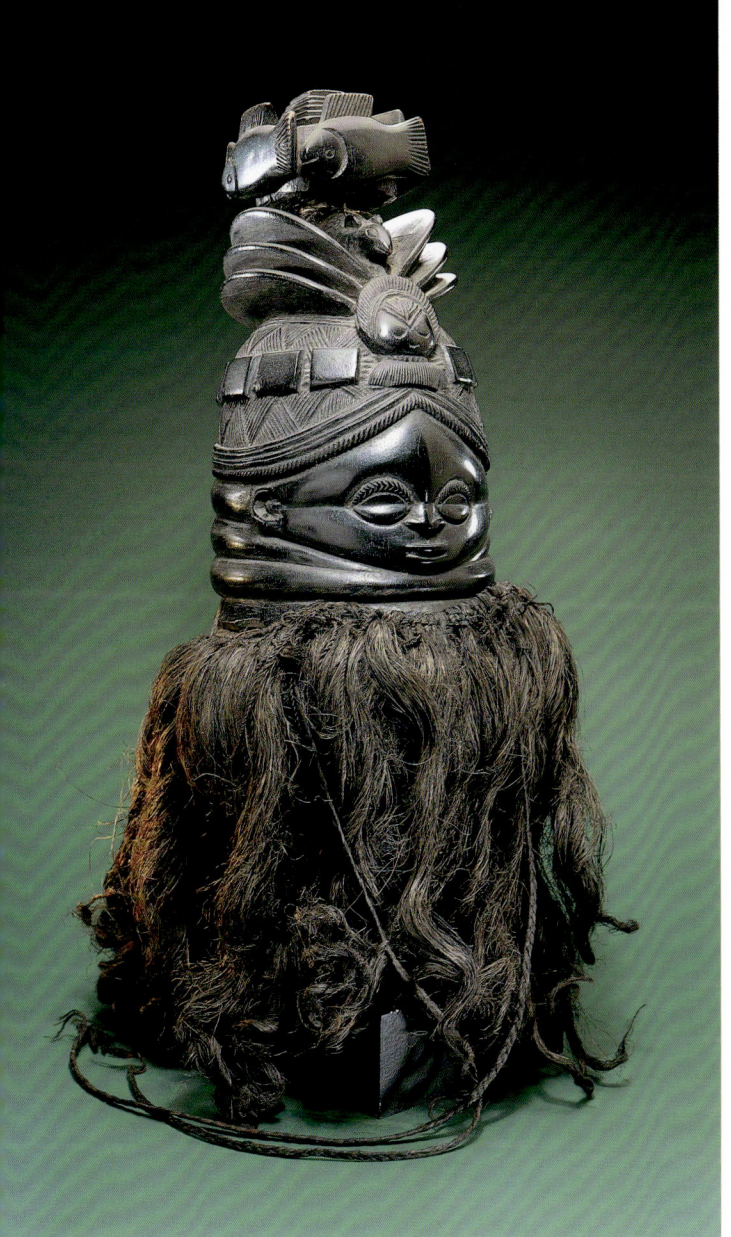

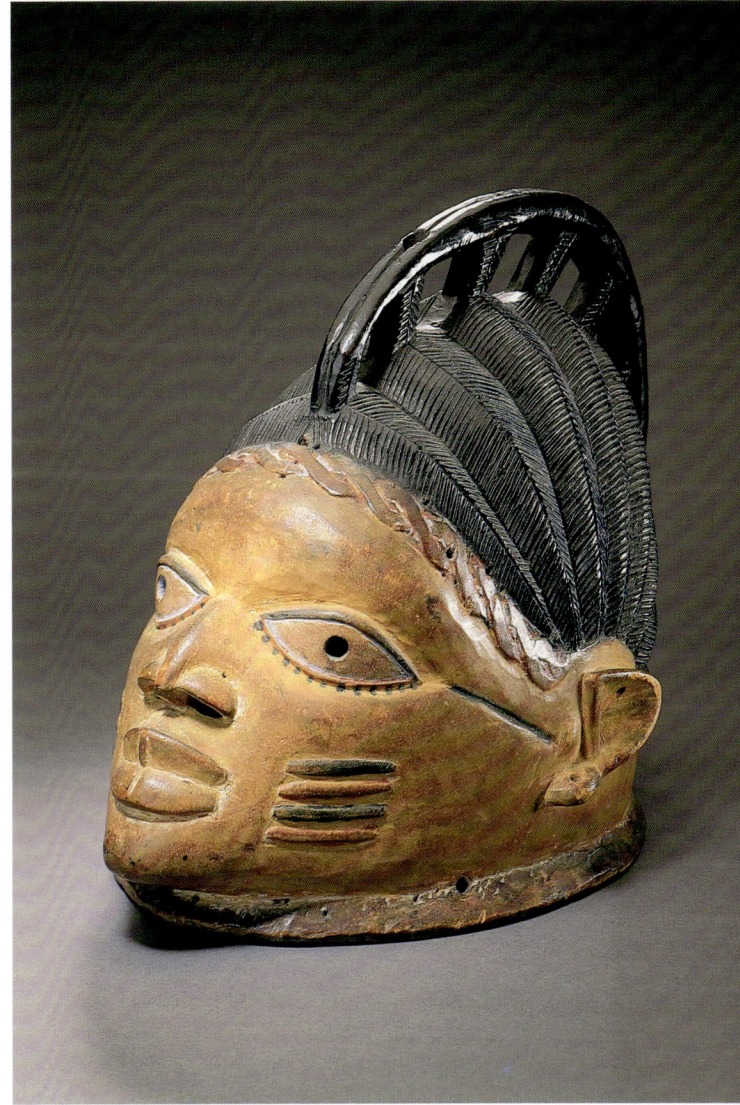

CAT. 8

SOWEI HELMET MASK
Mende, Sierra Leone
Wood, plant fiber
H: 46 cm
FMCH X99.52.4; Anonymous Gift

Sowei masqueraders danced to mark significant moments in the educational cycle of young women in Mende society. Until recently, all Mende girls and women belonged to Sande, an association that taught and fostered self-awareness, as well as practical and esoteric knowledge concerning adulthood, marriage, and childbirth. Women commissioned and performed *sowei* masks; this is rare in Africa where men typically perform masks. A spirit was believed to come to a woman in a dream, revealing its identity and leading to its reification in the form of a mask. This mask, with its gleaming black surface, ringed neck, and complex superstructure ornamented by fish alludes to water, the source of secret knowledge and the deep wisdom that Sande bestowed upon its young initiates (Phillips 1995; Boone 1986).

CAT. 9

GELEDE MASK
Yoruba, Nigeria
Wood, pigment
H: 24 cm
FMCH X65.4742; Gift of the Wellcome Trust

Gelede masquerades honor women and womanhood and promote spiritual well-being and social harmony. Featuring pairs of female masks, the spectacle expresses the ambivalence that Yoruba men feel toward women. Women are regarded as the pillars of society and the source of its regeneration, but elderly women are assumed to possess supernatural powers that can be harmful. *Gelede* appeases and propitiates; it celebrates "our mothers" and comments on current events and social issues. This mask projects the serenity and composure associated with women whose powers are inward, covert, and mysterious (Drewal and Drewal 1990; Drewal 1977). The mask wears *agogo*, or a bride's hairstyle, with braids rising from the hairline to create an elegant longitudinal crest down the center of the head (Lawal 1996). The marks on her cheeks are called *pele* and indicate family, lineage, and cultural identity (Henry Drewal, personal communication, 2000).

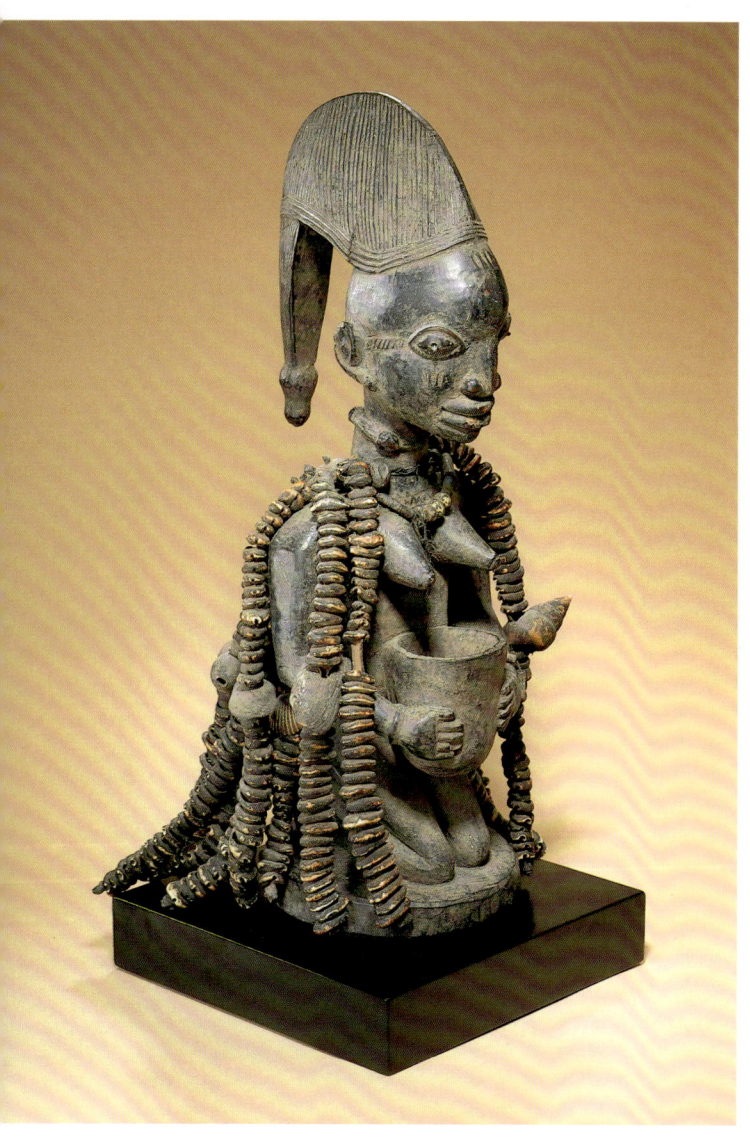
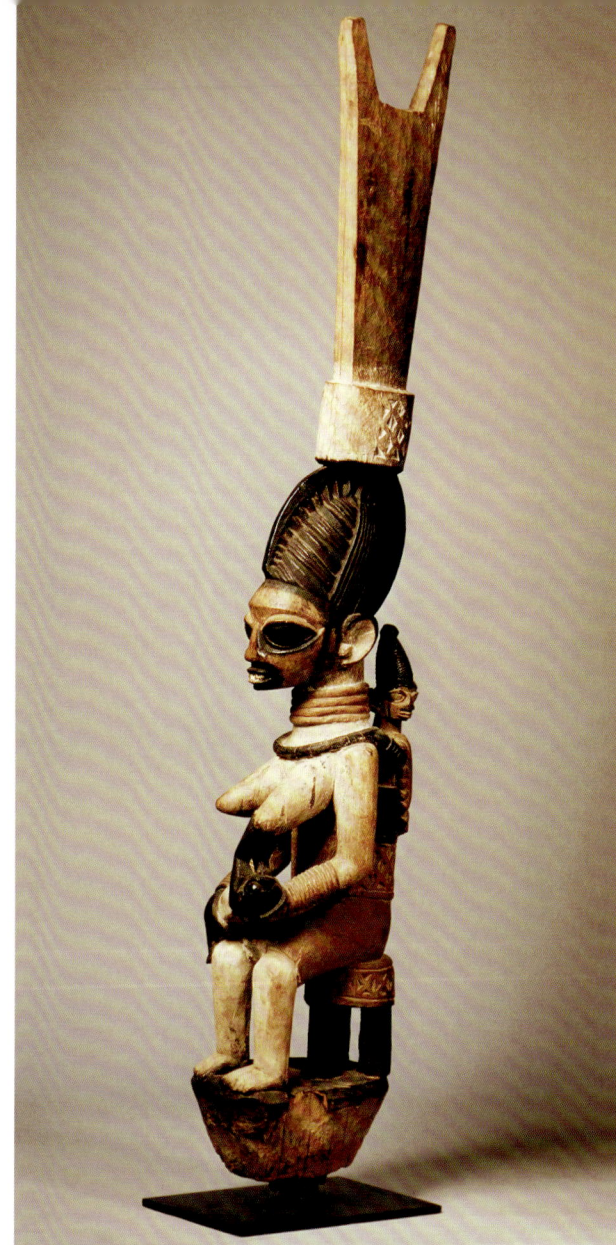

CAT. **10**

SHRINE FIGURE
Yoruba, Nigeria
Wood, cowrie shells, snail shells
H: 51.5 cm
Terry and Lionel Bell

The genre sculpture of a mother and child (on her back) supporting a bowl can take diverse forms, depending upon which deity it is intended to serve. Here, the profusion of cowrie shells enveloping the sensitively carved figure refers to the deity Eshu/Elegba—the principle of uncertainty and the embodiment of contradiction—who resides at crossroads and oversees the vagaries of the marketplace. The unpredictable deity is often associated with gender ambiguity, and this female figure's phallic coiffure expresses Eshu's penchant for reversals. The sculpture undoubtedly once belonged to an Eshu shrine and most likely depicts a female devotee (Henry Drewal, personal communication, 2000). It may also be a reference to the prominent place occupied by women in business and to the fact that women rule market activities in West Africa.

CAT. **11**

VERANDAH POST
Yoruba, Nigeria
Attributed to Areogun of Osi, Opin Ekiti, twentieth century
Wood
H: 195.6 cm
Private Collection

Yoruba artists have always been greatly admired for their individual visions and their contributions to society (Pemberton 1989; LaGamma 1998). Areogun is one of the best-known masters from the early twentieth century. His hand is recognizable in many verandah posts and *epa* masks, and his signature style is a sensitive organic rendering of the human form. Here, a mother proudly nurses her infant, while bearing a second child on her back. The allusion to "mother" as the pillar of society is made explicit in this exceptional post. This figure may be a mother of twins, a most revered status among Yoruba peoples, who refer to such a woman as the "mother of all." Her necklace also identifies her as a priestess or a titled woman in society (Henry Drewal, personal communication, 2000).

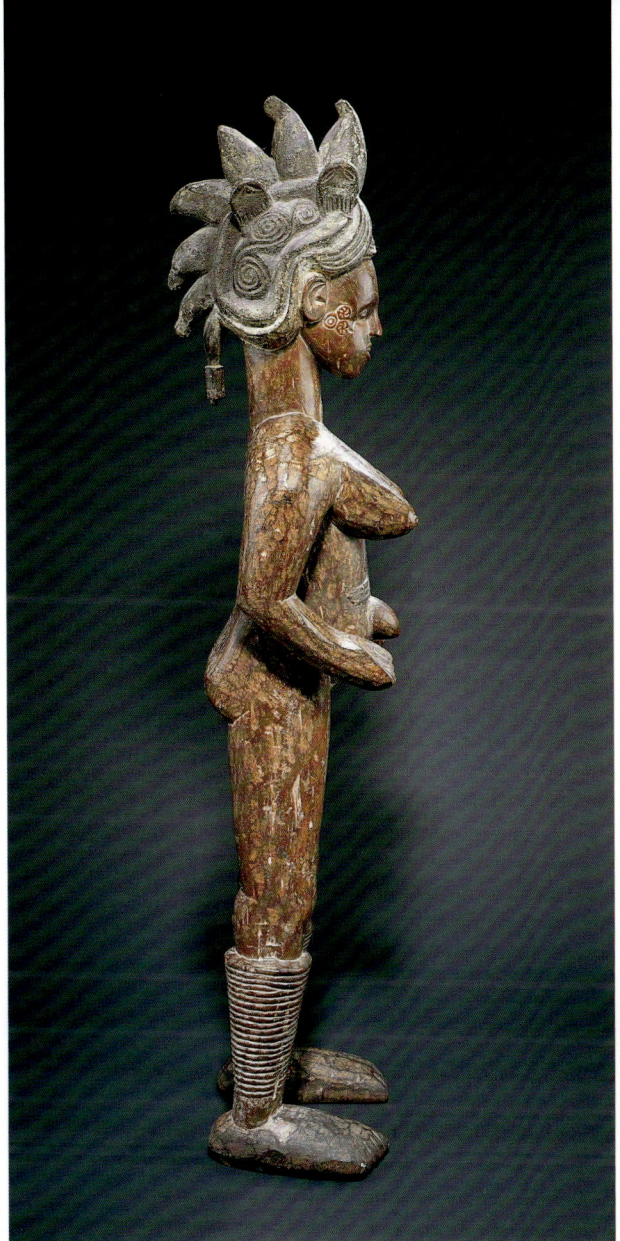
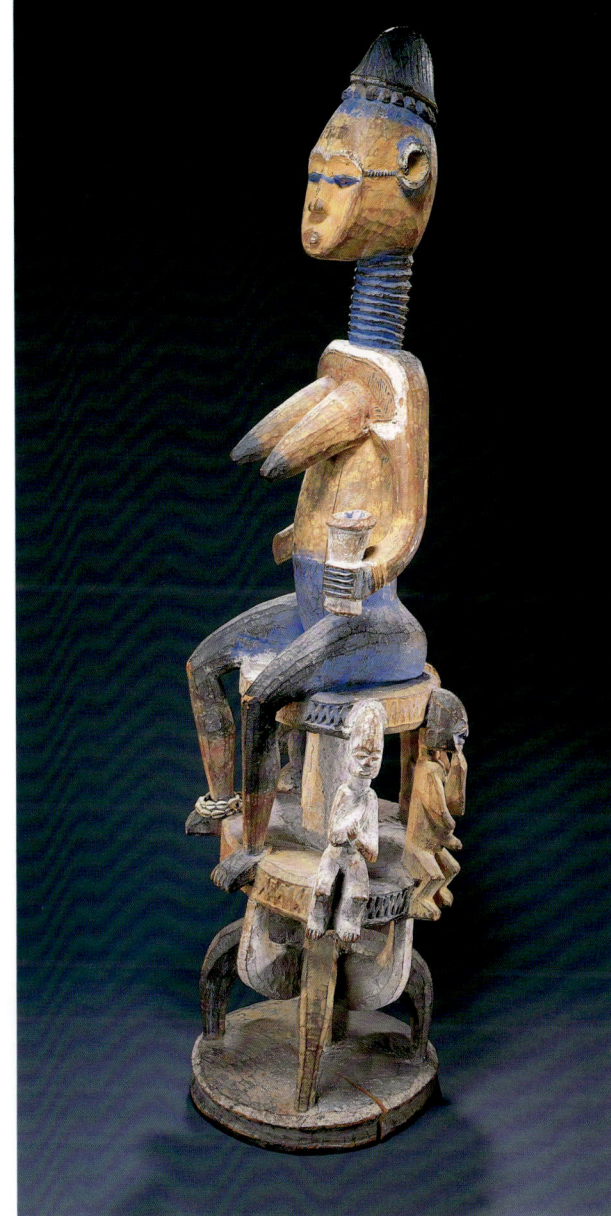

CAT. 12

ALUSI FIGURE
Igbo, Nigeria
Wood, pigment
H: 130 cm
John B. Ross

Proud and dignified, this flamboyant female figure represents a young Igbo girl decked out for her coming-of-age ceremony. She displays a magnificent hairdo and is represented as wearing brass leg rings and a beaded necklace. The figure was probably once part of a family group of *alusi*, or tutelary deities. *Alusi* celebrate familial ties and are brought together annually in a "festival of images" to recognize legendary village founders and extended family networks. This figure's upward-facing palms are generally interpreted as a sign of goodwill and the openhandedness of the gods (Cole and Aniakor 1984, 90–92).

CAT. 13

FEMALE FIGURE ON MULTIPLE STOOLS
Igbo, Nigeria
Wood, paint
H: 122 cm
FMCH X65.5836; Gift of the Wellcome Trust

This dramatic sculpture is one of three known Igbo female figures from the north-central area of Igboland that are shown seated on stools; the precise context and meaning of these figures is unknown. Collected in the Awka region, this figure sits on an openwork stool resembling those used by high-status members of the Ozo titled society. Four smaller figures are perched around the upper tier. It is likely that the figure hailed from a prestigious shrine. The facial features are anomalous, but the neck rings are a sign of beauty in southern Igbo regions where they are described as a "rainbow coiled around the neck" (Cole and Aniakor 1984, 93). Igbo consider the rainbow to be beautiful as well as being a sign of rain and thus of fertility for the earth. Earth is both deified and anthropomorphized as a woman. Igbo people believe they are the Earth's children along with other gods (Herbert M. Cole, personal communication, 2000).

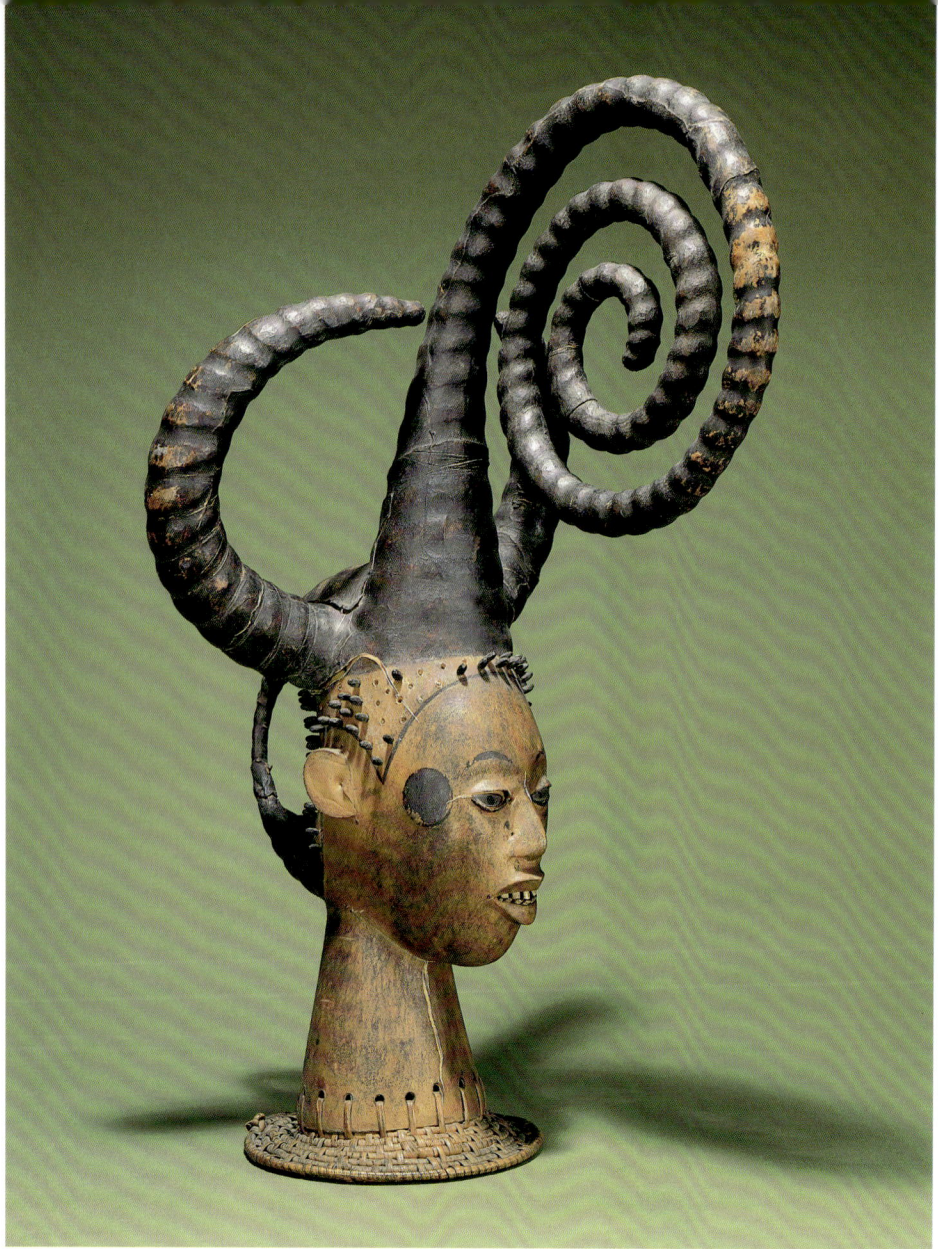

CAT. **14**

FEMALE CAP MASK
Efut, Calabar, Nigeria
Antelope skin, wood, tin
H: 27 cm
FMCH X65.8235; Gift of the Wellcome Trust

The antelope-skin covered cap masks of southeastern Nigeria and southwestern Cameroon feature extraordinary hairstyles. Various associations made male (dark brown) and female (light brown, as shown here) cap masks (Eyo 1981). They were worn during a play called *Ikem*, which may be translated as "all of one heart and one mind." Its purpose was to represent and honor ancestors. The dramatically coiling tresses of this mask recall a hairstyle worn by young women at the end of initiation in preparation for marriage (Nicklin and Salmons 1988; Nicklin 1981, 167). The round raised markings on the temples indicate ethnic identity, and the enigmatic expression is typical of female cap masks. Nicklin and Salmons attribute this mask to one of two famous artists working in Calabar at the beginning of the twentieth century (personal communication, 2000).

CAT. **15**

ODOGU (ANCIENT MOTHER) HEADPIECE AND ENSEMBLE
Northern Edo, Nigeria
Lawrence Ajanaku of the Okpella people, Ogiriga village, 1970s
Cotton fabric, burlap, natural fiber padding, yarn, thread
H: 161.5 cm
FMCH X76.1711 and X76.1716; Gift of Mrs. W. Thomas Davis in memory of W. Thomas Davis

The cloth appliqué dance ensembles of Lawrence Ajanaku reflect the vitality of African artistic production and celebrate the female form in motion. This ensemble is one of several commissioned by the UCLA Fowler Museum of Cultural History from Ajanaku, an exceptional artist who was taught by Okeleke, a master of the cloth appliqué technique. Dazzling ensembles of this type were worn in masquerade performances called Okakagbe, which the northern Edo adopted around 1920. The masquerade is intended to inspire beauty and joy and takes place during religious festivals. This ensemble embodies the spirit of Ancient Mother, the most elaborate and prestigious of all the figures that perform. Her headpiece supports multiple smaller figures that are probably her children, and her flattened elongated breasts allude to the many children she has nurtured during her lifetime (Borgatti 1979).

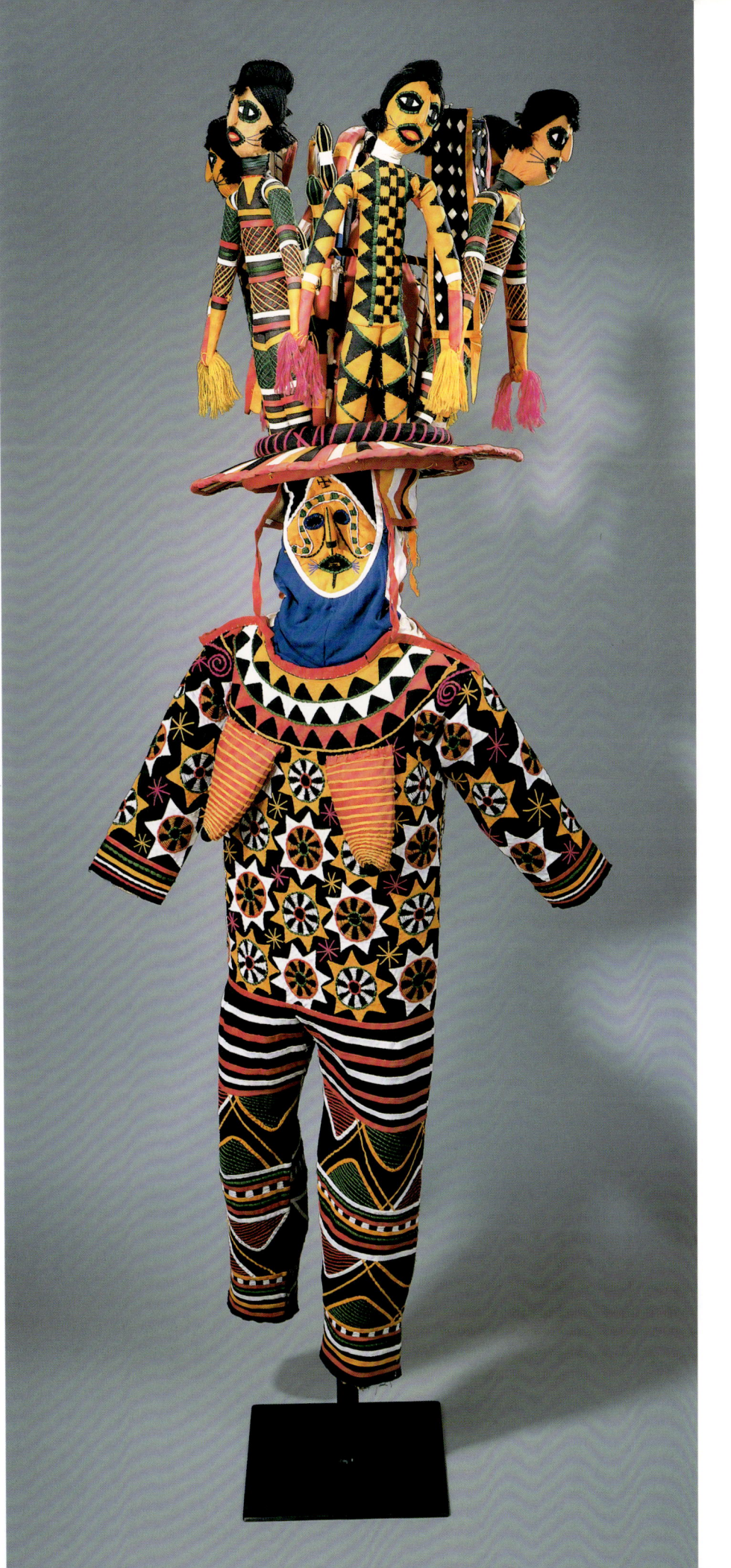

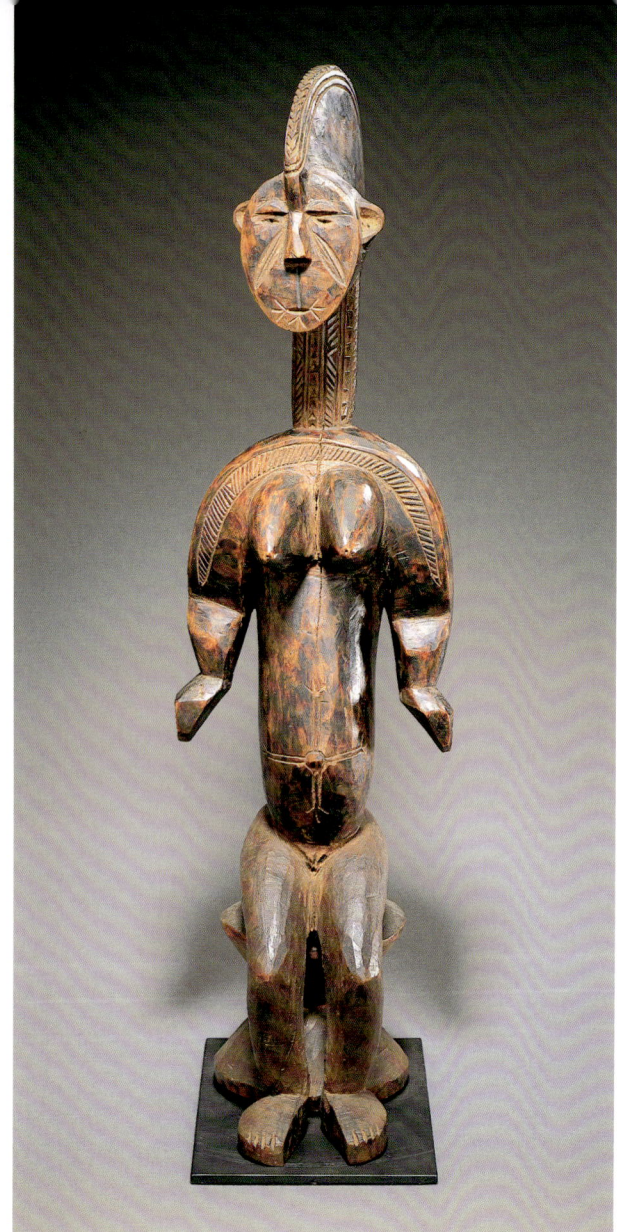

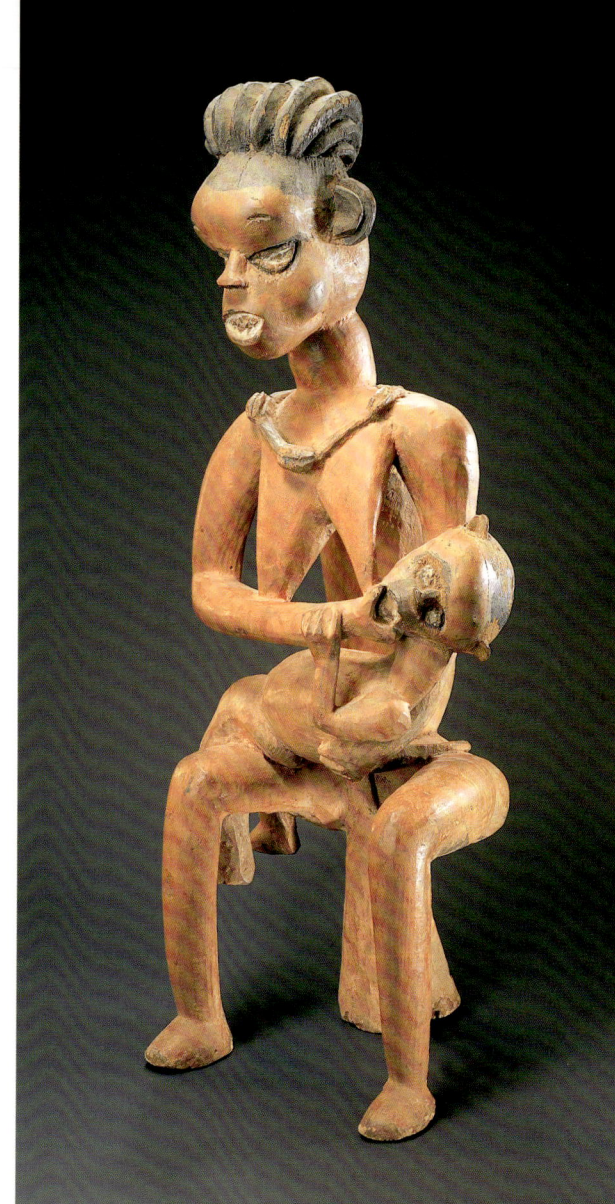

CAT. **16**

SEATED FEMALE FIGURE
Igala, Nigeria
Wood
H: 64.5 cm
Collection of Dr. Richard and Jan Baum

This female figure, seated gingerly on a stool with her arms configured in a dynamic fashion has a finely incised figure on her back. She is very close in form and style to another female figure with a known provenance. The latter is attributed to an Igala artist named Umale who lived in Ukuaja, a small hamlet in the Dekina division of Kwara State in central Nigeria. Although little is known of this figure's original purpose or meaning, seated female figures were common in this region and generally served a protective function. This figure might have been associated with Idoma figures called *ekwotame*, which were placed in close proximity to the corpses of male elders at funerals. Igala and Idoma peoples probably share a common origin, and their art forms reflect the cultural and linguistic overlapping of the two groups (Sieber 1961, 5).

CAT. **17**

COMMEMORATIVE FIGURE OF A ROYAL MOTHER AND CHILD
Bamileke, Cameroon
Wood
H: 85 cm
Private Collection

Among Bamileke and other Western Grassfields kingdoms, commemorative sculptures are made to honor the king's wife who gives birth to the first child, male or female, after the investiture of the king. This figure is depicted wearing regalia normally worn only by the king himself, including a prestige cap and a necklace with large chevron beads, to signify the organizational duties that a king's wife must undertake at the palace. On a more abstract level, she symbolizes the perpetuation of the royal line (Northern 1984, 91). Her expressive face and dynamic pose suggest the strength and vitality of the king's feminine counterpart.

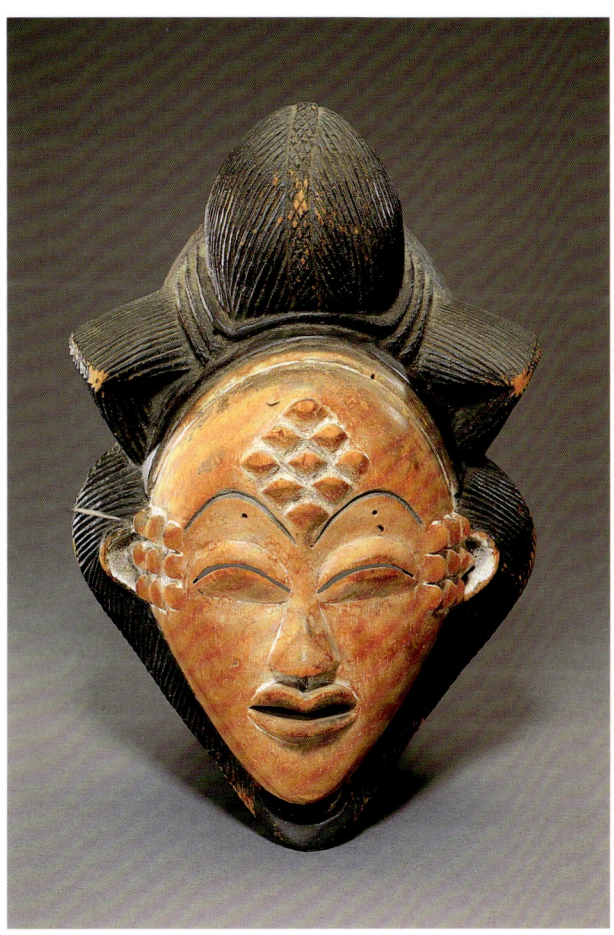

CAT. **18**

FEMALE MASK
Punu, Gabon
Wood, pigment
H: 33 cm
Jerry Solomon Collection

Female face masks whitened with chalk have been documented since the late nineteenth century among a constellation of peoples in southern Gabon and southwestern Republic of the Congo. The masks, called *mukudj*, were worn by male stilt dancers for commemorative events, such as celebrating the life of an important person. Dancers are said to ingest medicines and wear protective talismans to achieve a lightness of movement and a state of spirit possession required for spectacular performances. The remaining traces of white pigment on this mask signal the beneficence of the spirit world. The scarifications on the forehead record a regional aesthetic practice that was associated with outstanding beauty but has come to stand for lineage histories (LaGamma, personal communication, 2000). In recent years the masks have appeared in other contexts, as house and business decor to make statements about ethnic identity (LaGamma 1996).

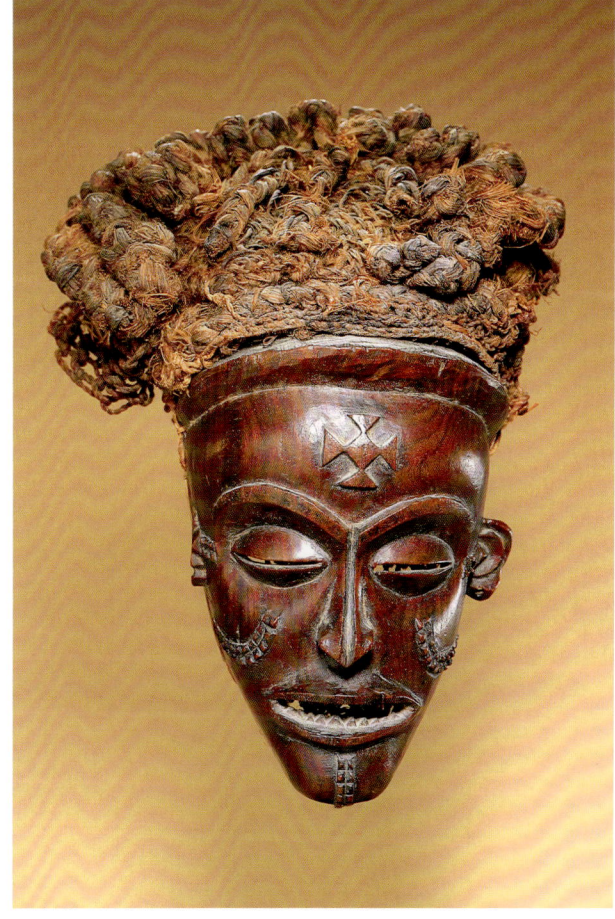

CAT. **19**

MASK FOR A FEMALE ANCESTOR
Chokwe, Angola
Wood, plant fiber
H: 34 cm
Private Collection

Chokwe female masks called Pwo celebrate ideals of feminine beauty. Pwo is a renowned female ancestor who is revered by Chokwe and related peoples. During young men's *mukanda* initiation rituals, younger and older men wear Pwo masks to enact women's roles in society. Chokwe make a distinction between a mature, adult Pwo and the younger character, Mwana Pwo (Jordán 1998, 94–103). This example with ample scarification markings on the face is most likely the mature Pwo, whose well-defined facial features are further enhanced by an elaborate raffia coiffure.

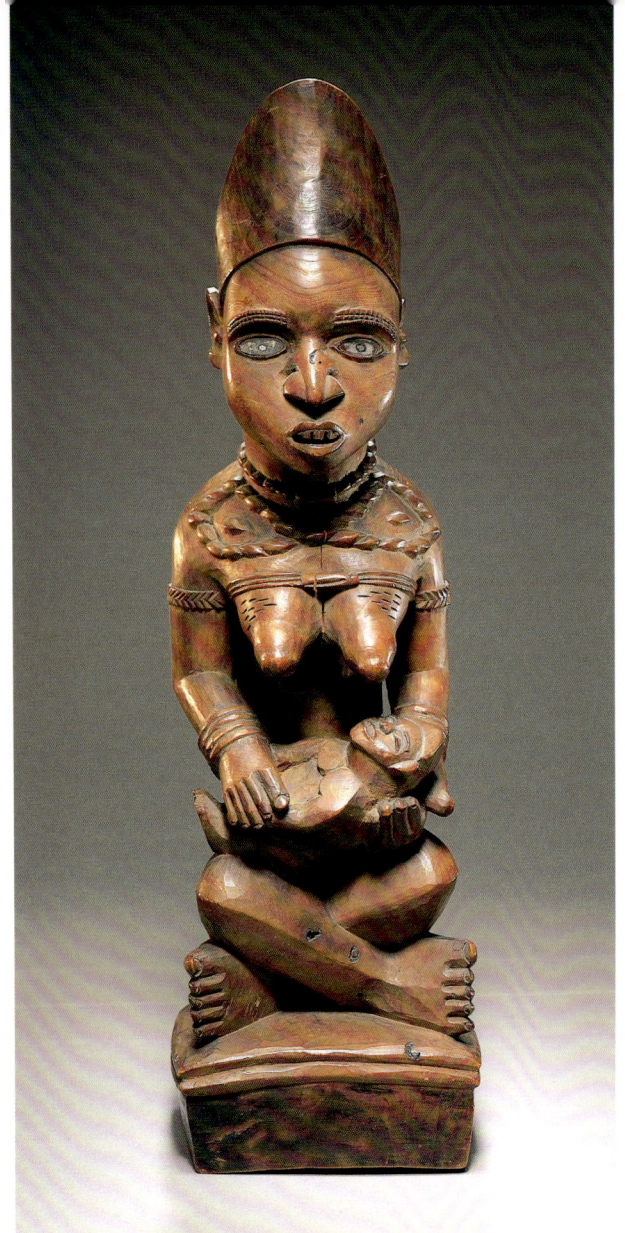

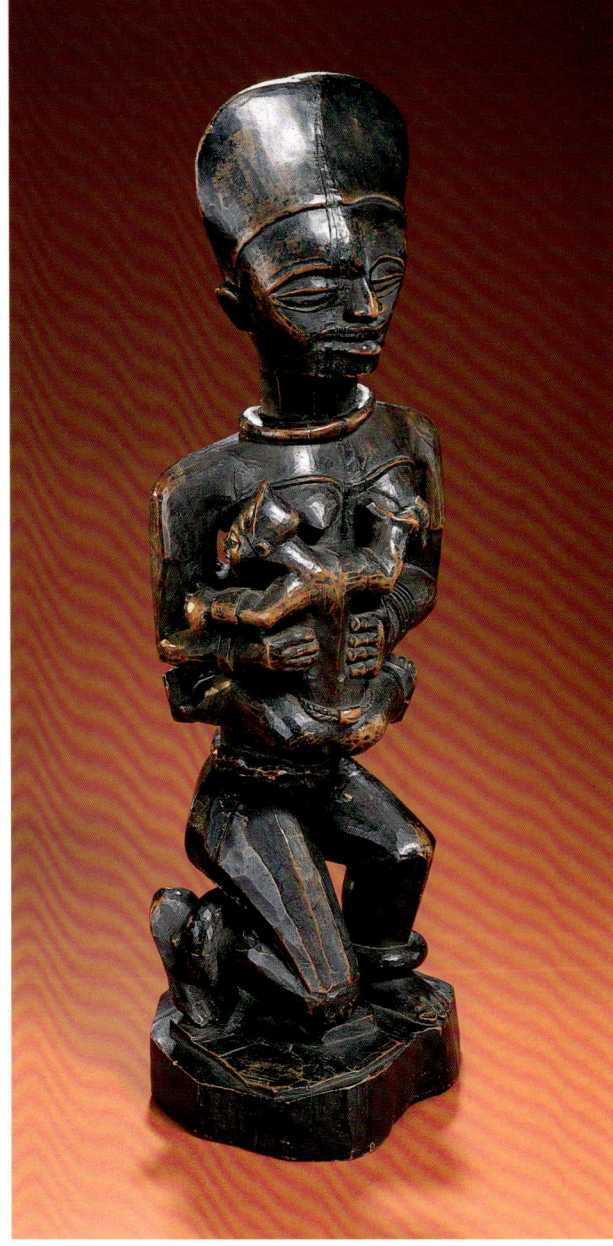

CAT. **20**

MOTHER AND CHILD FIGURE, *PFEMBA*
Yombe, Democratic Republic of the Congo
Wood, glass
H: 40 cm
FMCH X65.7497; Gift of the Wellcome Trust

The genre of *pfemba* figures is one of the rare instances in African art where the female image is created specifically to assist with fertility. These figures of cross-legged women bearing an infant in their arms were used in a women's fertility association founded by a famous midwife. With their filed teeth, raised lozenge-shaped scarification patterns, mitered coiffures, and breast and arm bands, these figures convey valuable information about the cosmetic practices and ideals of beauty of the Yombe. This figure's other-worldly gaze is produced by the insertion of glass into the eyes, and its deep red surface is the product of years of anointing with crimson camwood paste, a cherished cosmetic associated with states of dramatic transformation, such as childbirth (MacGaffey 1996, 146).

CAT. **21**

MOTHER AND CHILD
Yombe, Democratic Republic of the Congo
Wood
H: 43.5 cm
FMCH X65.5458; Gift of the Wellcome Trust

Motherhood achieves an athletic stature in this sculpture of a mother and child. Although Yombe and related Kongo cultures have a legacy of maternity figures, this particular example is unusual in its rendering of stance and movement. Yombe artists do have a tradition of asymmetrical poses rare in African art, and there are many statues poised on one knee. Yet, the particular way this artist has captured the movement and life of the child and of its protective mother goes beyond reality to make larger-than-life declarations about womanly strength and nurturance.

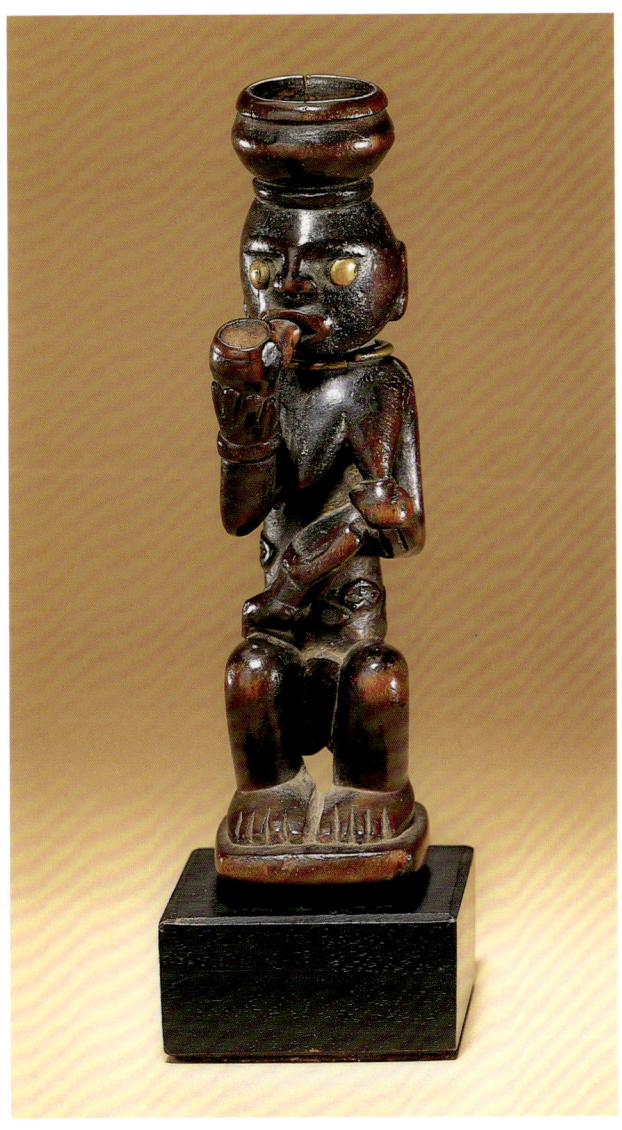

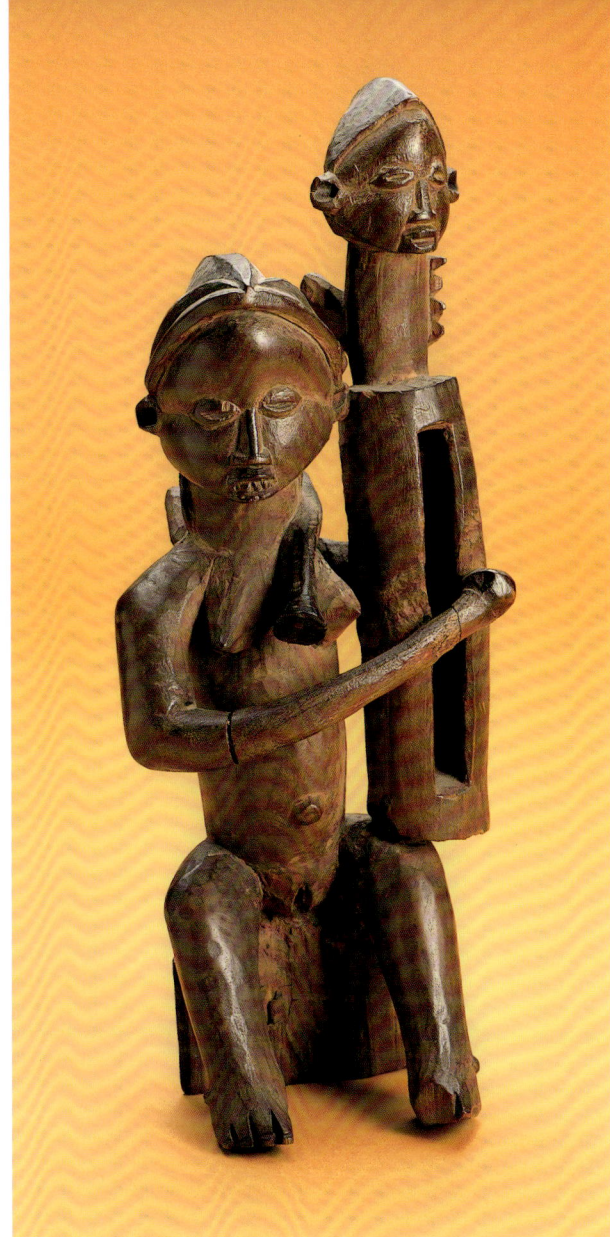

CAT. **22**

MOTHER AND CHILD FIGURE
Kunyi, Democratic Republic of the Congo
Wood
H: 17 cm
Saul and Marsha Stanoff

The monumental presence of this small figure proves that scale lies in the eye of the beholder. It might seem anomalous to have a nursing mother smoking a pipe, but pipe smoking is not restricted to men in Africa, where it is often the prerogative of high-ranking individuals of either gender. This figure also serves as a mortar, most likely to make snuff from leaf tobacco. The use of the head cavity as a mortar is a play on the notion of an *nkisi*, or power figure, which contains empowering medicinal substances in its head.

CAT. **23**

FIGURE OF A FEMALE DIVINER
Mbala, Democratic Republic of the Congo
Wood
H: 38.5 cm
FMCH X85.974; The Jerome L. Joss Collection

Mbala *pindi* figures are talismanic devices to enhance the powers and capacities of clan chiefs. It is likely that this was one of a pair of figures (the other being a male) in a ruler's treasury. Divination with its combined fields of medicine, psychology, and litigation is frequently a women's profession in central Africa. Here, a female *ngoombu* diviner is shown playing a drum and wearing a prestige ax over her shoulder. The positioning of the drum and the natural extension of the woman's arm across the drum's body are suggestive of a mother and child figure. Diviners were called upon following the death of a ruler to name the successor and to mediate interregnal disputes within the community (Bourgeois 1994, 122).

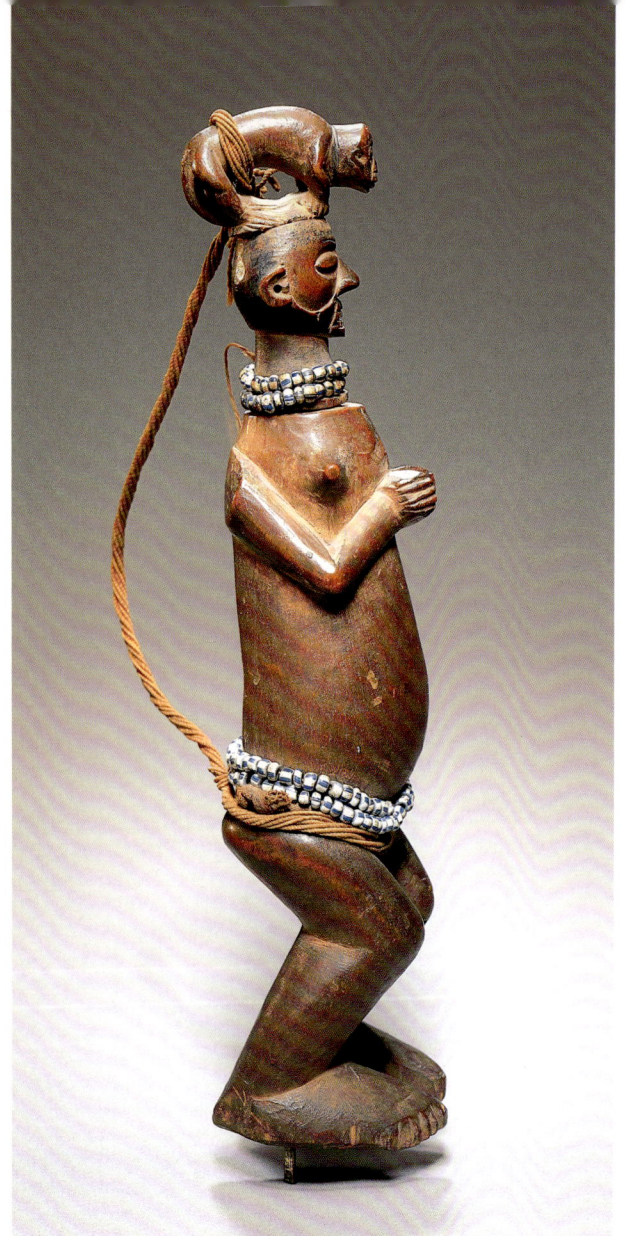
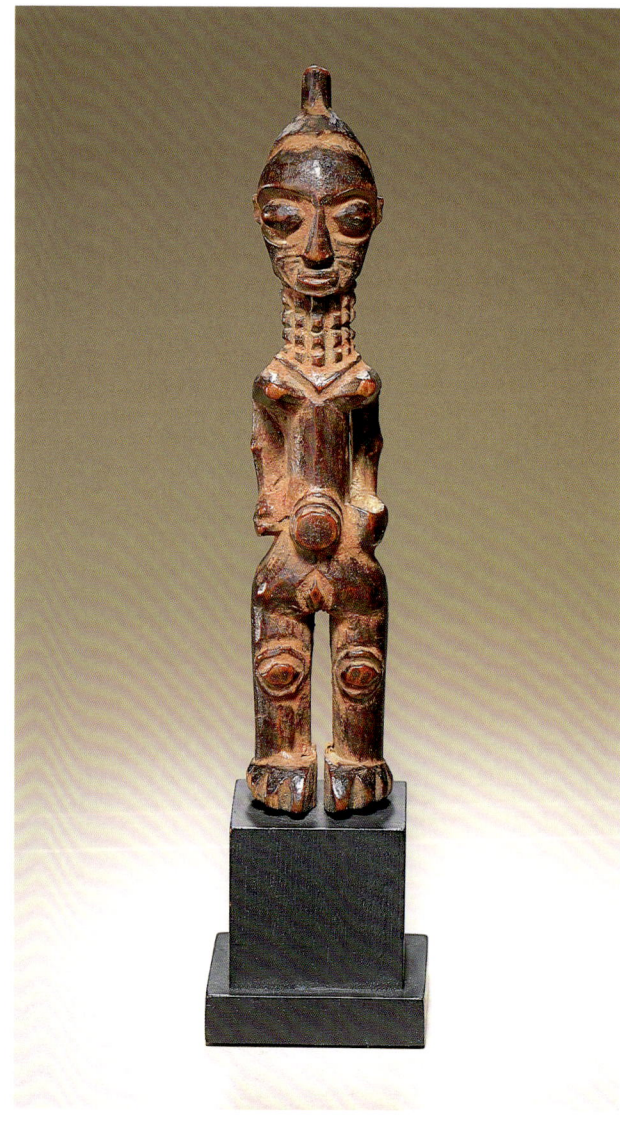

CAT. **24**

FEMALE FIGURE WITH STOPPER
Yaka, Democratic Republic of the Congo
Wood, beads, fiber
H: 28 cm
FMCH X64.118A,B

African artworks often serve as containers. Here, a female figure surmounted by a carved animal doubles as a medicine bottle: the cavity in her head may once have held powerful healing agents (Bourgeois 1995, 303). The animal mounting the woman's head is reminiscent of initiation masks from this region, which sometimes depict a zoomorph atop a human face. While the animal may be a reference to clan identity, it might also pertain to the notion of spirit possession. In many parts of central Africa, diviners become possessed by the spirits of particular animals in order to acquire the powers they need to combat malevolence and protect their clients. This female figure with its typically Yaka stylistic features is powerful in its geometry with legs echoing arms, and breasts splayed to the sides. African artists often go against naturalistic representation in order to tell stories of greater conceptual weight and abstraction.

CAT. **25**

FEMALE FIGURE
Luluwa, Democratic Republic of the Congo
Wood
H: 15 cm
FMCH X91.1654; Anonymous Gift

Luluwa aesthetics are pared down to essentials in this diminutive sculpture, which probably served as *mbulenga*, or a power figure. Such figures provide general protection and well-being, especially for pregnant women and children (Felix 1987, 88). Whereas most Luluwa sculptures have pervasive curvilinear scarification patterns, this small and intimate sculpture denotes such markings through simple concentric circles around the joints and through the textured chiseling of the neck. Its surface reflects the loving application of camwood powder, a cosmetic with cosmological significance.

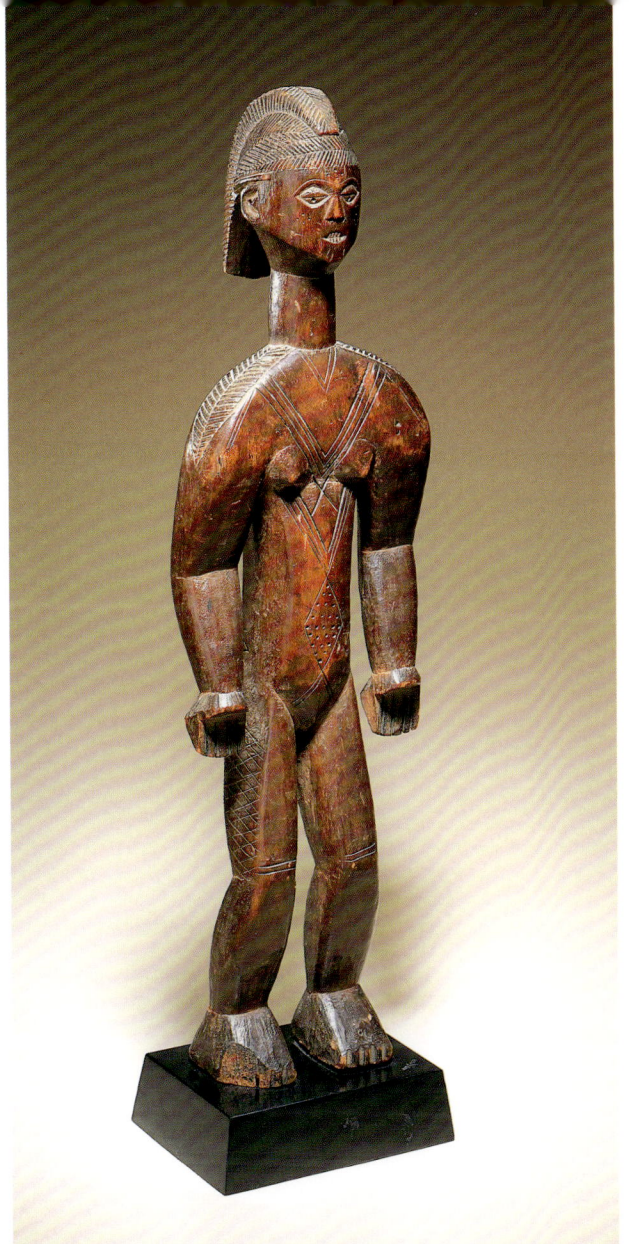
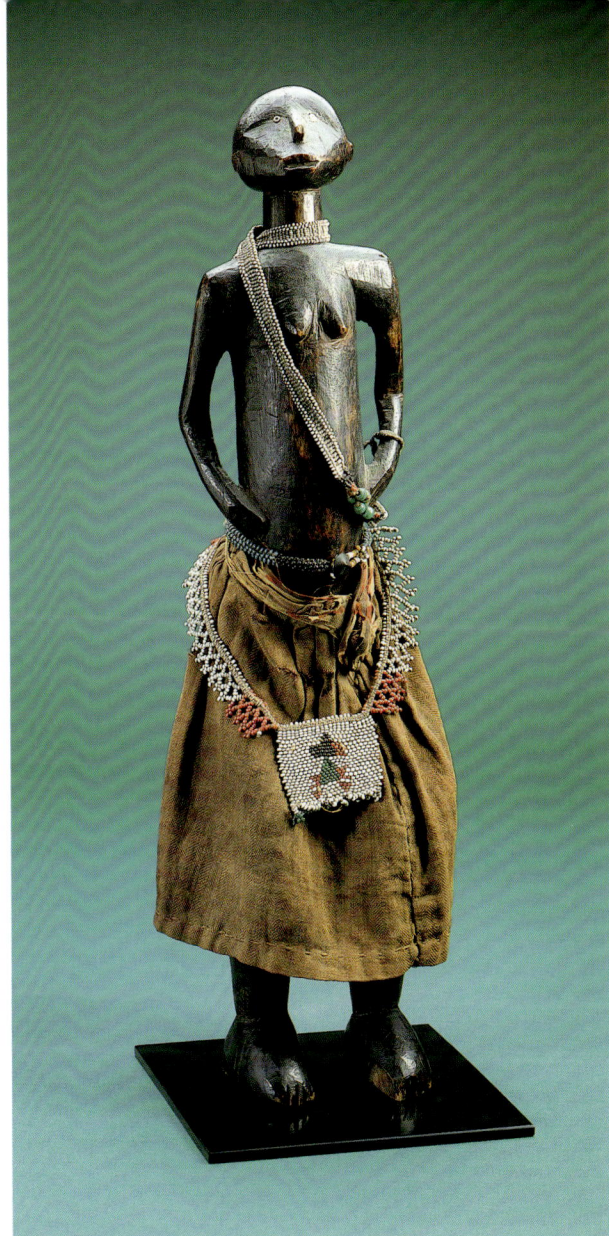

CAT. **26**

FEMALE FIGURE
Mbuun, Democratic Republic of the Congo
Wood
H: 51 cm
Dr. and Mrs. Ernest Fantel

While many African female figures have scarification patterns raised in relief, this figure is unusual for the extremely delicate and fastidious manner in which the patterns are incised into its surface. The figure's bent knees and outward-facing palms identify it with other Mbuun objects that have the same characteristics. Oral tradition attributes the open-palm gesture to the son of Effa, the female founder of the original Mbuun clan, who confronted his opponent "flex-legged, holding soil in the palm of his hands" (De Palmenaer 1996, 158).

CAT. **27**

FEMALE FIGURE WITH SKIRT
Maravi (?), Malawi, Southeast Africa
Wood, beads, cotton, cloth, buttons, thread, leather
H: 48 cm
FMCH X86.1738; The Jerome L. Joss Collection

The beadwork on the figure's skirt is characteristic of both South African Zulu women and Ngoni women in Malawi, and it may reflect the migration of Zulu-led Ngoni peoples to new lands around Lake Malawi in the early nineteenth century (Blackmun 1994, 139–40; Robbins and Nooter 1989, 520). The figure demonstrates a point that is often forgotten when looking at African art: much African figural sculpture was once at least partially clothed from the waist down. Often the patina of an old sculpture will reveal where a garment was worn. African sculptures are rarely "naked," in the Western sense of the word, which implies loss or absence. Rather, whether clothed with garments or enhanced with scarifications and beads, African sculpture is almost always about the ways that the body accumulates meaning and communicates messages through additive adornments.

BIBLIOGRAPHY

Suggested Reading for "Conversing Forms"

Luba Art

Mudimbe, V. Y.
1991 *Parables and Fables: Exegesis, Textuality, and Politics in Central Africa.* Madison: University of Wisconsin Press.

Reefe, Thomas Q.
1981 *The Rainbow and the Kings: A History of the Luba Empire to 1891.* Berkeley: University of California Press.

Roberts, Allen F., and Evan Maurer
1985 *The Rising of a New Moon: A Century of Tabwa Art.* Seattle: University of Washington Press for the University of Michigan Museum of Art.

Roberts, Mary Nooter
Forthcoming "The King is a Woman: Gender and Authority in Central African Art." In *Nature, Belief, and Ritual: Art of Sub-Saharan Africa at the Dallas Museum of Art*, edited by Ramona Austin. Dallas: Dallas Museum of Art.

Roberts, Mary Nooter, and Allen F. Roberts
1996 *Memory: Luba Art and the Making of History.* New York: The Museum for African Art; Munich: Prestel Verlag.

Alison Saar

hooks, bell
1995 "Talking Art with Alison Saar." In *Art on My Mind: Visual Politics*, 22–34. New York: The New Press.

Lewis, Samella
1990 "Alison Saar." In *African American Art and Artists*, 284–86. Berkeley: University of California Press.

Lyons, Lisa, and Grant Mudford
2000 "Alison Saar: Afro-Di(e)ty." In *Departures: 11 Artists at the Getty*, 48–51. Los Angeles: J. Paul Getty Trust.

McNaughton, Mary Davis
2000 *Alison and Lezley Saar.* Claremont: Ruth Chandler Williamson Gallery, Scripps College.

Shepherd, Elizabeth
1990 *Secrets, Dialogues, Revelations: The Art of Betye and Alison Saar.* Los Angeles: Wight Art Gallery, University of California, Los Angeles.

References Cited in "Imaging Women"

Blackmun, Barbara W.
1994 "Standing Female Figure." In *Visions of Africa: The Jerome L. Joss Collection of African Art at UCLA,* edited by Doran H. Ross, 139–40. Los Angeles: UCLA Fowler Museum of Cultural History.

Boone, Sylvia Ardyn
1986 *Radiance from the Waters: Ideals of Feminine Beauty in Mende Art.* New Haven: Yale University Press.

Borgatti, Jean
1979 *From the Hands of Lawrence Ajanaku.* Pamphlet Series 1, no. 6. Los Angeles: UCLA Museum of Cultural History.

Bourgeois, Arthur
1994 "Charm Figure." In *Visions of Africa: The Jerome L. Joss Collection of African Art at UCLA,* edited by Doran H. Ross, 122–23. Los Angeles: UCLA Fowler Museum of Cultural History.
1995 "Figure." In *Treasures from the Africa-Museum, Tervuren,* 303. Tervuren: Royal Museum of Central Africa.

Cole, Herbert M., and Chike C. Aniakor
1984 *Igbo Arts: Community and Cosmos.* Los Angeles: Museum of Cultural History, University of California.

De Palmenaer, Els
1996 "Cup." In *Masterpieces from Central Africa: The Tervuren Museum,* edited by Gustaaf Verswijver et al., 158. Tervuren: Royal Museum for Central Africa; Munich: Prestel Verlag.

Drewal, Henry John
1977 "Art and the Perception of Women in Yoruba Culture." *Cahiers d'études africaines* 17(4): 545–67.

Drewal, Henry John, and Margaret Thompson Drewal
1990 *Gelede: Art and Female Power among the Yoruba.* Bloomington: Indiana University Press.

Eyo, Ekpo
1981 "Headdress." In *For Spirits and Kings: African Art from the Paul and Ruth Tishman Collection,* edited by Susan M. Vogel, 167. New York: The Metropolitan Museum of Art.

Ezra, Kate
1988 *Art of the Dogon: Selections from the Lester Wunderman Collection.* New York: The Metropolitan Museum of Art.

Felix, Marc Léo
1987 *100 Peoples of Zaire and their Sculpture: The Handbook.* Brussels: Zaire Basin Art History Research Foundation.
1995 *Art et Kongos: Les peuples kongophones et leur sculpture.* Brussels: Zaire Basin Art History Research Center, Brussels.

Glaze, Anita J.
1981 *Art and Death in a Senufo Village.* Bloomington: Indiana University Press.

Jordán, Manuel
1998 *Chokwe! Art and Initiation among Chokwe and Related Peoples.* Munich: Prestel Verlag.

LaGamma, Alisa
1996 "The Art of the Punu Mukudj Masquerade: Portrait of an Equatorial Society." Ph.D. diss., Columbia University.
1998 "Authorship in African Art." *African Arts* 31, no. 4: 18–23, 89–90.

Lawal, Babatunde
1996 *The Gelede Spectacle: Art, Gender, and Social Harmony in an African Culture.* Seattle: University of Washington Press.

MacGaffey, Wyatt
1996 "*Pfemba* Maternity Statue." In *Masterpieces from Central Africa: The Tervuren Museum,* edited by Gustaaf Verswijver et al., 146–47. Tervuren: Royal Museum for Central Africa; Munich: Prestel Verlag.

Nicklin, Keith
1981 "Headdress." In *For Spirits and Kings: African Art from the Paul and Ruth Tishman Collection,* edited by Susan M. Vogel, 167–68. New York: The Metropolitan Museum of Art.

Nicklin, Keith, and Jill Salmons
1988 "Ikem: The History of a Masquerade in Southeastern Nigeria." In *West African Masks and Cultural Systems,* edited by Sidney Kasfir. Tervuren: Royal Museum for Central Africa.

Northern, Tamara
1984 *The Art of Cameroon.* Washington, D.C.: Smithsonian Institution Traveling Exhibition Service (SITES).

Pemberton, John III
1989 "The Carvers of the Northeast." In *Yoruba: Nine Centuries of African Art and Thought,* edited by Henry John Drewal, John Pemberton III, and Rowland Abiodun. New York: The Center for African Art in association with Harry N. Abrams, Inc.

Phillips, Ruth B.
1995 *Representing Woman: Sande Masquerades of the Mende of Sierra Leone.* Los Angeles: UCLA Fowler Museum of Cultural History.

Ravenhill, Philip L.
1994 *The Self and the Other: Personhood and Images among the Baule, Côte d'Ivoire.* Monograph Series 28. Los Angeles: UCLA Fowler Museum of Cultural History.

Robbins, Warren, and Nancy I. Nooter
1989 *African Art in American Collections.* Washington, D.C.: Smithsonian Institution.

Sieber, Roy
1961 *Sculpture of Northern Nigeria.* New York: The Museum of Primitive Art.

Vogel, Susan M.
1997 *Baule: African Art/Western Eyes.* New Haven: Yale University Press in cooperation with The Museum for African Art, New York.

Walker, Roslyn, and Philip L. Ravenhill
1999 "Female Figure." In *Selected Works from the Collection of the National Museum of African Art,* 37. Washington, D.C.: Smithsonian Institution, National Museum of African Art.

Photo Credits

Conversing Forms

All images were taken by Don Cole, © UCLA Fowler Museum, with the exceptions noted below:

Courtesy of the Jan Baum Gallery—2A and B, 11, 12 (detail), 18, 23, 34, 40, 42, 52–53, 59, 73–74; Dick Beaulieux—26, 47; Anthony Cuñha—24, 30, 38 69–70; Denis J. Nervig, © UCLA Fowler Museum—35; Robert Pacheco, © The J. Paul Getty Trust—25; Douglas M. Parker Studio—6, 8, 10, 46; Jerry L. Thompson—39

Imaging Women

All images were taken by Don Cole, © UCLA Fowler Museum, with the exceptions noted below:

Antonia Graeber—14; Denis J. Nervig, © UCLA Fowler Museum—27; Richard Todd—1; Courtesy of Valerie Franklin—11

CONTRIBUTORS

MARY NOOTER ROBERTS, the chief curator at the UCLA Fowler Museum of Cultural History, received her doctorate in Art History from Columbia University. Her research focuses on the philosophical underpinnings of African visual arts and expressive culture. From 1984 to 1994 Roberts served as senior curator at the Museum for African Art, New York, where she organized numerous exhibitions, including *Secrecy: African Art that Conceals and Reveals* (1993); *Exhibition-ism: Museums and African Art* with Susan Vogel and Chris Muller (1994); and *Memory: Luba Art and the Making of History* (1996). She is the author of *Secrecy: African Art that Conceals and Reveals* (1993); *Exhibition-ism: Museums and African Art* (1994), with Susan Vogel and Chris Muller; and *Facing Africa: African Art in the Toledo Museum of Art* (1998). She has also co-authored with Allen F. Roberts *Memory: Luba Art and the Making of History* (1996), *The Shape of Belief: African Art from the Michael C. Heide Collection* (1996), and *A Sense of Wonder: African Art from the Faletti Family Collection* (1997). Dr. Roberts has taught at Swarthmore College, Columbia University, and the University of Iowa. From 1997 to 1999 she served as President of the Arts Council of the African Studies Association. She is currently conducting field research with Allen F. Roberts on the arts of the Mourides, a contemporary Sufi movement in Senegal.

ALISON SAAR is perhaps best known for her expressive large-scale sculptures made from found materials, although she is accomplished in a variety of media. Her works draw upon diverse cultural legacies and address sexual and racial stereotypes, as well as issues of social identity and spiritual transcendence. Born into a family of artists, Saar attended Scripps College in Claremont, California, and received her master of fine arts degree from the Otis Art Institute, Los Angeles. Her work is included in the permanent collections of many major museums, including the Metropolitan Museum of Art, the Whitney Museum of Art, the Hirshhorn Museum, the Los Angeles County Museum of Art, and the Walker Art Center. It has also been featured in numerous exhibitions, among them: *Secrets, Dialogues, Revelations* with Betye Saar at UCLA's Wight Art Gallery (1990); *Alison Saar: The Woods Within* at the Brooklyn Museum (1993); *Directions* at the Hirshhorn Museum (1993); *Fertile Ground* at the High Museum (1993); *Travelin' Light* at the Santa Monica Museum of Art (1999). Most recently she was one of eleven artists commissioned to create a work of art for the exhibition *Departures* held at the J. Paul Getty Museum (2000). Saar is the recipient of a John Simon Guggenheim Memorial Foundation Fellowship, an Artist Fellowship from the National Endowment for the Arts, the Distinguished Alumnus Award from the Otis Art Institute, and most recently, the Flintridge Foundation 1999–2000 Award for Visual Artists.

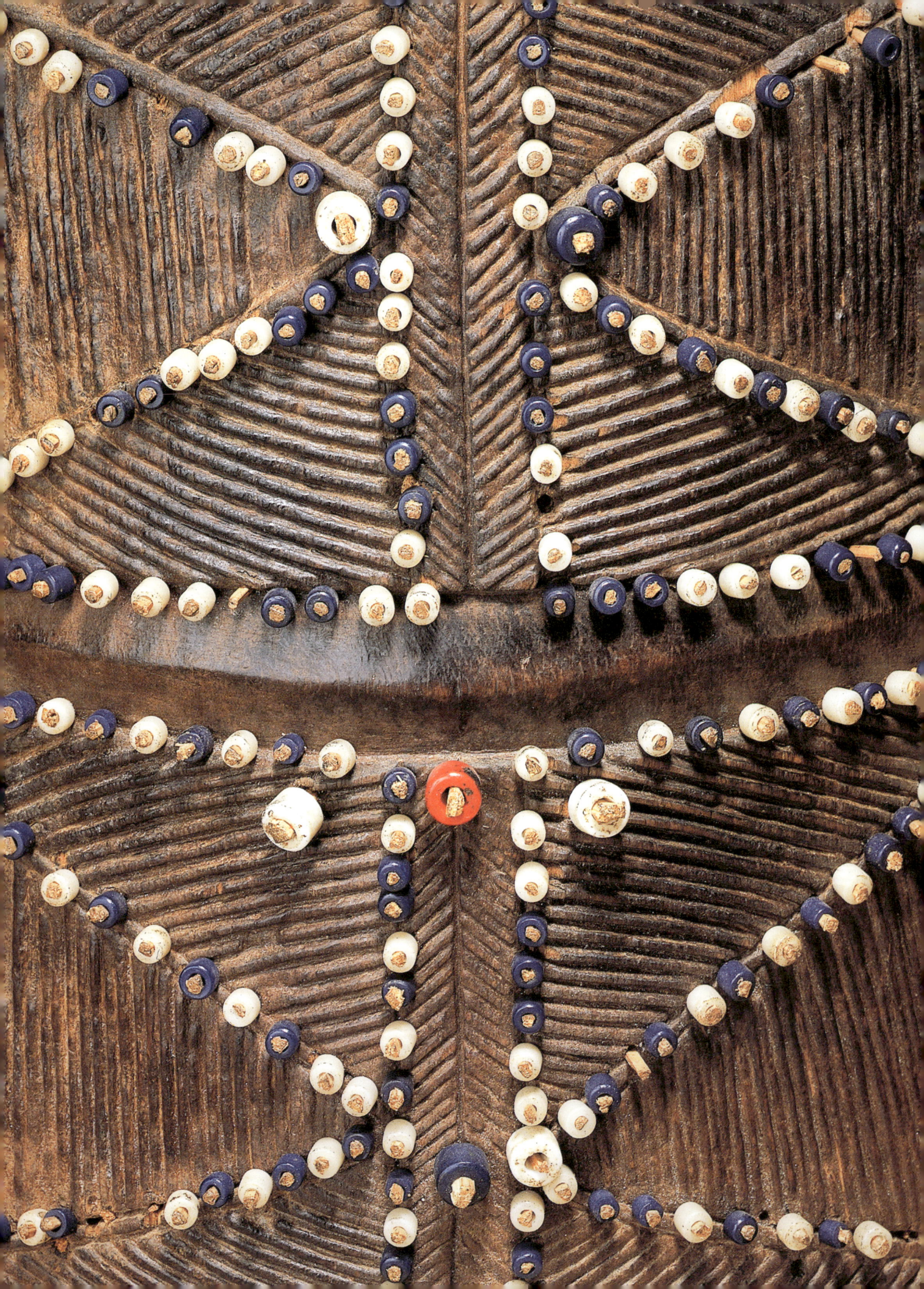